JUST ONE SPARROW

*The Dance Between
Nothingness and Somethingness:*

UNDERSTANDING LIFE AS ART

BY RACHEL CORDAY, PHD

For Kay Kindall

Copyright © 2013 Rachel Corday
All rights reserved.

ISBN-10: 148004511X
EAN-13: 9781480045118

Contents

The Picture i

The Beginning

Chapter 1: There Is Never Not Nothingness 1
Chapter 2: The Divine Heart of Life 19
Chapter 3: The Stream Against the Rock 43
Chapter 4: The Trap of Expressive Life 67
Chapter 5: The Gift of the Present Moment 89
Chapter 6: Nothing That Is, Is 115
Chapter 7: Stuck Out Here All Alone 139
Chapter 8: Great Creation Requires Great Resistance 153

The Middle

Chapter 9: Sitting in Presence With Those Around 171
Chapter 10: Look To The Earth 189
Chapter 11: The Mistake of One is the Mistake of All 215
Chapter 12: Life Creates Time for a Single Moment 253
Chapter 13: The Invention of Mental Alone 277

Chapter 14: Every Structure of
 the Earth is Our Teacher 295
Chapter 15: Art Will Call You With
 A Cosmic Power 311
Chapter 16: The Heart of the World is Broken 341

The End

Chapter 17: Jesus Was An Actor,
 Christianity Was A Show 373
Chapter 18: Nothing Is Not Divine 409
Chapter 19: The Heart of the Parent is the Child 433

Introduction

The Picture

Upon Entering the Trap

When I was little I ran and played and leapt across fields of freshly turned earth. I climbed to the tops of fir trees, and watched homemade boats float down the gutter in the rain.

I saw the presence of Life everywhere. There was nowhere there was not presence.

Then I got stuck in a trap. I was stuck in the trap for many years. Yet from the trap I could see things that were not trapped. I could see the robins in the front yard were not trapped. I could see the yellow peace roses were not trapped. But there was not presence anymore. Presence was somewhere, surely. But presence was gone from me.

I loved to go into empty churches because I could just touch the hem of presence there. But presence was not the church. Presence just hung around somewhere, somewhere in the periphery.

The church was a trap, but presence was not trapped. I just could not find it anymore. Presence was not in my trap, and all day and all night I longed to find it.

Christianity was a Trap

The books of Jesus were a trap, but the words of Jesus were not trapped. Christianity was a trap. The hearts of people were in a trap, but the heart of presence was not in a trap.

Then I could not remember presence. What I felt, all day and all night, was the longing in my heart for something that had no place and no name. But it was something, and it was somewhere, and it called me.

Presence Visited Me

Sometimes from my trap, the heart of presence visited me. It came to me in the words of John Steinbeck, and in the music of Pablo Casals playing Bach. I could see the words of John Steinbeck and the music of Casals and Bach were not trapped. Sometimes I could see things that had been trapped but were no longer trapped. The words of Dostoevsky had been trapped and freed. The poetry of

Sylvia Plath had been trapped and freed. The music of Rachmaninoff had been trapped and freed.

There Were No Cracks

I HAD NOT WORDS, I had not poetry, I had not music, I had not dance in my trap.

There was no ladder, there was no lever, there was no leverage. There was no key, there was no jailer.

There were no rungs, there were no cracks, there were no walls to mark.

I Climbed and Fell

YEARS WENT BY AND there were no provisions, there were no sounds, there was no chair to sit in.

The trap was in my throat and I gagged, the trap was in my lungs and took my breath, the trap was in my feet and hobbled my walk, the trap was in my head and blinded my path.

In my mind I climbed and fell. I climbed and fell and climbed and fell. I tried to climb, but there was nothing to climb. I fell. I fell, and fell, and fell. I could not stop, and I could not go.

The trap was not in my heart. My heart was free to break and break and break, but it could not release me from the trap. My heart grew tired. My heart grew tired from the weight of the trap. The weight of the trap would not budge from my heart, it would not be persuaded to move a fraction, and would not hear of a rest.

The Presence Before the Trap

My heart grew old when I was but young. It grew weak in struggle, and humble in defeat, and broken down in sorrow.

Still my longing did not cease. But at times, words and music and pictures outside my trap would float through, and I recalled the presence I had known before the trap. My heart loved these times and listened with all its might for clues. If there was Life that was not trapped, surely I could listen and hear the way. Surely I could look and see the way.

My Heart Hung Out

My heart hung out in Butterfly and Boehme, in Raphael and Durer, in Manet and Pissarro.

My heart hung out in Goethe, Blake, and Wordsworth; in Scarlatti, Beethoven, and Puccini; Turner, Courbet, and Delacroix.

My heart hung out in Shakespeare, Cervantes, William Saroyan, Tennessee Williams and Flannery O'Connor.

The Heart of Freedom Called

As years went by, my heart kept listening and kept looking at the freedom it once was. It could see that the heart of the words and the music and the pictures was where it belonged. I could see that the heart of freedom was the heart of its own, and it called to me. It called me to come. My heart would be free in the truth of Life's expression.

My heart called me to express like the words and the music and the paintings so that we could be free too. And as I began to express, my heart and I created a door, and we walked out of the trap and into free Life.

Presence Rolled in like a Tide

As I expressed, in writing and song and dance, the expression of Life came to me. The presence I had once known

came rolling in like a tide. Presence was all around, and it was free, and it knew no trap.

I knew the presence as divine with Life. It was not the presence of God, but was the essence of all gods, every god, in all things of Life. Gods are expressions of the struggle in Life as well as the celebration.

It was the presence of the heart of Life. It was not of a distance, given from afar. No, it was in the present moment, in everything that was. It was Life, Life expressed. It was Divine Mother, Tao, Brahman, Thor, the names given to the heart of our home. It was divine Life that calls us to come home and that never stops calling, never stops being the love that we are.

Not Day Without Night

In sacred Life there is not day given by night, or night given by day. There is not light given by dark, or dark given by light. There is night, only night, and there is day, only day. And yet, there is not day without night, or night without day. Light requires dark, dark requires light.

All of Life is the expression of Life. All of Life is somethingness. It is the day in the night.

All of Life is the unexpression of Life. All of Life is nothingness. It is the night in the day.

Nothing is not Love

Between nothingness and somethingness, there is love. Love is Life. Love is the heart of Life and the motion of Life. Love is the dance of Life, and all things are in the dance, and all things are the dance.

Nothing is not love.

The heart of love creates, and the heart of love is created. All things are expressions of the heart of love, and all expressions express Life.

The Life of expression is the heart of expression, the heart of expression is its creation, and its creation is the art of Life.

Creation is the art of Life, and art is the creation of Life.

Nothing is not Life

All Life is the art of Life. Everything that is is the art of Life. Not anything that is is not the art of Life.

Nothing does not have and is not Life. All things are the art of Life. All things are the artist's materials of creative Life. Nothing that is is not the invaluable material of the heart of Life.

Life Cannot Not be Living

It is the desire of Life to be Life. To be Life, Life expresses into Life. Life expressed is the art of Life, and the heart of Life is the artist of Life.

Life is living and cannot not be living. It has and is no time, no space, no beginning and no end. It is art becoming and is art being.

The living Life of Life is the dance of Life. It is not something, it is nothing. There is not somethingness, there is only nothingness. It is not nothing, it is something. There is not nothingness, there is only somethingness.

Nothingness is, and somethingness is. Here, one, two, is the motion of Life. It is the eternal dance.

The Beginning

"Is that all there is?
Is that all there is?
If that's all there is my friend
then let's keep dancing,
let's bring out the booze
and have a ball
if that's all
there is."

Peggy Lee

1

There Is Never Not Nothingness

INEFFABLE PRESENCE OF FORM

WE ARE THE ART, and we are the artist.

We are called to know Life and to be Life. The heart of Life is the dweller of presence and the house of presence. It is the ineffable presence of form that urges our creation, and calls us to create.

Life expressed is not bound by time or space. It is space which can never be stretched or filled. It is filled with nothing whatsoever. It is time having never run out.

Life expressed is the nothing of nothingness, and the something of somethingness.

What we need to know, we already have. We already have it because we are the source of it. Nothing but ourselves can keep us from the knowledge of ourselves. Nothing but ourselves can bring us to the knowledge of ourselves.

Nothingness Makes Space

Nothingness and somethingness are space-free and time-free. There is never not nothingness.

Nothingness is not like a wall one reaches and can't get over. Nothingness has no barriers. Nothingness makes space possible. It makes time possible.

The wall we reach is just a shade of color we paint. There is no wall we can't paint over.

It does not matter if we live or die on the wall. The heart of Life, the meekness, the littleness of a child, calls us to itself and will do so forever because that is what we are.

Presence, Life's Moment

There is no heaven. There is no Garden of Eden in which to be condemned, there is no Nirvana, no land of Utopia. There is no big God and no little gods. There is no place and there is no time.

What is it then, that is? It is Presence, expression into the moment, in and out. Presence, the moment of Life. We give the moment a name such as grace or the yin and

yang of balance in the Tao, but what it is is the nature of nothingness. It has no name and cannot be named. It has no sound and cannot be heard.

WE ARE WAITING FOR NOTHING

ONE AFTERNOON IN THE summer of 1976 I sat at a table in the Berkeley library reading Beckett's "Waiting for Godot", and I reached an epiphany. I was awakened and in my awakening there was nothingness.

What are we waiting for? We are waiting for something that never happens and never will happen. We don't know what we are waiting for, but what else is there to do? We do things while we wait, we create some kind of Life. Some of us wait slowly, some of us wait quickly. But we are all waiting for nothing. While we wait we get old and die. And in the end, what have we waited for?

Surely there must be something we are waiting for. But there is nothing no matter how slow or how fast we do it, no matter who we are or what we do.

We wait for nothing because there is nothing. We make up ways to deal with nothing. We make up religions and practices. We make up philosophies to try and think our way out of nothing.

We make up rules and systems to try and cover it up. We make children to try and avoid the fact of the imminence of nothing.

We make up poems and songs to deal with the fact of nothingness. We try to gain favor with it, as if by getting up close it would influence our exemption.

But nothing is nothing. The truth of existence is nothingness.

We Can't Let Go

But we can't let it go at that. Surely, we say, there must be something to nothingness. So we keep on, we keep on waiting for something until there are no more pages left to the book.

No, nothingness is not something, it is nothing.

Nothingness is just nothingness. In the beginning and in the end, and all of all that there is, is nothingness.

A Description of us All

But do we wait for nothing, or do we wait for something? Is there only nothingness, or is nothingness somethingness?

There Is Never Not Nothingness

For much of my Life I have been ill with a brain disorder that causes severe depression. There was a genetic predisposition in my family for brain chemistry disorder, and I had been the receiver. Over time I came to realize that depression is a description of us all, it is the stage of us in our picture of Life. Depression is the place we have created in our art.

Depression is artistic material. It is the material in our art with which we create void. What is hell to us? It is a place not just of hopelessness, but torturous hopelessness. It is the hell of continuous hopelessness, of never being allowed to get chummy with hopelessness; never being allowed to befriend hopelessness, to get used to it like a prison cell or an iron lung. It is the hell of hopelessness forever acutely fresh, eternal fresh suffering.

This is what catatonic depression is. It is something, the acuity of which you can never escape. Over time I have seen that instead of nothingness, depression is the suffocation of Life. It is unremitting turmoil. I have seen that depression is somethingness. Depression is an expression. Depression is a part of the dance of something.

It is not death that we fear, not the end of Life, it is torture from which there is no end.

Letting Go Absolutely

What is depression? It is you in the emptiness thinking the emptiness has been ransacked. The emptiness exhausted.

Depression is not nothingness. Depression is somethingness. It is a response to the apparent barrier, the wall beyond which you cannot get.

Nothingness is real and depression is not. Depression gives way to nothingness. All gives way to nothingness.

Depression may outlive us, but the absence of depression can never outlive us. The absence of depression, letting go so that thought is released from us, and words are let go, and interpretation, and any anything at all, this absence is the answer toward wellness. It's the way through, not by adding, not by doing, not by waiting, not by effort or by no effort, but by letting all of everything go absolutely all the time.

The Way Out

Depression isn't the end, nothingness is the end. Depression is a void, but nothingness is not a void. Nothingness is nothingness, and the void of depression is somethingness. Depression is torture in the void of Life, not in nothingness.

The way out is to wait longer, to stay near the awareness of nothingness, of presence. Nothingness is presence.

We think nothingness must be worse than depression. But nothing is worse than catatonic depression. Depression is not forever, nothingness is forever. The thing to do is to see beyond hell, to see beyond that within which torture can exist. Hell, depression, is something, but the truth of existence is nothingness.

What then, are the qualities of nothingness? The qualities are not depletion or exhaustion or depravation or emptiness or any anything. There is no energy or any lack of energy in nothingness. There is not anything conceivable in nothingness.

Nothingness is not anything with any quality. When we say I have nothing, or, I have nothing to live for, or nothing matters, we are not referring to nothingness, we are referring to the depression of depleted somethingness. In nothingness there is no somethingness. There is nothing to be depleted.

Time Is Not Important

The qualities of nothingness are no space and no time. Time is not important. It is only something that appears

to happen in space. When space is created, space is room. It is room, and what happens in it is somethingness. What happens in somethingness is existence. In existence there appears to be quality. From quality comes quantity and from quantity comes time. When space closes up, there is nothing and there is not time.

What is space? Space has no function except for the expression of quality. Space is no more important than time. Space is just something to put things in. Why would space happen? The answer to this question has to do with space in its relation to nothingness. Nothingness is unspace and untime. If there were space in nothingness it would not be nothing. The only thing that can be said of nothingness is that it is infinitely inconceivable.

For the truth to be anything it has to be infinitely inconceivable. This means no space and time, no something, not anything. Only if this is true, can the nature of truth be sought. Otherwise truth would pile up like so much garbage in cosmic landfills.

Thus, truth takes up no time and no space.

Nor is it possible to say that space came from nothingness. The only thing possible to say is that the only thing that can possibly be is that whose truth is nothingness.

Depression is not the End

W̲h̲a̲t̲'s̲ ̲g̲o̲o̲d̲ ̲a̲b̲o̲u̲t̲ ̲n̲o̲t̲h̲i̲n̲g̲n̲e̲s̲s̲ is the fact that it's not something. Depression is about something, and if you stay in something long enough, you will see that at the heart of something is nothing. This is the way out. The ways out and in are always through the heart. Depression is not the end, death is not the end, hell is not the end. There is no end but nothingness.

This is at the heart of the seeker, to become enlightened, to awaken to the awareness of nothingness. This is Moksha. This is Nirvana. This is the yin and yang of Tao. This is Brahman. This is Thor. This is all gods and all things.

There is only nothingness, and there is only somethingness. There is not God or Shiva or Brahman or Buddha or any any kind of supernatural being. Nothingness is not a thing, a power, a force, or any any kind of thing at all. Nothingness is the un-one.

There is only Un-one

T̲h̲e̲r̲e̲ ̲i̲s̲ ̲n̲o̲ ̲O̲n̲e̲ at all, there is only None. There is un-god. This is where we are deceived. We reach toward something, when the thing to do is to awaken to no-thing.

We are in the nothing-something. It is not the One. The One is not one at all. There is no One, there is no whole. There is no whole because there is no part. There is only un-one. There is the un-one of nothingness.

We Are Nothingness

What is it about the un-one that can bring us to enlightenment? How can we be capable of awakening to shunyata, to nothingness? Surely if we can awaken to it, we must have some relation to it, it must have something to do with us. Else how could there be anything for us to awaken to?

How could we know nothingness if there wasn't something to nothingness? It would not be possible.

The answer is that we are capable of awakening to nothingness because we are nothingness. We are it. That's the reason we can awaken to it. We are the un-one.

How can nothing come from nothing? That is, what is the reason for this phenomenon called Life that moves in space and time? What breathes into Life to make it so?

What else but nothingness could it be?

Is there no way that somethingness has to do with nothingness? Yes, there is a way. Nothingness cannot know

itself by itself. There could not be nothingness without something to be aware of it.

In this way, somethingness and nothingness work together. Otherwise, what is the point of nothingness?

There is a point to nothingness only insofar as its use to us as something. Nothingness exists for us. It is for Life and is its essence.

THE ROAD TO NOTHINGNESS

IT IS NOT NOTHINGNESS itself that has a point, but only me or you in relation to it.

I have seen that nothing is anything. That is, I have seen the nothing of nothing. And yet, there is awareness of nothing. There is consciousness. There is a presence in me that has seen that not anything is anything. This is what is called awakening, to cut through the backdrop of all we see and feel every day and experience the truth revealed. This is the great reward for staying face to face beyond time with the challenge that Life offers.

This awareness then, what is it? Where is awareness?

Awareness is not me. I am as much nothing as anything else.

What awareness is is something expressing. It is the motion of the wave. But I cannot say what awareness is to me any more than the ocean can say what the ocean is to it.

We separate from all things except awareness. In the west we make awareness God. But awareness is not a god, it is just a function that seems like a god.

Awareness is the road to nothingness, that's all it is.

Awareness is something, then. It is a benefit of Life, a gift. It allows us to become enlightened to the fact that we are not stuck in the somethingness of Life forever. In Life there is the presence of nothingness. This is the way. This is the search of every seeker throughout time.

Nothingness Does Not Create

Life then, is not created by nothingness. There is nothing in nothingness to create. But the gift of Life is that it is not and cannot be cut off from the truth of itself. The heart of Life is existence. It is the space and all things in space which created itself.

What is it that creates? It appears that nothingness creates, but nothingness does not create. The whole point of nothingness is not to create. What creates is Life. Life, the waving of the wave.

Freedom From Expression

What we have is nothingness, and somethingness, of which we are a part. The feature of somethingness to us, is awareness.

We attain freedom when we come to know nothingness, period. We become free. When we get free, we are free of expression and of the possibility of un-expression. We get free of all that is within the somethingness struggle. We get free of inexpression, which is depression. We get free of the depression of pain. We get free of the depression of imprisonment. We get free of depression for the Lifetime of the moment having become aware. We get free of depression because we get free of rejection. Rejection is the most powerful of our artistic materials, and when we awaken to the light, rejection cannot stand. Neither rejection nor any material whatsoever can withstand the occurrence of awakening. Awakening releases all that is, to freedom.

There is no pain except in somethingness. There is no imprisonment except in somethingness. There are no materials except the materials of somethingness. When we become aware that somethingness, the world, is not the truth, then we take the step into nothingness. When we go into nothingness we get free because in nothingness there is no space to confine us and no time in which we can be limited.

Just One Sparrow

༄

The Coming of Night

When my brain broke down, I lost the ability to eat, to stand upright, to speak. The world was joyless. Not even joyless, it was lightless. The days were torturous. I could not move and I could not not move. I could not be and I could not not be. When the day came to an end my torture was redoubled. I had just gotten used to the onslaught of day, and now I endured the coming of night.

Just when I began to settle into the torture of night, dawn came and the hugely more torturous day. The light, the noise, the commotion. And I could not move, and I could not not move. And my mother dragged me to look at the sky and I covered my head from her and from the horrendous space and distance above me.

༄

Expelled from Life

When we reject one another in our picture of Life, we create the material of depression. Depression is artistic material. All that is in existence is artistic material.

With depression we create for one another the inability to be in the world. We create a world that is insurvivable,

where the qualities of existence are torturous. We cannot fulfill its requirement of having to be and to act. We are paralyzed from action because our own awareness experiences the world as actively painful. With the instrument of depression, we make a world that creates pain with intent. It is as if you were a foreign body which the world works with all its forces to reject. You are expelled from the Life of the world.

The material of depression in the world is not meant to kill. It is meant to torture through exclusion. In depression we are the goat upon which sins and mistakes and offenses to the gods are piled. We are kept alive as long as possible as we are driven into the desert, feeling without reprieve the slashes of whips, the beatings of sticks. In the end we die inconsequentially, having served our purpose.

The Guilt of Millennia

We are the sacrifice that suffers for the collective wrong doings of our tribe, our communal picture. And yet, it is our own suffering we create. It is our own rejection, our own exclusion. We create, and we suffer our creation.

With sticks we beat one another for our lies, for our cheating, for our laziness, for our jealousy, for our pride, for

our greed. For our guilt over these actions we are slashed and beaten and banished.

This is the meaning of the material with which we create depression.

With depression we immobilize one another, and with guilt we create a beating stick that lasts through Lifetimes. Is it our own guilt? No, it is the guilt of ages. It is the guilt of millennia.

THE ENLIGHTENED GOAT

IN TIME, WE BECOME the enlightened goat, the goat that says it doesn't matter what you do to me. I am not part of this something of yours. I am nothing.

But it does matter what we do to each other. Enlightenment is not the end, like the Buddha under the Bodhi tree. Enlightenment is as much and as often as the sun coming up every day. The point of it all is not to become impervious to pain and suffering. That's what we think we'd like to do. To just go to reach nirvana, reach oblivion and not be human any more. Get off the wheel of samsara and settle down in a hammock to snooze for eternity.

But that's the same mistake as getting caught in the idea of how to get out of things. That's our big question. How do we get out of this? When do we get out of this?

The key to everything is to increase the trap so that we're not in an eternal panic. Because there's nothing to get out of. There's no challenge, no race, no journey, no road, no mecca, no path, no destination, no beginning, no end. There is no time, period.

There is no north, no south, no east, and no west.

There is no up, no down, no good, and no bad.

This is the heart of Life.

2

The Divine Heart

You are the God

The Heart of Life is the freedom of God, and you are it. You are the freedom. You are God. God is you. The old God is gone and is merely hanging by a thread in this modern world. The new god which is not God at all, is within you. There is no god outside yourself. There is nothing outside yourself including your own physical being.

You are earth god, world god, god somethingness of nothingness. You are the god that cannot be trapped. You are the god of this bit of consciousness in this bit of time. You are god of the transformational expression that you are. You, this mysterious thing with a connection to the light of truth, this makes you the god that you are. In any moment there exists nothing but the god of that moment. There is only one moment. In the next moment there comes another god for that moment. This is the moment and you are the god in it.

There is only one time and it is now. This is the Zen moment. There is only Divine Mother, love, and Tao, truth. There is only Brahman, infinite wisdom. There is only Awakened Heart, and you are it. It is you who are the very god of God. The old supernatural God in the heavens is gone. The omnipotent God, the grandiose God of being is gone. The more present god, the god that is only Life expressing itself in infinite ways through infinite gods, is the Life of the god presence, revealing itself to you, having been there all along. This god, ever within you, is Life.

I Would Try and Keep my Life

During the years when my brain chemistry continued to slowly and irretrievable break apart, it appeared that the battle plan was drawn. I would try and keep my Life, and my illness, this antithesis of Life, would try and take it away. I found that this brain disorder was an instrument of tremendous caliber. It showed me the colossal strength of its arm, and I had to give in. I was outmatched. I was outranked and I came to know it. I had to change my mind. I had to increase my trap. I had to let down the edges of reality by letting go of my Life, by dying.

And yet, the energy of my youth was surging. My drinking had not yet brought me to defeat. Indeed I would go on drinking for another twenty years. I was filled with the power of Life, with the desire to create my picture of Life.

But at the very notice of Life coming in, my picture would be taken down. It would not even make an appearance. I was like a grand engine of the Union Pacific Railway. Mighty, built for effort and endurance. But somehow a defect crept in, an imperceptible derailing in my frontal cortex. And the defect would bring down my every effort to give the engine the Life it needed, no matter how much fuel or how much care or how much hope it was given. Brains can't be fixed except by themselves. They can heal but only they know how to do it. Sometimes they can do it, other times they are too damaged to readjust or to survive.

Accept the Trap

Enlarging the trap means reconsidering. It means stopping in one's tracks and changing every idea we have about what should happen, even the basic energy that drives us forward.

The way to enlarge the trap is to accept the trap, to let go to it. Not in defeat. Not as a loser, but as a player, as a move of intelligence toward Life. The game is about how to have Life at any cost. We get smarter in the creation of our art of Life, and learn to let go when to let go means Life. It is not a move of avoidance. It is not a move of fear. It is not a move away from death, no. In this move, death is not an issue anymore. Death has already been traversed. This move is about having Life because of Life.

The Struggle is Gargantuan

The struggle prior to letting go of Life, the struggle to hang on, is gargantuan. There are no words to describe its strength, the desire to hold onto Life.

If you know in your heart that there is only nothingness in truth, then defeat in the space-time world of somethingness is moot. But to come to this realization means going through Life and death, defeat and renewal. Defeat of Life is a colossal achievement. It is power beyond comprehension. The death of Life out of time, before death as a natural end, is an explosion of power that shakes the earth. Death out of time means an interruption of the wave in its move to the crest. It is the creation of a new wave within

the wave. To achieve such a breakthrough is shattering. It is nothing less than the creation of new Life.

This radical departure is what is required to increase the trap. This is how it's done. Severe illness, illness that kills, can only be dealt with on its own terms. Its whole purpose is transformation. It is a gift. It is new material presented in the middle of the picture. It appears on our canvas as an obstacle, as a terrible mistake. But it isn't. It's a lamppost beckoning us into a whole new and Life-giving direction.

Illness, pain, suffering, loss, all these things that break us in body and heart and spirit, are meant to bring us through to another side. They are meant to show us death, to offer death so that Life can get free. Death is just a jumpstart.

Every Trap is the Key

Every death makes the revelation of nothingness possible. In nothingness the world comes tumbling down like a house of cards. Every trap disintegrates in the moment. Every trap is the key to itself.

In the heart of Life there is no trap because there is nothing to be trapped. The only trap possible is that created by you and by me in reality. The trap of illness, the trap of

pain and suffering, the trap of imprisonment, all the same trap, is a trap made possible only in the space-time world.

What I did about the trap then, when I was ill with brain chemistry disorder, was create more room by letting go of Life by accepting defeat. Defeat is good. Defeat has purpose, it is as good a material as any of our materials. All that is in the somethingness experience is artistic material meant for our use as the artists of Life. I perceived defeat as so much sludge, a time and Life-devouring specter that had no Life and no function of its own. Defeat, like all our materials for making our art which is Life, must be experienced. There is no perspective in the moment of experience. The point of experience is non-perspective, non-reflective. The point of experience is to be there, to feel the moment directly in the moment.

What I came to know through experience was that the sludge was not anything of itself. It was not the living of my Life draining from me. It was not sludge at all, it was an instrument of the art of my Life. It was something much greater, something which could open the way to a much bigger Life than I could have imagined without it. It was a way to take me out of temporal Life and connect me with the eternal Life of nothingness. It was a way to take me out of the Life of the world and human form, and put me into the Life of the ungod.

You are not Imitation

Something cannot be created from something. Something can only be created from nothing. How can something be created from something already in existence? This would not be creation, it would be imitation. You would be used. And you are not imitation. And you are not used. You are brand new every moment. You are created from pure nothingness. You are the art of the heart of love which is Life.

In my experience, I would find that the Life of the world, the Life of my body, would be replaced by the Life of nothingness. As time went on I became more and more empty of Life. Only in this way could nothingness reveal itself to me.

Losing changed my trap. It changed the artistic surface upon which I had to work. It was not a better trap, it was a trap of a different direction. It wasn't a freer trap, it was a trap of defeat. It had to be a trap, a good trap, a trap with substance and integrity. It could not be brief or weak or flimsy or flawed. It had to be a very great trap. And it was. Through the trap of defeat I was transformed from youth into ancient age within a few years. I was old by age twenty.

Through the trap of defeat created by my illness I was slowly and powerfully and inexorably pushed toward death. My picture had created me. What I had to do, what one does, is go through it, live in the trap, and be in the trap, because that's what a good trap is. You can't get out. You simply have nowhere to turn, so your experience is the experience of the trap. What I had to do was let go of the picture of me the world had created so I could begin to create my own.

Roll till you Die

THIS IS THE TRANSFORMATIONAL experience. Sisyphus cannot roll the stone up the hill over and over again forever. He becomes ancient and dies. He only rolls until he is dead. Only then can he stop rolling. Only then can he be emptied of Life.

You can't stay in one spot in your picture forever. The wave of Life is motion. It is the motion from nothing to something to nothing. What we do is let go of one place and move on. We grasp and release over and over again like a monkey in the jungle. We move in motion from the rest to the pulse, from painting to being painted to painting. We move from creator to created to creator, one, two, three.

We move from being in the picture to being the picture, letting go of the picture that has been painted of us by Life, so that we can become the creator, we can move from the subject to the verb.

As children, the art of our Life is created. We are not outside the picture, but in the picture. As we go along, our artist's materials are revealed, and as they are revealed, we are revealed. As we are revealed, we begin to hear the notes that are meant for us to hear and to record upon the score of our Life.

We Are The Song Singing

It wasn't until I was emptied of Life that I could begin. Sisyphus doesn't have to roll the stone anymore because he died to it. I could not get free of my trap until I was dead to it, until I was defeated utterly.

That's the way it happens. As creations of awareness, we are transformational, changing from being in the picture, to being the picture, to creating the picture. We are the song and we are singing the song. The thing to see is that rolling the stone until we're dead is the way to Life. We are expressions of living Life, Life that has no beginning and no end. We die to the picture of the creation so

that we can be born into the picture of the creator. We are the creation, we are the creator.

The way to Life is to see that all of creation is of the world and that all of un-creation is not. All the things of the world are of creation. Yet un-creation is true, and creation is true. One is one, the other is the other. We get in the picture, we get out of the picture, we create another picture. This is the motion of Life, the wave, the crest, the rest. When we see nothingness instead of somethingness, we are free from the trap of the created picture. The created picture is the sculptor's stone from which we are set free.

The Notes of Suffering

The instruments of illness and suffering and loss call us to consciously let go of every idea we have about anything. Let go of the desire to understand and to have understanding. Let go of the desire to be found, let go of the desire to be lost. Let go of Life, let go of death.

The notes of pain and suffering in our symphony call us to let go altogether. Let go of wanting, let go of expectation, let go of faith, let go of hope, let go of God. "I pray God to rid me of God," Meister Eckhart said. Let go of God, because there is no God to let go to. The colors of

struggle in our painting go beyond the need to be rescued by God. We have nothing from which to be rescued. There is no God that needs to know more about what's going on than we do. There is no God that knows anything.

There is no God at all. There is no power to save us because there is nothing from which to be saved. There is nothing but me and you, and Life, and there is not me and you. And there is not Life, there is only nothingness.

THERE IS NO CREATION

HOW DOES CREATION COME from nothingness? How can nothingness create when there is nothing in nothing to create? The answer is that there is no creation. Nothing is created. Nothingness cannot create. Nothing is nothing.

But consciousness of nothing must be something. There cannot be nothing by itself. What am I that I know nothingness the same way that Amma, Divine Mother knows shunyata, nothingness. Am I nothingness aware of itself? How can nothingness be aware of itself? No, we reason, nothingness could not be nothingness.

Surely something lies beneath reality, we think, beyond our reach. We use our intellect to try and discern what it is. We think hard, deducing and inducing. We

use hallucinogenic drugs and mescaline mushrooms. We fast, meditate, chant, and pray. We turn to sex, drugs, and rock and roll, to keening, weeping, and wailing. In infinite ways we try to gain access to that which we feel we do not have. We feel deprived out here, out here in regular reality. Regular reality has become mundane, boring, unsatisfying. We have lost faith. We have lost our eyes.

But it is only a stage in the creation of our art of Life.

Windowpane Acid

In the 1970's I was living in Honolulu and windowpane acid was at its peak. I would drop two or three hits. Mostly I would trip alone in a safe place with everything I might need for twenty-four hours near me. But once I was at a concert in Diamond Head crater. The brightness of the sun was overwhelming. Heat, no shade. My friend Vicki came up with the side of a chicken in her hand, waving it around, just off the ground. I couldn't tell if it was real or made of rubber. Her center of gravity was low, and she leaned back, her willowy body naked from the waist up. She wore shorts and flip-flops. She didn't bend her knees much when she walked, but moved like a kind of stiff-legged bird, a flamingo.

What it was, this brain chemistry assault with which I had chosen to sculpt this place in my form, was a kind of anti-Life. It was the height of over sensation, from the sun, the vacuity of the crater, the noise of the crowd, the hard ground. This color I had chosen for my picture changed my experience of the picture. It added a brain-changing color that took my heart away from my structure. It took me out and left me at a forgotten distance. All that was in my picture was a lot of colors and shapes sitting outside of context, and my eyes seeing without me being there.

It is not away from Life that we find Life. Life is not anywhere away, it is nowhere but only here, only now.

Tools Without the Artist

Brain chemistry-changing processes like LSD take us out of the picture so that what is left is uninterpreted materials, seeing, hearing, feeling, tasting. While we're not in the way to interpret, our eyes can go watch colors or listen to notes without the heart of us there to take it in. We are the tools without the presence of the artist.

We can go to that place of non-being in many ways, through many processes that alter brain chemistry. But unless one's heart and head are available to accompany the

trip, then there's no one to use the information. It is a sensory experience without form. While it may be entertaining, like being the movie while watching it, without substance it is useless.

It is like sex for itself, or a carnival ride. It is like beginners luck, or a new meditator's glimpse into eternity. If you're in it for the joy ride then that's what you get. Because the only way to get substance from experience is to give it. The only way to receive in substance is to be present in the midst of experience, not with the surface of sensory input alone, but with heart and mind as well.

The Goods of Life

Illumination has no short-cut. There is no short-cut to the revelation of any art. When one begins to paint or compose or dance, it is possible for something beautiful to occur. But in the beginning, as one is dabbling about the edges, glimpses of possibilities are revealed. The longer one stays in the milieu, in the practice, the more of what could happen is revealed moment to moment.

Everything that is is a practice. The longer one practices, the better one gets. This is as true for you and I in our art of Life as it is for Itzhak Perlman's art of the violin. We

can't reach in and get the goods of Life without practicing anymore than Itzhak Perlman can reach in and get Mozart violin concertos without spending years of moments, back to back, learning how to get better.

Changing Brain Chemistry

Altering brain chemistry lends a preview of what can be, but the experience is useless without the form and structure of the artist, without you, yourself there to interpret what is perceptual and sensory into what can only be known in the wisdom of the heart.

Superficially changing brain chemistry is not a means through which greater reality can be grasped. There is no such means. Brain chemistry changes alter the experience of reality, but they are not ways through which greater reality is attained. Reality is attained through the practice of being present in it. Through Lifetimes of conscientious practice, we gain reality and exceed it. We become awakened to it.

Reality is not automatic. In fact we are infants in the face of it. We do not know what to make of it because we have not practiced being in it. We have spent too much time abdicating to God and to even greater untruths. We

reach out to it like babies. One day we will awaken to it. Enlightenment is not meant for the rare few, it is meant for the common all. It is the gift and the destination of Life.

This time and space experience that we call reality is not a commodity that can be had or taken, or a trick to be unveiled or a puzzle to be solved. It is not a perceptual conundrum. It is the art of Life. Reality is not material in space. It is not something objectively discernible. It is the experience of the truth of oneself, and the truth of oneself is nothingness.

Reality is a Storefront

Reality is a storefront, a backdrop to a different and truer and more substantial reality. We feel that once we get it, once we get there, then we'll be there, we'll be one with the universe, united with God. Then we'll have the number on this place. We'll be one up.

Will we? And one up on what? What good will it do us to be one up? Except to strut about and remove ourselves even further from the world. We become then, the emperor with no clothes.

One day we will move through physical reality, nothing being any longer solid or an obstacle in any way. We will

rearrange molecules and walk through walls. Throughout the ages some enlightened ones have materialized a dense reality like Sai Baba did with holy ash. For we are not our bodies. We are naught but the potential of nothingness. We are the wave of nothingness.

Like most people once they are shown how, I can take a screwdriver in my hands, open the top of my head, breathe into it and as I breathe out my hands simply turn down and bend the metal. This is no new trick but has been done for centuries to show the malleability of reality, to show the true nature of reality, to show the lack of anything solid on earth. But no matter what we can do or what we learn to do, no matter in what ways we can get out of this apparently solid reality, we can't live anywhere but in it. Everything else is tricks. Meditation can ground you and center you, but only Life can fill you with joy. Only Life can make you glad like a child.

What Meditation Is

We think we do meditation to retreat from the world because the outside world is inadequate, the outside world doesn't have it. We think this world is so much distraction, filled with irritating obstacles to climb through like junk in a landfill.

But what meditation is is taking a moment to remember who we are. To remember we are not in a rat's nest, but that what we are in is nothing. We are nothing. And when we remember we are nothing, then we create new room within which to go ahead.

The world is not junk in our way. It's all artistic material for us, the artist. All of it. And who are we? We are nothingness breathing. Nothingness in, nothingness out.

Meditation, stopping on the trail, is not to withdraw from the world, it's to stop. We need to stop because we get lost. We need to stop because in our motion of nothingness, there is a time to retreat. There is motion, there is the crest, there is rest. This is the nature of nothing. It is the nature of art and of all of Life.

Meditation is not to Escape

Meditation is the natural rest, a rest in the music score, like the rest in the dance, the rest in the painting; a rest in the day, a rest in the night, a rest at the bottom of our breath. This is meditation.

Meditation is not a way to get away from anything. It is not to escape. Nor is it a way to get to anything. It is a rest. It is a breath. In this way, meditation is not meditation.

There is no such thing as meditation. There is the pulse and the rest. This is what there is to Life.

Meditation is not the key to getting into Life, any more than the trough of the wave is the wave. The only way to get into Life is to live it fully like a child. Every awakened being knows this. You're the trough, then the crest, then the trough, then the crest. You go up, you go down. You laugh, you cry, you die to the arms of the Mother. This is the way.

Depression is Motion Stuck

When we talk about our artistic material of depression, we see that there is no motion. Depression is motion stuck. Depression is exhalation without inhalation. Depression is the adult without the child. It is night with no dawn. It is death remaining death. Catatonia in depression is the brain broken so that all is lost, buried too deep to reach. Speech, hunger, sound, motion, all gone, all unable to add to a dying Life.

Yet when we turn to the little child we see it is not ground to a halt, death remaining death. No. A little child floats like a duck. A little child does not have to take hallucinogens or learn transcendental meditation. A little child

just does little child. You think you can't do little child anymore? You think you have to sit before the Maharishi and find out who you are? No. What you have to do is let go of every notion of everything. You think your little child knows less than Yogananda's little child? No. You little child, and Yogananda little child, you are the same. Right now, forever.

The Hindu Gods Roar

We want someone to tell us the answers so we don't have to be vulnerable. We want to know and to hold on at the same time.

We are not quite ready to step off the cliff like the Tarot Fool, to let go of our last handhold. This is the best trick. The Hindu gods giggle and roar with laughter. It is like a summer fair under a blue sky and high billowing clouds and the music of the merry-go-round in the distance. The gods laugh for joy. The gods are children laughing at nothing at all. The gods are us, laughing with surprise, laughing with relief, laughing with delight. We are Krishna, Saraswati, Ganesha.

But in days of depression or discouragement or loss we are time stood still, the machine stuck by a cog. We are the

shining train engine that cannot go, no matter how much coal it swallows, no matter how many engineers come to tinker.

There are no gods to laugh in the dark days. How can we let go? We would let go if we could. Instead we go elsewhere. To booze and bongs, to ashrams and satsangs, to gurus and ganja. We go to Maine to retreat and the Caribbean to cruise. We go to addiction and to non-addiction, to sex and to abstinence, to sugar and carbs, to grains and leafy greens; to juice fasting and purifying and separating ourselves from the degradation of a puerile world.

ENTERTAINMENT IN OTHER PLACES

WE GET SQUEAKY CLEAN and go on to greater things. Astral projecting and metal bending and ash materializing and transubstantiation and writing books.

Others want to walk on water and heal things and practice psychometry in Vegas and telekinesis on TV. We'd like to be fortune-tellers and bring back messages from the dead because we don't have enough to comfort us here. We have one unspoken goal, Entertainment In Other Places. Because it's not here, we think. It's not in this room. It's not in you, and it's certainly not in me.

Just One Sparrow

We want to be Reiki masters and Tai Chi experts and collect black belts. We'd like to think of Life as a journey. Life isn't really a bad thing, we say, an arduous and pointless task as we thought previously. It's a journey, an adventure. It's not a big waste of time in which we are less significant than insects.

We study the I Ching and astrology charts and crystals for clues, for ways to gain advantage, always looking for a way to get one up. But these things are tricks. They are Krishna playing games. The real trick is here, right here before us. I look at the solid wood table in front of me. I see the function of it and the denseness. What is this table? What trick? This table is just a table. Hah! That is the trick. What is this table? This table is somethingness to nothingness. That's all. It is creative material. No matter where we look or what we do or what program or belief system we cling to, it isn't there. What is it? It is presence. It is the presence that we long to be consumed by. But presence is too featureless we feel. It is beyond us and we need something else something solid we can understand. So we continue down the queue of spiritual diversions. But no matter what, we cannot seem to get one up on Life. In fact we will never get one up. We do not and will not ever gain a vantage point.

We think someone, something, some day will show us the truth and the truth will make us happy. Even though

we know in our hearts that no one has it. That's how much we don't want to be vulnerable. That's how much we don't want to be humble. We would rather die, and do regularly, because we have locked up the child in us. We have put it in a trap and it's our only way out.

We are Children Called

It is not meditation or prayer or any practice or any one at all that can tell us more than our own child within about who we are. We are called to be little children, not in order to plumb the depths of reality, but to be fully present in the miracle before us in this moment. The point of being here is to be here. We know how to do it. If we didn't know how to do it already, we wouldn't be able to do it at all. We wouldn't be here.

It is not we who hold the key to our child, it is our child who holds the key to us.

We Live a Double Life

We live a double Life, like I did when I sat at the bar at night until last call, and showed up in a flower print dress for church the next morning. We all do it all the time.

And in the bar and in the sanctuary we are looking for the same thing. We are looking for comfort. We are looking for comfort because we do not have answers. We do not have answers because there are no answers. We've been lead into the wilderness and are lost. All we can do is ask questions. What is this place? We are lost in a trapped place, with no way out. How did we end up here in the wilderness? Here in the bar, here in the sanctuary, alone here in this room? We forgot who we are. We got caught up in the world and started to think we were of the world instead of in it. We forgot that the world has nothing to do with us.

Everything in the world, all things, are living works of the art that is Life. The world is true, but it is not us. In the world we are one stroke, one movement of the brush, one step of the dance, one downbeat. We are the pulse, the crest, the rest, we are expression. We are the something of nothing.

3

The Stream Against the Rock

The Tabula Rasa

Nothingness is eternal. It is the tabula rasa. Nothingness is nothingness. It is the unexpressed. Somethingness is somethingness. It is expression.

This is not to say that nothingness is not altogether nothingness. It is altogether nothingness. And Somethingness is altogether somethingness. When a stream is Going by a rock in the creek, what is a bit of water against the rock? First it is something and then it is nothing. First it is there and then it is gone. It is a stream of nothingness-somethingness-nothingness.

When fire has touched the wood, the wood is touched by fire, then the fire has gone on. The fire is and is not and is and is not.

When a dancer moves across the floor, what part of her is in the air and what part of her touches the ground? First she is in the air, then she is in another air. Air, no air, air, no air.

The stream is never less stream, the fire never less fire, the dancer never less dancer. And yet the stream, the fire, the dancer, all have touched, all have burned, all have danced, all have lived.

Nothing Proceeds

This, the touch, and the no-touch, this is how nothingness and somethingness are together. One is never more or less than the other. Neither is one then the other. Both are fully nothing, and fully something. Nothing and something exist at the same time, and nothing and something do not exist at the same time.

Nothing and something are free of space and free of time. Something does not proceed from nothing, and nothing does not proceed from something.

Nothing proceeds.

Nothing is nothing.

There is no substance.

There is no space.

There is no thing.

If there was one thing in nothing it would be this: a rest, a beat, a rest. This is all there is. What this is is motion. It has no substance and no form. Yet everything that is is

this motion, a leaf on a branch in a gentle breeze, a giant tidal wave that heaves, crashes, and rests. All things are this motion.

There is Singing

This is how nothing and something are. The breath in, the breath out. Not one before the other. Not one after the other. But rather, nothing, something, nothing, something. Each breath is nothing. Each breath is something.

There is no sound, and there is sound. There is silence, and there is singing. There is silence, and there is wailing. The same silence is in wailing as in singing. The same sound that makes up wailing, makes up singing. Wailing and singing and silence, they are all nothingness and they are all somethingness.

This pulse that is in wailing and singing and silence is the same. There is only one pulse. The same pulse in expression is in non-expression. There is no difference. Expression and non-expression are the same.

The pulse is the height of motion.

This is antithesis.

This is orgasmic.

This is the union of nothing and something.

It is the heart of Life which is love.

This is the love of un-god.

The heart of love is the dance between something and nothing, the climax between the rise and the fall. It is not about opposition. The incoming breath is not opposite the outgoing breath. The incoming breath is forever incoming, and the outgoing breath is forever outgoing. Nothing is forever nothing, and something is forever something.

For many years I have said, In my next Life I want to be a lamb. People say, But you'd just grow up to be a sheep. They do not understand that a lamb is a lamb, and a sheep is a sheep.

Joy is Outside Expression

Non-expression is a tool of expression. What brings joy is outside expression because expression is part of the world. It is you in the world. What you are in the world is a step into something. What you are beyond the world is nothing. You are the love between nothing and something.

This does not mean that there is anything more than nothing and something. But you are the nothing and the something. When you realize this you will see that the world and all things in it including yourself is an appearance, and

you are not it. You are the step, the motion itself. You are the power of Life. You are the art and the artist. You are the creator of the god and the god.

When you realize this you will see the world for what it is. The world is the appearance of a step. The step is an act. The act is creation.

Creation is an act. It is a painting being painted, a song being sung, a dance being danced; a world flung into place like a stagehand putting a prop into place.

Nothing We See is True

Creation never stays the same and never changes. The story of Shakespeare's A Midsummer Night's Dream, did it really happen? Where is it now? It is nowhere. It is a play, an act.

All of Life is like this. Nothing we see is true. It is maya. Illusion. Magic. What is true, then? What is true is you as nothing and you as something. You as nothing are the artist, you as something are the art.

As nothing, how do we create? Creation, the worlds, the characters, the colors, is the interplay between nothing and something. It is the motion itself. When I sat on the floor of the Berkeley library that day in 1976, I became

awakened to the absolute nature of nothingness. I realized that nothing is not nothing without the impulse that reflects it. Nothing is not nothing without something. This is not to say there is nothing by comparison to something. It is to say that nothing must be nothing in order for something to occur, to be the act, the step, the expression.

We ponder the nature of reality. But when awakening comes, the nature of reality does not matter at all. Because reality is not reality, it is an act. It is the sweep of a paintbrush, the walk of a character onto the stage.

Reality Is Art

Reality is art. And it is all the things that art is. Expressive, substantial, form-taking, and living.

Art is living. It is form and structure expressed through Life. What makes art so is that it has Life. It has Life because it is expression, an outgoing breath of that which reflects nothing. Nothing that is is not art.

Art is the something that somethingness is. Art is living somethingness. In my awakening I have seen that all things are not void but all things are nothing. Nothingness is not void. Void, emptiness is of the world. Emptiness is a container. Nothing of Life can be contained. All things

are expressions of nothingness and somethingness. Life is not the something of nothing. Life is the motion, it is the dance. The something is the expression, but it is not Life. Life is the wave that causes the crest.

Life is not something and nothing together, it is somethingness and nothingness. In nothing there is something, and in something there is nothing. One does not begin or end in the other. Neither have beginnings or endings. They simply are what is and what is not. This is the Tao of what is. The night is not lack of day. The day is not lack of night. Night is night, day is day.

Art is the Crest

ART IS EXPRESSION. ART is the crest. It's the target when you throw something and hit it, and it's the thing you throw. Art is the punch. Art is a relationship to nothingness. Somethingness on the canvas is important only in relation to the nothingness of which it is a part. The space is as important as the intrusion. All art is an expression of this principle. The profound spaces in Beethoven's Emperor, or Rachmaninoff's Second, or Handel's Water Music. The notes are only as effective as the silence which supports them.

The sketches of Durer, or the monumental effect of space offset by form in a Correggio. When you look at the space you experience a great sweeping drama, as in a Turner watercolor; or in a John Constable, where space seems an infinite tide of sky through which one can enter and float into a center of resolution. In the art of Daumier, and Courbet, it is the subtlety of space that allows the form to take central focus.

On the stage it is the same. When to speak, when to move, when to act, all this has to do with how one uses space and stillness.

We know these things. We have an aesthetic sense of form and balance and contrast and style. We have a sense of when something has Life and when it does not. Forms of human design we separate between what has Life and what doesn't. One we call art, the other we call junk. But there is nothing that is art and nothing that is junk. All things of the world are art in progress.

Nothing is Outside of Nothing

In the natural world, all things have Life, all things have art and are art. When we look to the art of nothingness and somethingness, we see that all this is is art. All

that is, in the way of nothingness and somethingness, is the expression of Life. There is nothing that is outside of nothing. There is only nothing, and there is only something. There is the rest, and there is the pulse. It is Life, and all Life is art.

What makes Life art? Life is art because art is that which has Life.

What is art? It is anything that has Life in it. What is the Life in it? It is the movement between the crest and the trough, the love between nothingness and somethingness. It is action.

All things make art because all things are art. The nest of the bird, the web of the spider, the kill of the lion, the grandmother elephant leading her herd. All this is art because all this is true Life.

What is the art of humans? It is us being created and us creating. But what is that? We have separated ourselves from the earth. How can we know how to create our art of Life? We cannot.

Life is a perfect work of art. If it weren't it would not be art and would have no Life. That's why we can count on Life, because it is a giant and tiny work of art. We know this, that's why we try and go after what we have a hunch about. We know there's more in there, in the pool of Life. We dive in again and again, endlessly, because we know we

are in there somewhere. We know we are not alien from Life and yet we are separated from it. no matter how close we get we are excluded.

Art is a Lamppost

This unknowing is a stage of our art, it is a clue to who we are. To discover who we are, we create art. We create art because art is a road back to ourselves. It is a lamppost beckoning. The lamppost is a light that says, Here you are, here you are, here you are, over and over again.

We have never and will never not have a lamppost beckoning. Because the lamppost is our true self. The lamppost is our light back to the nothing-something dance.

The mother-father of us, this duality, the plus and minus, this team, the art and artist of us, is the nothing-something. The god that we are is the nothing-something. The Zen, the Tao, the Brahman, the Atman, the Christ, the existential and nihilistic void of us is the nothing-something. Nothing is not nothing, and something is not something.

Art is the way to look for the lamppost. It is the way we find our way back to ourselves. When we create art, we say, "Ah, there it is. There I am." And we rest assured.

Expression is Fleeting

EXPRESSION IS FLEETING. It is the dance, the movement. It has no beginning or end, it is a movement within the beginning and end, and there is never beginning or ending, there is only movement.

Poet Reg Saner says, "A poem is never finished, it is just abandoned."

This is true of all things. The dance is danced until it is danced, but there is no ending to dance. The song is sung until it is sung, but there is no end to song. The play on the stage is acted for the moment and then it is gone, but there is no end to the play. In the painting or the sculpture, it goes as far as the frame, or the resting of the sculptor's tool, but painting can never end, and sculpture can never end that which is to be formed.

Art is not an object or an expression or an act, it is a calling to the beloved, to the god that we are. It is not a building up or a building down, it is the in-between. It is us answering ourselves, god answering god.

There is not God unless there is not God. There is only God because there is not God. We are both god and not-god, ungod, artist and art, nothing and something. Something does not come from nothing. Nothing and

something make each other possible through the motion of love. Love is the calling of motion to be moved. Art is the motion and the moved. It is Life calling to itself.

This calling is love. The heart of love is the reason for nothing and for something. It is the reason there is not nothing without something, and something without nothing.

It is not nothing that is ineffable. It is not something that is ineffable, it is not love that is ineffable. Nothing is ineffable. All that is is that-which-would-be-expressed.

What Love Is

Love is not somewhere or some time, it is all where and all time. Love is not one degree or another degree. It is not with quality or without quality.

Love is not something or nothing, not part of anything or more than anything. Love is the calling of the dance to dance, it is the calling from the valley to the crest and the crest to the valley. It is the calling of the in-breath to the out-breath and the out-breath to the in-breath. Love is the pulse calling. It is the prize of the poet and is filled with light.

The Stream Against the Rock

Why is love? Because it is the heart of being calling to be. It is balance calling to imbalance. It is synthesis calling to antithesis, harmony calling to discord.

There is not harmony and then disharmony. There is not something finished and something left undone. In nothingness and somethingness there are all things and all things that are not.

In love, there is expression and there is rest. Wherever there is Life there is love. The motivation of the rose blooming is love. Life lives because love wants it. Love wants Life and does not ever stop calling to it.

If there were not love there would be only nothing and there would be only something. There would not be the crest of the wave, there would not be the valley, there would be no motion and there would be no Life.

It is love that keeps nothing and something calling. Love is never out of balance, never less, never more, never not in perfect expression of itself. Love, like all of our tools as artists, is ever-present. It is the tool closest to our hearts because it is closest to home.

This does not mean that love is something. Nothing is outside of nothingness. But in the illusion of somethingness, it is love that keeps us alive and in motion, creating, procreating, and in relationship with the Life we experience.

Our Efforts are not Wasted

When we express in the world as humans, our movements seem to be erratic and fragmented and incomplete and capricious, and we are used to calling these movements futile and inadequate. In nature we do not see efforts as wasted. Other beings live, eat, sleep, mate, and die. In this living of Life all things express all that they are.

A rose never holds back its petals. A tree never doubts its reach for the sky. A meadowlark never brings forth but its full heart of song. A panther does not hold its limbs in tension as it hangs in rest from the tree. The ocean does not cringe from the weight of its fullness, but is space enough for every drop, for every tiny gathering of Life.

We Are Being Becoming

Our efforts are not wasted. In everything we are and do, we are being becoming. We learn from our natural world how to live. We are here to learn from the world. It is the world that teaches us how to come back to ourselves, so that we might be ourselves like the songbird and the rose.

The world is our lamppost. Even though we think the world is something, and we are something else, it is not

true. Even though we think the world is transient and foreign and inscrutable, it is not so.

We think some things are art and some things are junk, but in the truth of nothingness and somethingness, nothing is that is not art. All junk is part of a bigger picture, a bigger drama, a bigger dance. The bigger art is not trash and cannot be trash. It is art. All Life is art. All that is is art.

Truth is an Experience

Art is that which expresses truth. And all things, all that is and is not, expresses truth. Not anything is free of truth. What is truth? Truth is nothingness and it is somethingness. Truth is all that there is. There is nothing that is but truth.

Truth is an experience, not an ultimatum. Truth is a word we make up to describe the experience of recognition. When we recognize the Life in the art, or the Life in the art of Life, we say this is truth. This is the actuality of the way things are. Truth is an experience of the lamppost, of the awareness of who we are.

When one becomes enlightened, it is a revelation of truth. It is a figure in a painting who awakens, steps out of the picture, and looks back at the picture. When she looks

back at the picture, she sees that she is in another picture. She sees that there is not one picture, but all picture. There is not one song, but all song. There is not one play, but all play. "All the world's a stage," Shakespeare said, "And we are merely players."

Hindu consciousness understands this. The world is a drama, and behind every face is Atman, the truth of who we are which is Brahman, the truth of us as the very heart of Life. There is not God that is something God. There is not God that is nothing God. There is not God. There is nothing to create anything in, and there is nothing outside anything in which to be created.

Expression is the un-god.

Nothing ever was Created

CREATION DOES NOT COME from something. Something does not come from something. Something cannot create, and nothing cannot create. Nothing is or ever was created. All things are created before we created them. We create what we suspect is true. It is love, always bringing us home, that allows us to create our way back to it.

Love is not a state, it is not a quality. It is not a value. It is not peace, joy, harmony, or expression.

Love is recognition.

When you recognize nothingness and when you recognize somethingness, you see that this is the milieu of Life, and that Life is fueled by passion. It is passion for fulfillment and growth. It is passion to reach the beloved. It is passion that makes nothingness and somethingness not the void but the fulfillment.

The void is not the void because it is nothing. It is passionately nothing. Passion makes the void and all things something. Something is not only something, it is passionately something. This passion, this motion, this Life seeking out itself, is love.

You are the Beauty

IT IS FOR LOVE that one seeks, because love is the presence of power and the home that we seek. Love is the art of Life and the art of Life is perfect fulfillment. Art is an expression of truth, and truth is the awesome and the astounding fact of Life. To be a part of this, to be this, is to be the beauty that is the heart of Life.

You are the painting of Life. You are the dance of Life. You are the beauty. When you recognize that this is what you are, this is love.

When you hear the meadowlark's song, it is beautiful. It is pure. It is glorious. It is infilled with the power of Life. This song that you hear, is you.

This is why you can rejoice. Because you are part of a beautiful painting. You are part of a resounding chorus. You are part of the sunrise. You are the heart of the mountain you behold.

You are the B Minor Mass.

You are Mendelssohn's Elijah.

You are Beethoven's Emperor Concerto. You are the flash of lightning and the power of thunder.

You are the flame of fire, the breath of air, the Life-giving water, the fruit of the earth.

We Cannot be Enlightened

This is enlightenment. We wish to be enlightened because we think it is something we do not have. But we cannot be enlightened. We cannot be given anything more than we already are. We don't need more light because we are not in the dark.

We are enlightened already. We should just as well wish to be endarkened. We are just as far from the dark as we are the light. There is no dark. There is no light.

The Stream Against the Rock

It is not enlightenment we seek, it is Life. We seek enlightenment because we feel we need more in our lives and enlightenment is the prize, the key to an advantageous Life. We feel we are trapped outside looking in like the five of Pentacles in the Tarot deck. In the night a barefooted woman walks in the snow beside a young man on wooden crutches. Neither have wraps or covers for their head. It is clear that without respite they will soon freeze to death. They pass a church with a window bright with light. But they do not look in. They do not seek refuge. They do not turn to the light.

We must first turn to the light, we must be willing to see the light. We must want the light and learn that all we must do is awaken to it. Turn to it and it will shine upon you. You will be awakened and you will be saved from the freezing dark night. This is how we are in our rags and weariness. But we will see the window in time, and the light, and we will be home.

What we want is to see, to understand and to not be excluded, to not be blindfolded from the light that falls from the window and beckons us to it.

The Damnation of Life

We have been taught that through enlightenment we get free of Life's suffering. We escape samsara, the wheel

of Life. We free ourselves from the net of maya. We escape the damnation of Life by going to heaven, by reaching Zion. We become one with Yahweh or Allah by following rules laid down by divine law. We feel we can supersede reality if we learn the deepest Zen meditation, or rigorously follow the steps of the Mahayana way.

We have been taught to see Life as an obstacle, a nightmare of temptation and suffering where our rewards are spare and are joys are few and all we can do is look to the future after our troubles are over.

In the old Christian song, it says,
"I've got a mansion,
just over the hilltop,
in that bright land where
we'll never grow old.
And some day yonder
we will nevermore wander
but walk on streets that
are paved with gold."

Life is the way To

Life is the obstacle, but it is not an obstacle to somewhere else. It is not in the way of Utopia, of nirvana. It is

not the way from, it is the way to. The obstacle of Life is the gateway. It is the canvas through which we create the art of living Life. Jesus said the road to Life is hard and the gate narrow, and few will enter. He understood that living is the road to Life but if you want it you must go into it at every opportunity. You must be in Life with passion, a passion great enough to be painted irretrievably into your art. This is the way to get free.

Sometimes we don't want to see the light, we don't want freedom, we don't want truth. What we want is for God to look at the light instead of us. We'd like to join with God and not have to think about it at all anymore. We think God has it, God has the light and we don't. We have forgotten that the light is here. We feel it is someplace else, someplace protected and as blissful as if we were stoned. We think of Gautama under the Bodhi tree, floating away, into the arms of the One. We think of Jesus floating up to heaven, having merged with the Father like a reverse paramecium. One with the Father till the end of time.

What is One?

We think we want to be enlightened so that we can be one with the right power, so we can get one up on

the universe. We think of ways to find access to the One. We pursue endless excesses and deprivations, and masters, teachers, gurus, and all manner of tricks and short-cuts.

But we do not really want One. We want Life. If we are ever one with anything it is Life. And as soon as Life gets us it throws us out, divided away to find our own integrity. What One is is nothingness, and we don't want nothingness, we want somethingness. Nothingness is not for Life. There is no Life in nothingness anymore than there is anything else.

One is not Somethingness

We want both One, and not-One.

We want to be One, and we want to be conscious at the same time, to keep our selves. We want to have our cake and eat it. We want to think One is somethingness, but it is not so. One is not somethingness. There is no such thing as One.

We want both to be, and not to be. We want not-One and we want One. We want somethingness which is Life, and nothingness which is un-Life. One is not to be, One is to not be.

One is not Possible

To be is to live, and in nothingness and somethingness there is Life. This is not One. The heart of Life is not One. Tao, Brahman, Amma, the divine heart of Life, is not One. Life is nothingness and somethingness, and somethingness and nothingness. It is not One. One is not possible. There is only nothingness. We don't want One, we want Life. One has a place in climax. It is the crash of the wave, one to another. This is the time of One. It is the coming together of creative necessity.

There is not Life and Life. There is only Life. Life cannot not be but itself. What we want to see is the truth of ourselves not only as something, but as nothing; not only as ourselves in masks playing roles in the world, but as the actor playing all roles. When we see ourselves as the painter as well as the painted, then we get free. We get free because we see the truth that we are not only the art but the artist. We are not only the moved, but the mover. We are the subject, the verb, the object. This is the wave. One, two, three; one, two, three.

4

The Trap of Expressive Life

We are Stuck

It is not Life that we want free of. We want to be free of the trap that expressive Life is. We don't like feeling victimized by the very thing that we want. We have seen Life as the giver and the taker-away, the comforter and the tormentor, the healer and the plague.

We see Life as the source and the dead end, plentiful and impoverished, beautiful and ugly, twisted and plain, fortunate and disastrous. We want out of it because we can't seem to get into it. We are stuck. What do we do?

We keep answering the call of our art to be created because the gift of our art is freedom. It is expression expressed. We keep creating our work-in-progress because we cannot turn away. Through our creation is our freedom, as the creation of us is freedom.

We want to be as all Life on earth. We want to sing when we sing, eat when we eat, rest when we rest, and die when we die. We do this as the children that we are. To live

in wonder and humility as well as strength. To cry when we cry, to laugh when we laugh, to work when we work, to sleep when we sleep, and to awaken when we awaken.

Life Doesn't do Anything to Us

We puff ourselves up in our masks on the stage of Life. We sidle up to Life and pick a fight. We pretend and flaunt and push and pull. We cry out in rage, and wretch in sickness, and fall in sorrow. All these things we do by way of creating who we are in our picture. We are the artist creating our way back to itself.

All these things we do in the still surrounding of Life. Life doesn't do anything to us, it abides while we struggle in a straight jacket that we perceive binds us. We are the form that struggles from the block.

The Birth Struggle

What is the struggle? It is the struggle to renew, to be born. It is the struggle to get into the truth of who we are, and in this truth, to stretch and express and live the being that we are.

The Trap of Expressive Life

The struggle from the trap is the birth struggle, when we are born as form, when the artist struggles to find shape on the canvas, when the sculpture struggles to find form in the clay, when the actor struggles to find the truth of the character she is portraying, these are ways to emerge into reality so that we can create.

All these things are the same. The bud unfolds into a rose and it has arrived. It arrives, takes a breath, and it is itself. It is in the midst of being.

Herself Calls to Her

When the painter finds the shape and the sculptor the form and the actor the character, they each stand back, take a breath, and say, "There it is. She has arrived. Yes."

This is recognition of what the artist already knew was there. She looks and looks, and searches and agonizes, and if she can't find what she knows is there in one place, she looks somewhere else. Because she knows it is there. How does she know? Because it is herself calling to her. She knows herself and herself knows her, and when herself calls to her, she must, and will, answer.

This is the call of every artist, and every artist is you.

It is you that is in the canvas, and the clay, and on the stage. You are in the rosebud. It is you.

This is the struggle. You struggle, not because you are trying to get out of something, but because you are trying to get into something. You don't want out of Life, you want into Life. You want to be your being in Life.

The Narrow Gate

When we search for truth, and we meditate or chant or pray or fast or take drugs, we are looking for the narrow gate of which Jesus spoke.

We are looking for ways to see a greater reality than this seemingly solid and mundane one that refuses to let us in. We are looking for ways to escape the distractions of our eyes and ears, the longings of our bodies and our passions. We want to quiet our minds and focus so that the periphery can fall away, and in our focus find the deeper truth of being.

In the search for that which is ultimate, some surpass collective reality. Sai Baba materializes holy ash. Tomas Green Morton materializes perfumes from the ethers. I am empathic. People use different materials in their search. Clairvoyance, clairaudience, psychometry, astral projection,

intuition, transubstantiation. All these abilities demonstrate the non-locality of consciousness. Where then, is consciousness? Who is it that is conscious? We are, we who are the artist, the art calling for itself. It is the artist that is the desire of somethingness for expression. This is what somethingness is. It is the expression of nothingness.

Consciousness is expression, a stroke of the paintbrush, a downbeat of the conductor's baton. We can free ourselves from reality because there is no expressed reality. There is nothing solid, and nothing that is that is.

There is no Place at All

It is the world, solid or not, that we come back to. The reason is because the world is the picture we are in. It is the canvas. There is no other place than the world. There is no other place because there is no place at all. There is no space with things in it. There is no time in which things happen.

All the world is is a brush stroke, a movement, a crest of somethingness that releases into the valley of nothingness.

We become enlightened, and see we are a brush stroke, and we are born into our freedom as artist. This is Tao, this is Yoga. This is it. This is the awakened heart of Life.

WE CAN PLAY ANYONE

Is this the peace then, the laughter, the love we have to give and the compassion? Is this the self we radiate through awakening, through recognition, through enlightenment?

Yes. When we awaken to ourselves as expression and are born into ourselves as expressor, we are free and have sprung the trap. This is awakening.

When we awaken, we see that we are a player on the stage in a drama with all other players. We can play anyone. We can play anything. We can play the sun, the moon, the stars, the galaxies.

When we see that we are not one face, one mask, one character, but any character, and every character, we are free. We are born. We are free from the death of our Life, and born into the Life of All Life. We are free from the trap of our expression, and born into the freedom of All Expression.

No longer do we suffer for ourselves, because we are not ourselves. We feel the feelings, the pain and triumph and sorrow and joy, the darkness and the lightness of the character, but we are not the character, we are the art.

I am I, you are you. We are Artist.

The Trap of Expressive Life

WE CAN'T GET OUT OF ANYTHING

AT THE SAME TIME you are artist, you are art. Nothingness is not nothingness alone. Our birth as artist is through our Life as art. Our Life is the point of it all. We can't get out of anything. We can't make our sorrow less or our striving less or our pain less because we realize we are only a character. No. Enlightenment is not less Life, it is more Life. The way to awaken is to enter fully in. We must be every bit the character. We must feel all that she is.

Because the character is us. Her story is our story. In <u>Acting the Essence</u>, I write to my students, "Not acting means feeling all the joy, all the agony, all the anger and strength and longing of the one you are giving Life to. Not acting means feeling those feelings truly, just like we feel our own feelings truly. We claim the feelings of the one we are acting in depth and breadth just like we claim our own. As much as we can be someone else is as much as we can be ourselves. We want to not act anyone else just as we want to not act ourselves."

When we hold back in our lives, just as if we hold back as a character on the stage, or a composer of the musical score, we are not believable. We are not ready to step fully forward. When we hold back, when we deny ourselves

from being fully human, whether through discouragement or depression or diminishment, or pride or arrogance or greed or fear, no matter what the reason we hold back, we will never be fully believable because we will never be fully human.

We are the Art of Life

Our art, who we are as works of art, is fully human, with every strength and every failing and every passion that drives us. When we as artist see ourselves as fully human, then we are the art of us expressed. What is the art we are meant to be? Life. We are the art of Life.

It is Life, fully expressed Life that has the Life of the artist in it.

The way to get born in Life is to do die to it.

When we see La Boheme, our hearts are filled with the beauty, the fully expressed humanity of the story and the song. When we see Swan Lake, we are transported with the purity, the sorrow of death, the longing of Life. We go away reaffirmed, infilled with the motion of Life, with the experience of the truth that is within our hearts, that is within every heart to express, because every heart is an expression of the divine heart of Life.

This is why we must allow Life to fully live in us. Because the purpose of Life is to awaken us to itself. What Siddhartha did when he arose from the Bodhi tree was to go on with his day. He was not then impervious to Life. He laughed and cried and worked and rested and died.

But he no longer experienced Life as a trap. He saw that he was no longer the sufferer to be suffering, but as the sufferer to Life, the sufferer to be born. And he was born. And he was free, and is free.

Suffering to Humility

Suffering cannot withstand humility. We cannot suffer if we are not trapped. If we let go of the trap, suffering subsides. When we awaken from the trap of Life, there is no longer anything to get free of. Suffering is the call of humility to be the child that we are, the new creation we are called to be.

What is the trap? It is thinking that we are left out and rejected from moving on toward Life. We have artistic materials everywhere such as strength, forbearance, and hope. But they are lost to us under the weight of the seriousness of our materials. We can't get out because we don't know how we got in. Still, our materials are there for

a reason and when we can we will solve the puzzle and leave the trap.

We have to create ourselves out of the trap. We try to manipulate the trap so that it seems that we are something, we are not the emperor with no clothes. But it does not work. What we do is keep at the art of Life which is ours and only ours to create. We go into Life because it is the way out of Life.

When we try and make Life what we want, we do not succeed. In our efforts to make what is not makeable, we each become Sisyphus. We cannot make what we want, or do what we want, or have what we want, because what we want is not here and never will be. Who we are is not here at all.

We do not exist.

Nothing that is, is.

There is no space nor things in space.

There is no time for things to happen in.

Suffering to freedom

In Life there is suffering. We do not want to call suffering lack. Suffering is not lack of anything. There is no lack and there cannot be lack in the world. But suffering is

suffering. It is the call of love to love. The love that is the motion of somethingness suffers to come, suffers to be.

Nothing is not nothing casually. Nothing is not nothing inertly. It is not nothing only to be nothing.

Something is not any something. It is not random something or something without being anything. No. Something is art. Something is art because it has Life. That Life is our instrument of love that creates the motion of Life. Love is the calling of nothing to something, and the calling of something to nothing. In this way, there isn't nothing at all and there isn't something at all. There is love.

The Catapult of Suffering

Love is the call. It is the call of the art to come forth. It is the call of something to nothing.

In this call is the motion. It is the motion that creates all things. The mountain, the valley, the rise, the fall.

The mountain suffers through the earth, the valley suffers through the desert floor, the sun suffers through the evening, and the night suffers through the dawn.

Suffering is the catapult from which Life must be hurled.

Life is not casual. Life is not random. Life is not lost. Life is not confused. Life is not indifferent. Life is not oblivious. Life is for us and not against us. Life is the infinite inspiration that assures that there will never not be creative something and never not be the holy nothing of nothing.

What this Life is is the breath in, the breath out; the cresting wave, the unfolding rose, the heart that beats, the rest upon the shore. This motion of Life is the guiding presence of our artists tool of love which cannot help but seek us always. The cementing tool, the tool that calls our art to itself, is love. But love is not outside us like God. Indeed love, like all our artists tools is the nature of our being. Nor is the idea of God outside us at all. God does not live either inward or outward, but God is only our longing for ourselves, for the home of our hearts.

Love cannot be manipulated like God can. Love cannot be exploited like God who we call upon to win our personal and national wars. Love belongs not to God but to us as children of divine Life. It is a tool guiding our materials, lighting our way. It doesn't matter that love is only one of our artists tools. It is love that leads us home as we create our picture of Life. It is love that abides and calls gently as we make our efforts both small and large. It is love that provides the Life of Life. Love is our own god, our own way home to which we ultimately turn.

The Trap of Expressive Life

There is reward in seeking Life, because Life is the thing, Life is the call. Life is everything. Even though we are the thing, and are the Life, in this Life where space appears to be and time appears to happen in it, our experience is of the endless motion upon which we are carried.

THE ART MAKES THE ARTIST

OUR EXPERIENCE GIVES US the idea that we are one place and something else is another place. This is how it must be arranged. We can't be the art without being the artist. This experience of distance from Life gives us a chance to awaken to ourselves as Life, as artist.

In order for Life to occur there is the artist and the art. The artist makes the art, the art makes the artist. Life is a way for Life to discover itself. In this process, in this motion, there is movement, and in this movement there is the catapult. The catapult suffers resistance in order to take the pulse through itself. The wave suffers the crest.

Suffering is not something of itself, just as nothing is something of itself. Suffering is at the height of getting through, like getting through a wedged space in the rocks that will not fit you. Nothing does not suffer something else. The wind suffers the air, the fire suffers the flame, the

water suffers the earth, and the galaxy suffers the planets, but nothing suffers nothing.

Life Cannot Die

We, as expressions of art called human, suffer the Life that is in us.

We do so because we are in motion. We call it growing, but it is us in motion. We are in motion and will always be in motion. The reason for this is because we are Life and cannot die. We are Life and that's what Life is. It is alive.

All that is and is not is alive. There is no beginning and no ending except in this process which is motion, the artist moving to the art, the art moving to the artist.

The reason we suffer is because we are called by love to Life. We are called from crest to crest, to the orgasmic peak, and we must climb. This is Life. We are the art being called into creation.

Suffering challenges our hearts. Our heart is the love that calls us, the artist searching for the art. What is our art? It is us searching for ourselves. In our hearts we feel longing for union with the artist as the rest longs for the pulse. In longing we suffer. Sometimes we see who we are and the longing recedes. We hear the meadowlark, the

laughter of a child, we see through the eyes of a little dog, or a horse or an elephant, and we are filled with joy, and in that moment we say, "Ah, there it is!"

We have seen Life, and it has seen us.

The Picture of Love

Love is the picture. It is the artist of the artist, in this union of love with love. Nothing longs alone. We are longing and we are not longing. We are all Life which is all love. In this way, we long together, we suffer together, we find Life together and the fulfillment of our longing.

When we keep the river of our hearts flowing, this motion that we are, we love one another and all beings of Life. It is the way of love to care, to bring its expressions, its own way of being, to itself. Our hearts then, are open to all others, to all of Life, every animal, every tree, every drop of water. This is the compassionate nature of Life.

To be as children, to care for the suffering of another, to live Life in the ebb and flow of its moments, this is what love calls us to do. It is love that we are called by. We cannot not love. We cannot deny love. We cannot get out of love. We cannot be anything but love. We are trying to find love. We cannot but try to find love.

The Beauty in Searching

This searching, this reaching for our form and shape and color and sound that we are in the painting, this is beauty. Beauty is all and every effort of the heart to find what it is.

Beauty is beautiful. It touches us and moves us and shocks us and startles us. It has infinite ways of revealing itself. It is not only serenity and glory and awe. Beauty is all that is. It is wrenching and ghastly and terrifying and agonizing. It is recognition. It is recognition of a greater truth of ourselves. Beauty, too, like love, creates an awakening and is an awakening. It is a lamppost.

There is beauty in all things.

Beauty reminds us who we are. In every holocaust there is a bird somewhere singing. There is no holocaust which is only holocaust. There is nothing which is only nothing.

In darkness there is light, in light, darkness.

Light Begins in the Dark

We have thought that Life has come from the presence of light, but science has shown that Life may have

begun in the darkest recesses of the ocean, in the deepest deep where there is no light at all.

Just so, the day begins in the depth of the night. While the light is affirmation of day, it is in the night, in the dark, where light begins.

We would rather be in the light and see the things we recognize and that are familiar. We look into the faces of the people and the animals and the birds and the sights that we love. We look at the trees and flowers and we watch time pass in a world where at least, if not home, there is a semblance of a place where we belong.

We are not so likely to look into the night. Not so likely to find beauty in the dark. But when, for example, I look at the orange sitting on my table now, and I begin to see the awesome nature of its color and shape, the play of the light around its curves, the firm softness of its quality, then I begin to see it for itself.

As I go further into the reality of the orange, I begin to want to know its essence. What is the essence of orangeness? I close my eyes, I see the sections peel away, I see the seeds. Then I look into the dark heart of the seed, and the bits get tinier and tinier until there is nothing. This is the nothing of the orange. The orange itself is the something of the orange.

We Must Go Into the Dark

In the dark center of the orange is its beginning, its seat of power. Many things we do not want to look at and do not want to hear, but if we look, and if we hear, we will awaken to who we are, and where we are.

The road is hard, and the gate narrow. But if you go, you will find it. If you face the dark, the gate will appear and you will go through it.

In Kali we go into the dark, in Psyche we go into the dark, in Hell we go into the dark, in Art we go into the dark. In birth we go into the dark. We must go.

When I listen to the heart of the Rachmaninoff Second piano concerto, there lies the most beautiful darkness I have ever heard. It is astounding beauty emerging from the dark. Our deepest longings, our most profound selves, our purest hearts, are in the dark. The dark is our birth, and because this is so, the answer, the seed of who we are, the seed of the orange, is also there. It awaits us. It will and does give us all of itself if we but search in passion and in silence.

The Trap of Expressive Life

Exposing the Inner Nature

When I read the poems of Sylvia Plath I am moved by her sheer power to hit the orange seed, the core of the darkness.

From "Suicide Off Egg Rock,"
> "He smouldered, as if stone-deaf, blindfold,
> His body beached with the sea's garbage,
> A machine to breathe and beat forever."

This is the calling of the artist, to expose the inner nature of a thing, and to reveal the Life of it. This is the art of it. The art of a thing is already there. The artist's calling is to find it and release it.

When I look at Goya's "The Third of May, 1808," its bold and flat and direct pointing to the darkness, I want to turn away from its showing, its thrusting of darkness right up to my eyes. But I cannot, because it is beautiful and the beauty shouts to me. It is filled with Life.

In Ruben's "The Battle of Anghiari," the darkness is monumental, turning and twisting, fighting and destroying and rejecting. This is a great and beautiful trap. The darkness runs through me like a warm river and opens a place deep in the forest of my heart.

The Darkness for Itself

Not many face the darkness for itself, but flee instead, to the known, to God, to the bit of picture that has already been painted. But the problem is that when we hang onto that bit of known Life, it erodes. It moves and crumbles away. We can hold onto it for a long time, but not forever. The trap is in holding on, in trying not to move. In the Tarot deck, the first card of the Major Arcana is the Fool. The Fool is an androgynous youth stepping obliviously off the cliff. He has no accouterments, no equipment, nothing but a small bag which he carries lightly over his shoulder. This is how it is. This is how we must go, giving up everything and all preparation, stepping freely off the cliff into the new.

Darkness Calls us Back

With the new, the darkness comes and the light comes. If we do not stay with the darkness as long as it is dark, it will call us back until we do. It will call us back because it is the light to the right way. We think we have turned away from it to find the right way, but we have gone the wrong

The Trap of Expressive Life

way. So the darkness calls us back. We think the darkness is the end. We think that darkness is a place that has nothing to do with us.

The Zen of darkness and light is to be in the dark when it is dark and to be in the light when it is light. It is not to stay in the darkness or the light, it is to stay in the moment. It is to stay in every moment.

In art, the darkness is the way. We begin in the darkness and go to the darkness. As we work toward darkness we are illumined by it, and this illumination spills out and takes form.

5

The Gift of the Present Moment

Being No One

On the stage, I teach my acting students to go as far into the unknown as possible and to be as much no one as they can be. The more we can be no one, the more space we have in which to be someone. When I show up at my keyboard to write, my desire is to put myself aside as completely as possible so that whatever might come to me might come freely, without the obstacle of me there for it to step over or to stumble upon. If I do not put myself aside, I enter the trap. I cannot give because I have not made room for giving, I cannot feel the gift of the present moment because I have not let go the feelings of the past moment.

This is so in all of art and all of Life. If I am an empty vessel, and always an empty vessel, always looking toward sacred nothingness, then there is no trap. There is no question about who I am, because who I am is nothingness.

Being nothingness, knowing nothingness is the beginning of every moment, and to know nothingness is to have

become illumined. The moment unfolds, illumination is rendered.

When you look at The Fool, without mind stepping off the cliff, this is nothingness. The moment journeys then, from beginning to end, from The Fool to The World, from trough to crest, crest to trough. In this apparent journey, the traps between nothingness and somethingness are set. Somethingness is the obstacle, the material in which form is found. Form is made through resistance. You, as Artist, take form and make it into Life. You create Life. This is power meeting power, the Art and the Artist.

The Fool is Life

In the beginning, The Fool is oblivion, in the end, The Fool is heart, the Fool is Life. At the end of the Major Arcana you come to the twenty-third card, The World. The World is all-fulfillment, all-expression having come into being. The Fool has become The World, and The World again becomes The Fool, in the very next moment.

First there is no form, then there is form, then there is no form.

Form, or somethingness, is what you make when you turn your trap into a door. You are the sculptor, and the

material. The trap is your unformed form, your nothing somethingness.

You sculpt your Life just as you sculpt a block of clay. The deeper you go into your clay, into the darkness, the more form you find, and the more illumination you render. You are The Fool working toward The World.

Working Toward the Crest

Rosalind Turrell, the great English organist and Bach artist once said that there is a complete transformational experience in four lines of Bach. A world begun, created, and ended in four lines.

This moving toward the crest and creation of the crest, is more and more infilled with power the more it is worked. The more it is structured, the more power it can release. The further along you go in your Life, the more you can find ways to build structure that will serve as a channel for power to be released through you. Structure can be built up, or it can be built down. Structure is a way of moving form in order to do what you want with it.

How do you know what you want? Your heart tells you, and your heart wants to tell you. You are fueled with the passion of your heart. Your heart is infinite passion. It is the

power of love, and the expression of love is passion. Passion is Life's revelation of itself.

Rosalind Turrell talked about the clarity of Bach structure. She said that the more clarity of structure produced, the more open the fountain of passion can pour through.

"Bach tells me what to do," she said.

Bach went into the depths and brought out great handfuls of power that he hurled into the body of the universe. He went in and laid dynamite in the arms of every deep crevice, and then lit one fuse after another. He exploded the form from the block. He blasted out of the trap. He learned how from his heart, from the guidance of his passion.

We are not Called to be Inert

Nothing else matters but being the expression that wishes to express through you. And even though into nothingness we go, we cannot and do not end there. We cannot only go into the depths of nothingness. We do not become enlightened so that we can stay there. We do not stay anywhere. We become enlightened because we want to know more than we see already, and when we see the light we simply know more about the nature of reality, for we have seen nothingness.

We do not desire illumination either to be set apart from others or to be of assistance to others. It is said that the Buddha never spoke. What would he have to say in words that could only be known through experience? He could not. He remained silent. Nor can any illumined being convey the depth of this knowledge with language. Explanations in words would be and are foolhardy and quite useless. Additional knowledge, illumination, is a way of Life. In the light no words are necessary. No additional demands are required, no obligation to be of assistance to others. But in the illumined one there is softness and a lack of concern that comes from letting go absolutely. There is a depth of understanding. It is simply the revelation of Life.

It is no particular person who finds the light, it is the gift of all to all, of Life to Life. It belongs to you, it is your right and your destiny.

<div style="text-align:center">

From the Sufi poet Rumi,
"Come, come, whoever you are.
Wonderer, worshipper, lover of leaving.
It doesn't matter.
Ours is not a caravan of despair.
Come, even if you have broken your vows
A thousand times.
Come, yet again, come, come."

</div>

There Is No Block

This is the kind of Life we can have and are meant to live. The crest of the wave does not move gently into place, it is catapulted.

We say, but Bach is Bach, I am no Bach, I cannot create form. I am not the artist, I am stuck in the block.

The reality is that there is no block at all, and you are not stuck. What appears to be a stuck point is only a turning, only an exclamation point. The stuck point is the vessel from which you emerge. You are living, you are in motion, you are expression and expressing. You have never been and will never be outside this motion of Life.

The stuck point is the narrow gate of which Jesus spoke. It is the catapult of the orgasm. When the crest peaks, when the pulse is achieved, when the orgasm attains itself, this is the source of all power, the climactic source of Life.

All Things Are Part of Something Else

"All things are metaphors," Goethe said.

All things are part of this brilliant simplicity. Everything is a puzzle piece pointing to something else. Language, words,

are meant to point at the reality to which they refer. But they are meaningless in themselves. Language is a tool meant to assist with the interpretation of meaning. But words are not the thing itself. What is the thing? It is the source of Life. It is a motion toward presence. In this way we are lead to discover that there is nothing but form to point to. Under the form is presence. We realize then that all that exists is presence. It becomes a metaphor for itself and there is no other. All things are like presence and in fact they are presence.

When we process language it is fueled by the desire to know and to comprehend. If we are a scientist or a poet, we seek deeply. We observe and we stay long in the urge to identify and to know. We seek the original form, the form itself before it was labeled and categorized and put away. In so doing we hope to get a glimpse of a greater truth, perhaps of presence, of reality before it became real.

BUILDING STRUCTURE

A DIFFERENT BRAIN STRUCTURE has made it possible for me to have many experiences of altered reality over a period of forty years. In western medical terms, the breakdown of reality has been described in superficial terms. There is no room for this kind of experience in the Judeo-Christian

belief system. The experience of a non-three dimensional reality challenges the limited interpretation that has been imposed upon it. In many cultures this is not necessarily so. The whole point of many spiritual practices is to release reality, the net of maya, altogether.

But there must be method. The point of spiritual practice, of Gautama going into the cave for nine years, or Jesus going into the hills for forty days, this creation of personal space is meant to be the source from which the art form that is Life can be built. The point is to find the structure of your form. This is the artistic process, and this is the way of Life. You build the structure, so that your Life can release all the passion that it, as art, has to give.

Without preparation the backdrop that is reality can collapse in one fell swoop. When it occurs without the ability to interpret the experience, it is a disaster instead of an awakening. It is the renewing maw of Kali without the heart of Shakti or the shape of Shiva.

Great Slams of Noise

Like Bach, art and the art which is Life must be built with structure, fine and intricate structure. Without structure, Bach would not be Bach, but only great slams of noise.

Just so when one's brain is broken or altered, what is created is form without structure. It is awakening with no one there to be awakened. It is free travel, free truth. It is a free show into the center of all that is. But there is no frontal lobe capacity to interpret the experience. Thus there is no focused consciousness upon which form can be built to reveal it. There is no presence of self to guide it. To experience without the accompanying deductive ability is all the raw material with no artist to use it.

The Meaning of Altered Reality

IT IS A LOSS to western Christian consciousness to be unable to interpret the meaning of altered reality as a result of brain dysfunction or of those whose meditation practice has brought them into the realm of altered reality. We have not learned how to interpret deeper experience because we have abandoned ourselves and are lost. We have turned to God instead. We have left God in the great wild blue yonder. We have made of it an idol so we can ask for what we want, for ourselves and for our country and the countries that support our country. All this to avoid going deeper. It is easier to rely on superstition, on God, than on Life.

This is why we are lost. This is why we are fragmented. This is why we do not know who we are, because we have thrown the heart of us into exile.

Broken reality is a reflection of this fragmentation. We have built a fragmented reality, and the form has responded accordingly. Brain chemistry changes, people become ill, they become the outpicturing of our common consciousness, of the common fragmented form that we have created. Altered reality means fragmentation, sight and sound and all sense of reality shattering like a window.

The Gift of Broken Reality

Nevertheless, this seemingly limited and crude and misguided form that we have created in brain disorder and in relationship with others is in itself only a stopping off place, only a part of our search to build structure. It is only structure that is yet incomplete. And this seeming fragmentation is not only part, but it is core, it is indispensable.

Through broken reality we can see the way out of the trap. We can see that there is not only no trap, but nothing at all. This is its gift. It is a magnificent and terrifying gift, and only the rare soul can enter in without losing itself altogether. This is the narrow gate.

Complete and utter fragmentation of reality is a great truckload of somethingness dumped onto your head all at once. Only the rare individual with unremitting desire and monumental strength can withstand this onslaught and turn to look and see reality for itself. Only the most audacious and absurd seeker can do it. It is the gall of gall.

Why is this experience the tremendous blast to the self that it is? Because it collapses all structure. The form of one's being is obliterated and there is no one left to pick up the pieces. There is not even a clue.

Broken Reality, the Experience of Nothingness

Broken reality is a direct experience of nothingness.

How is this possible? How could I, in utter fragmentation, come back from nothingness, since my somethingness was eradicated, dismantled down to the last corner? How, if I became nothingness, could I be somethingness at all?

The answer is because what I am, and who I am, is not something. I am not something. I am not nothing. I am the dance. I am the wave itself. I come back from nothingness because I can only have Life in somethingness.

It is not nothingness or somethingness that matters. It is not structure or form. I can find myself again because my self does not exist. I can find myself because the truth of me, the love of me that Life has given, carries me forward and brings me back to myself. The truth of me is that all I am is the love of Life. All that anything is is the love of Life. Love is the power that brings creation forward.

In altered reality, I am not really lost because who I thought I was is nowhere to be found. Who I thought I was is not lost because it never was in the first place. I see that I am not me, I am not found, I am not lost, I am not, period. I am not I. I am the love of Life. I am ineffable.

Love is the Lamppost

Love is our artist instrument of Life that brings all things into being and to which all other instruments turn. Love is the description of who we are. It is the heart of Life.

It is the lamppost.

In this experience, I see that I can never be lost. It is not possible to lose what does not exist. This is the yoga of the nature of Life.

I am the awakened without awareness of itself. I am the eternally awakening state of being awakened.

Nirvana is the stage of awakening. But Nirvana is not a place, it is a place in motion, it is the verb. It is me when I see that I am nothing, that I am not lost and cannot be lost, that I am the artist and the art.

Reality is Suspect

Everyone suspects fragmented reality. Everyone suspects that reality is a thin veneer, and that they, themselves in it, are fragile and can be broken to pieces like a fallen vase.

A theatre set is made up of backdrops and flats and props. When you go up to the wall on the stage you see that it is not a wall at all, it is flats, sections of wood covered over by canvas and painted. But when the lights come up and the actors come on, we say yes, yes, this is believable.

This entering in from a distance feels safe. We know the difference between what is real and what is not. If we could see that Life itself is the same, we could enter into Life in the same spirit. But in Life we think we are not the actor, not the figure in the painting, not the character in the story. We think the play is not the play, we think it is outside art. We think there is such a place as outside art and we're in it.

Yet we suspect. We suspect that no matter how we bolster the set of our lives, and how we believe in the painting and the story, it is still a set and a painting and a story. We are afraid that everything will come crumbling down around us, and we will be erased from the picture and that when everything disintegrates and erases there will be nothing left. Nothing will exist and we won't either.

Awakening comes when we see it is true that this is so, and that in its place is infinite art. In its place is infinite us, and infinite expression, and infinite Life.

We Are Infinite Story

We are not only this art of which we are a part now, in this set and story. We are all parts of all expressions for all time. Hindu gods express a wondrous drama of divine manifestation, representing many realities. Many sets, many stories, many characters.

We are not one story, we are infinite story.

The reason we suspect the fall of reality is because if we allowed it, we would get a glimpse into its deeper nature. The nature of reality is not the dance which does not dance, it is the dance. It is not the story having been told, it is the

story. It is one spontaneous motion, one toss of paint, one ray of golden light.

Where does the fear, where does the grasping come from? It comes from the effort of the crest of the wave to crest. It comes from the desire of form to be form. It is the love of somethingness for nothingness that causes it form.

Nothing Must Be

NOTHINGNESS IS REQUIRED, ELSE where can something come from? It must be absolute nothingness in order for creative structure to be built. If there is something already in nothing then there has to be nothing that the something came from. There is not something first that came out of nowhere. No, this is not so. Through our instrument of love, something is brought forth. This is the something of Life and we are it. Which comes first the chicken or the egg? The chicken. In this way, the chicken is potential in nothingness, the egg is the emergence into somethingness. The egg falls onto the belt of time.

And yet nothingness is not a giant space brimming with creation. There is not anything whatsoever in nothingness.

Just One Sparrow

INTEGRITY

There is integrity in nature. It is the integrity of Life to live, and not only to live but to live according to each expression from the most vast to the most infinite.

The integrity of Life is to behave in such a way as to complete itself. This completion, from beginning to end to beginning, is love. It is not love because it is love. It is love because what it is is an expression of recognition. It is the recognition of the source of home, and this is love. Recognition is Life-filled, and in recognition there is the heart that makes the blood reach for the pulse. To not only reach for the pulse, but to achieve the pulse and to rest again.

The motion is not only motion, not motion only for something to be created. It has love and is love. Love provides its integrity. Its integrity is absolute. Its integrity is never-failing.

In the art of Life, it is love and the integrity of its nature that causes power. It is the desire of power to achieve its expression. This is why each task finds completion. And it is why when the completion is gained it sticks. It holds form. When we find form as humans, we hold form. Holding onto form translates itself in us to possession and

grasping. We grasp onto the known now that it is known, just as we grasp onto the rocks as we climb the cliff.

The form has to be made before it can be released. Grasping and fear of the loss of form is part of the picture. It is in the painting. But what we can do is gain more freedom in the picture by seeing more of it. Then we are free to have more than one set for the drama and one series of songs and one storyline and one family of characters. We can be whoever we want to be. We can have many faces and many forms. We can be Shiva and Shakti and Kali and Durga, Saraswati, Ganesh, and Nataraja.

Grasping, Ungrasping

In broken reality the form has fallen. In every day reality it is this fear of falling form that keeps us holding on so tightly. In the end, we must let go of the rock and fall, just like the Tarot Fool from the edge of the cliff. We must let go of our breath sooner or later, so that another breath may come. This is the yoga of Life.

The integrity of Life assures that we do not fall into non-being. We do not fall into void. All we have to do is ungrasp. Let go and another handhold will come to us. We ungrasp into nothingness, and somethingness appears. We

follow our sense that somethingness is. We listen to somethingness calling. We find a way to build the structure to get to where we see but don't know how to get to.

Thus, we go into the cave like Buddha, and into the wilderness like Jesus, into the stillness of presence. Like the actor on stage who must put herself aside, we must do the same in order for the way to reveal itself in us. We are the form that must be molded.

We are the art. We are the artist, nothingness and somethingness in the infinite dance.

Fragmentation is a whole in disguise. It is unformed form. It is simply a jumbled puzzle. But it is an infinitely dimensional puzzle. With fragmented parts we can build a greater whole, a new whole that is a revelation. In it is just not mind, but heart-mind, kokoro. In it is the perfect expression of heart-mind.

One Reality

It is not so that other realities, other expressions, are more anything than the reality we are in. There is no other reality than this one. There are infinite experiences of reality. But there are not fewer pitfalls or more rewards in any other experience than this experience. When we think

that through meditation, or chanting or yoga or magic, or drugs or fasting or contemplating koans, or prayer, we can be brought to a fuller experience of who we are than we are right here in this moment, we are mistaken.

The material for the horrors of Life is equally everywhere. When Don Juan in the Carlos Castaneda stories went into different realms through the mescaline that infused his brain, he was awakened to other realms, he was not awakened to awakening. He was not awakened to an additional awareness, only different awareness. The same struggle that he found here, he found there. He found dark power and grasping. He found bad people and good people there the same as here. This in itself was what he brought back, what he learned, that the material for struggle is not anywhere more than anywhere else.

Don Juan had a connection to this reality to come back to. He had Carlos. He did not fall, as one does with broken brain chemistry, or feel himself demolished. He had a guide. He had a line on this side so he could find his way back.

Explosion

It is the point of practice to build one step at a time instead of falling in one fell swoop, because the power

released in a formless dive is obliterating. It is destruction. That is its purpose.

What this is, this power of explosion, is what it takes to begin again, for something to be released into nothing. Explosion in terms of time, is an ending. It is the end. It is awakening.

When we think in time, we see distance. We go from one place to someplace else. This we experience as process. And we experience formation as learning. Learning is formation coming into being with structure. Explosion catapults learning out of time.

We cannot experience explosion directly, as one does through altered reality, because explosion creates death. It is death. So we experience explosion through structure. Rosalind Turrell is able to release the most magnificent, the most awesome explosion of the power of Bach because she has gained structure over time. The form of Bach has been revealed to her as she has gone into him in process.

In music, in all art, in any practice over time, structure reveals form and form reveals passion. Passion is the power of love in form.

As in art, spiritual practice is a process of exploring the form of the self, so that structure can be built for the release of our nature which is the fullness of Life.

Time as Art

You are art. You doing yoga or meditating or dancing or singing, is you learning, structuring, the form of yourself, and as you do, your self unfolds. When you unfold, in the end, at the conclusion of the illusory process, you join with Art, the art having become Artist.

This sense of the existence of time, is the nature of Life. Time is the art of Life. It is the gift of Life, and its beauty, is expression.

Time gives us space in which to have Life in. This is the gift of time which is the design of Life.

Time is in itself an expression of somethingness, and the something that it is, is Life.

When The Fool steps off the cliff in the Tarot, she doesn't free fall and go crashing to the ground. She must only step off first. She must let go and begin. She steps off into process, and the adventure ensues. In finding the art that she is, she goes through an infinity of experiences which include all the form she has available to her, all challenges of the heart and mind. She is the art called human, and the materials given her are relevant to human form.

Bach's form was music, Martha Graham's form was dancing, Katharine Hepburn's form was acting, Delacroix's

form was painting, Wordsworth's form was poetry, and human form is time. Time is the material, the mold from which we unfold. In our time, in human time is everything we need to build the structure from which we can express the passion that is the heart of us. In the moment of that expression is awakening.

In the fullness of the passion of awakening, we express fully, and are released from form. We are catapulted from form, and crash into a new beginning. We come crashing like giant cymbals at the climax of the orchestra's symphony. We explode into the truth of who we are, the art flashing into the face of the artist.

This is the crest of the wave cresting into crest, the pulse of the rest pulsing into pulse. In this antithesis, somethingness is shot free into nothingness.

There is No One

Enlightenment is not the experience of oneness, it is awakening to nothingness, to the nature of presence. Nothingness and somethingness are not one. Nothingness is nothing. Somethingness is something.

Does this mean there are two, then? No. There are not two of anything. There is not any of anything. There is

only nothing. Nothing comes from nothing and nothing is nothing.

What is One? We think of one as something. We think of one as everything. We think of one as union. We think of one as heaven, as nirvana. We think of one as the ultimate, Brahman, merging with God.

But what we don't like about one is that in one, where are we? We have disappeared into one and we are no longer. We are nothing but one, and the one of floating mindlessness.

One is not One

But we are not one, and one is not one. There is no one. There is no all. There is no something at all. There is only nothing.

What is the oneness of fire? What is the oneness of water? What is the oneness of air? What is the oneness of earth? There is no oneness of fire, or water, or air, or earth.

What is the oneness of quark? The oneness of quark is something infinitesimal, and something infinitesimal after that.

At the center of the center of the most infinitesimal of infinitesimal, there is nothing.

In that case, is nothing one?
No. Nothing is not one. Nothing is nothing.

We Are Raw Material

THE GOAL OF AN actor on stage is to become one with her character. She becomes one with her character by putting herself as much into nothing as possible so her character can move in. The more the actor can move out the more the character can move in. The body is the vessel.

In the theatre, and in the clay and the canvas, is us, the actor. We ourselves are the raw material. We must learn how to become the structure through which the character can come forward. The better we are at providing the structure the character requires, the more completely she can know Life.

This is a rare sight, just as Bach as a composer is rare and Sylvia Plath as a poet is rare; Sai Baba is rare, and the C'i gong master Wu is rare. To see an actor who has truly made great art, who has given of himself and explored himself and found the means to reveal his findings, is to see the actor having become one with the character.

Oneness is the Illusion

But the trick is, as Alan Watts used to say, is that they are not one. The illusion is not their separation, the illusion is their oneness. There must be two to make the wave. Yin and yang describes the nature of Life.

There is always the artist within the art. Artist, art; chicken, egg. This is the way of Life. This is so in the stage of the theatre and in the stage of Life. You are the character that you yourself, the artist, creates.

When we experience the acting of a Sir Michael Redgrave or an Eleanora Duse, and we see characters come alive with mind and emotion and style and color and sound, all unique to that character, and we believe that Redgrave or Duse is that character, then their experience of oneness becomes ours. Redgrave, we say, and Henry the Fourth are one and the same person. Or Duse and Bernarda Alba, have become one. This illusion, this art, can be magnificent.

This achievement is art. It is in motion and it is motion. Art does not end in a painting or a poem, it is simply the end of a motion and the beginning of another. It is only an expression of the greater art which is of the artist.

The oneness that we see between a great actor and her character is the fulfillment of the art. But who lurks

behind? The magician, the puppeteer. We are all Alice in Wonderland, and when we are afraid of the reality of us shattering, as in altered reality, and we suspect there is an artist behind the character on stage, and see the Cheshire cat disappearing, these are the ways we know, these are the clues given us that what we suspect, is true, that there is really nothing at all.

6

Nothing That Is, Is

Only the Moment is Real

We think Mozart's Requiem is real. We think Hamlet is real. We think the scent of apple blossoms is real. I think this table before me is real. And it is all real in the moment. It is all real at the moment of expression. But outside the moment, nothing is real. Nothing that is, is.

What is, is the moment as expression.

What is the moment? The moment is a flash of flame. It is the pulse. It is the knife cutting into the block. It is the downbeat of the baton.

The moment is the structure of time. The moment is the structure, and the form is Life.

The Use of Pretending

In acting, as in all art, we cannot pretend to pretend. We cannot pretend to be the thing, or profess it or conjure it

or produce it with magic. The thing is the thing. It is the art that it is. It is something, and it requires all of what it needs to be itself.

The more of itself we can bring to it, the more Life it is able to express. The more Life it expresses the more believable it is. It is more believable with more Life because more Life gives it more room for us to recognize ourselves in it.

Who is ourselves? Ourselves is the artist. Ourselves is the heart of Life, the heart of the art we are.

We cannot trick art. Art does not respond to tricks. Tricks cloud Life. Tricks smudge and constrain Life.

Tricks

In learning how art works, we try and use tricks. We try and take short-cuts. This is because we do not see. We do not see the art of the moment. We do not see that the art is in the moment eternally. We think there is nothing here and something there. We want to leave here and go there. We do not see that there is as much art in this moment as in that moment over there. To know this in heart-mind, this is illumination. It rides on our minds and waits patiently. It surrounds our heads in a halo, waiting in presence and in stillness.

We try tricks in art the same way we do in Life. In acting we think we can pretend to be a character into whom we have not transformed and get away with it. But what happens is that the audience can feel this deception. The audience knows what's real and what isn't. As an actor, every time I am fully transformed into my character, it doesn't matter what I do, the audience is fully with me, fully there with me, conscious with me no matter what I do. But if I try and trick the audience and put forth a part of my character that I have not realized, the audience will respond in exact ratio.

You can get far with tricks. You can become very good at tricks. Just like forgers can with paintings. In the end, how do you tell the difference between the real painting and the forgery, between the real character and the actor forging the character? You can tell because what is real radiates Life. What is real is living. Real art is a living thing. It is a Life, and has Life. What is real is Life. Nothing else is real. Nothing but the art of Life has Life.

Heart and Mind

How do you create Life?

You create Life by revealing the heart of your work of art. Human Life has heart and mind. You cannot be mind

without heart. Mind without heart is structure without form. You cannot be heart without mind. Heart without mind is material without structure. The heart is the substance, the mind is the expression. The heart is the what, the mind is the how.

The mind is tricky. It is the mind that likes tricks. The mind thinks it can get around the heart. It's whole effort in the beginning is to get around the heart. That's the fool in the beginning of her journey, after she has stepped off the cliff. She likes to think all kinds of things. She likes to build buildings in her mind like a child with an erector set. She is that child. She thinks she is independent and can make things any way she wants them to be.

This is the mind without heart.

The mind can build the most extraordinary structures imaginable. It can build anything and then sit back and marvel at it. It sits back and says, Here it is. This is it. This is the thing.

But the mind without the heart is nothing. It is fickle and cannot focus. It has no heart to welcome it into the structure, so it quickly gets dissatisfied. It kicks over its structure and says, No, this isn't it after all.

The mind loves all things. It claims all things. It owns all things, and it uses all things. This is what it's supposed to do and it does it with aplomb. It does this tirelessly and magnificently.

Mind Without Heart

But without the heart the mind makes a huge mess. A huge, appalling mess. All it sees is things built everywhere, and torn down. It's a giant playroom.

Without the heart, the mind pretends its structures are everything. But the poor mind cannot and will not be anything

without the form to provide the mortar. When the mortar comes, the mind says, Now I see. I thought I had everything I needed, but I only had the craft. I only had part of the tools. I only had half of the blueprints.

The mind runs circles around the heart because it thinks figuring is easier than feeling. We think figuring is more easily discerned than feeling. Figuring seems formed already. When we think, we think we have already got the form. This is the trick of the mind.

The mind likes things, the heart likes no thing.

But the mind has not and never will be able to get away without the heart. The mind without the heart is the storefront without the store. It's the backdrop and the flats. It's the actor without the character. It's the forgery.

The mind is the craft without the art. It is Shiva without Shakti.

TIME AND SPACE

IN ORDER FOR THE actor to transform himself into the character, he must unfold his craft as led by his heart. She must feel his character's feelings instead of her own.

Stanislavski, the inventor of what became known as method acting, simply understood that characters in plays are real. He could see that there already is someone, a character, waiting to be born. Not only one character, but infinite characters. They are all there, waiting for Life.

All of Life is in the stone waiting for the stonecutter.

Expressions of Life, the characters that we are cannot gain space if no space is made for us. Space exists for time. Space is the form of the structure of time. Space is the heart, the form of the art of Life, and time is the structure. Time doesn't exist without space.

When we want space, we have it. An actor on stage makes space. He gets a clean canvas. His materials are his thoughts and his feelings. This he draws from and gives to his character when his character needs whatever it is he needs to appear, to grow, to become defined.

Genuine Feeling

No one but the actor can know the needs of the character. The actor is the artist. The character comes to him for Life. When he wants a longing heart, the actor gives him a longing heart. When he wants reserve, the actor gives him reserve. When he wants megalomania, the actor gives him megalomania.

But the actor cannot give from nothing. The actor cannot hand his character a serpent and call it a fish, following the parable of Jesus. No. He must hand him the genuine feeling. Where does he find his character's feelings? He finds them within himself. And he can find every one. He can find every shade and every combination. He can do this because the fact is, he too is a work in progress. He too is unfinished. He too is raw material. And there is no feeling or combination of feelings that he cannot experience. There is no feeling that the actor cannot experience, and we are all the actor.

When the actor says, or when you say, or when I say, I cannot feel this feeling for this person because I have never felt this feeling, we are mistaken. There is no feeling that is not ours to feel, just as there is no note for Bach not to find, and no color for Matisse not to discover.

Our art, the artist's art, the actor's challenge, is to find the feeling within ourselves and give it to the character to whom we are giving birth. There is nothing hidden that cannot or will not be revealed. The actor finds his feelings and allows his character, his self, to take this material from him so that he might have Life. Onstage or off, there is no other way.

Life is Form Expressing

If we say, I cannot create ugliness because I have no ugliness, I cannot create depravity because I have no depravity, I cannot create avarice because I have no avarice, I cannot create holocaust because I am not capable of holocaust, it is not so. We are deluded. Or when we say, I cannot create power and beauty and strength and transformational Life because I have not these things, it is not so.

Nothing that is living is not connected to all that is living. Life is living, and you are it.

All of what anybody can be, you can be.

All of Life is simply form expressing, changing and metamorphosing. It is the love having the Life.

Full Expression of Life

The full expression of Life is not optional. It is destiny. It is not about finding balance, it is about the expression of the passion that is Life.

If you do not go far enough, if you do not seek the narrow gate, if you do not stand before your art with all your heart and all your mind, you cannot have it. It evaporates into thin air.

Whether or not you are of stout-heart or of keen mind or of the enduring long-suffering soul, in any moment you yourself are art in formation. And you will reach the fullness of your Life, you will reach the glorious explosion of your self. This will happen and is happening right now because the truth of you is the glory of Life in this moment and in every moment.

The Container Does Not Matter

The container of the art does not matter. The container does not exist. What does exist is the Life. All work of art will perish. All the Bach and the Verdi, all the Raphael's and

Matisse', all the Shakespeare, all the Wordsworth, all the Plath, all the Hepburn's and Redgrave's and Duse's. It all will disappear.

The monumental sculptures of Buddhist art that the Afghani Taliban destroyed are gone. These massive symbols of human hope and meaning that were a magnificent beauty of the world, are gone.

In the volcano eruption of Mt. St. Helen's in Washington fifteen years ago, one of the most beautiful rivers in the world was destroyed, the Rogue river. In a few moments, the breathtaking, Life-giving, wild and free Life of this astonishing beauty of nature, was gone.

Still, these things are but form. The river was but the beauty. The river, the sculpture, the words, the dance, the painting, the music, it is all but form for Life that cannot die. It is reborn again and again without end.

THE MEANING OF DEATH

LIFE CANNOT DIE.

Birth is death. It is entrance into the trap of Life.

What is death? It is the completion of every breath. Every motion reaches a peak, and in every peak is death.

Death is required for Life, Life is required for death.

It is said that John the Baptist, the Hebrew and Essene, preached of giving up old ways and being reborn to the new, dying to the known and being reborn to new Life. The analogy is the same. John's experience is my experience, my experience is your experience. Our experience is of Life, death, rebirth.

The most ancient argument, asking is there somethingness or is there nothingness? is the same throughout time. It is the same argument. It is the same in any one day. Sometimes we feel we are dying, sometimes we feel we are living. Sometimes we are dying, sometimes we are living.

But no matter where we are in our degree of illumination, we always suspect, we always ask, we always sense Life. Our benchmark, our lamppost is the art of us being created by us as we are created by Life.

When we experience art, Life is proven. Because when we experience art in what we create, and in us as creation, we attain direct experience of Life. How and when it happens is as different as there are expressions to experience. But what we experience is the same, the call of the divine heart of Life to awaken and to be.

Nothing is God

ALL AROUND US ALL the time there is un-god. There is Tao, that which loves and nourishes all things, the presence that is un-god.

Everything that is is un-god. Everything that is not is un-god. Nothing is not God. Nothing that is or is not, is God. Nothing is nothing. It is only through nothing that there can be something.

The reason we look to art for nothing is because art is the encompassing of both sides of the picture. It uses every duality, every word, every color, every emotion, the light and dark, the rough and the smooth. These contrasts art uses along with heart and mind, feeling and intellect, form and structure.

Enlightenment is Process

WE HAVE EPIPHANIES. EVERY time we blink it is epiphany. Every moment is satori. We are epiphanous. We are satorous.

Awakening is enlightenment, enlightenment is awakening. Each moment, we awaken.

We think of enlightenment in terms of degree. We think of Buddha or Jesus or St. Theresa of Avila; or Meister Eckhart perhaps, or the tribal shaman, or the mother who heals. We think of enlightenment as becoming enlightened for all time, of seeing the greater reality of all of Life. But enlightenment, this most prized of all commodities, is not the end of all ends, the prize of all prizes. It is not a privileged entryway into an exclusive world. It is not reached at the end of an unfathomable distance. It is not restricted to those only who have conquered each step.

Enlightenment is not the eradication of all obstacles, it is the revelation of obstacles as expressions of the art that is Life. Enlightenment is the process through which we ourselves are illuminated as artist, and the enlightenment of all things is the purpose and goal of Life.

Enlightenment, the truth of Life, is equally everywhere present. Enlightenment is free. You may not want enlightenment now as much as you do sometimes. Some people don't much care about illumination at all. Some people are stuck in darkness all their lives. But enlightenment is not optional. You are not alive to one degree or another. The enlightenment of you is that you are fully and brilliantly and passionately alive right now. You are inevitably and presently every bit that Life is.

Your degree of experience of Life is another thing. You think you only have so much Life. You remember times when you had Life and you say, Then I was filled with Life. Yet the truth remains that all of Life is prepared to lift you up and bring you fully forward at any time.

Life is not Moral

You think that Life only comes in bits, and it comes to some more than others. You think that Life is bias, that it is age bias and health bias and talent bias and intelligence bias. You think that Life is moral.

You think that Life has moral bias.

But Life is not moral. It cannot be appeased or bribed or tricked or sacrificed by your behavior or your beliefs.

You think there is good Life, bad Life, right Life, wrong Life. But there is no good, bad, right, wrong, or any anything in Life but itself.

If there are none of these, how do we get the idea of them? We get the idea of them from ourselves, from our own feelings. Feelings, the raw material of who we are as art, are guides that direct us on the canvas, like color, contrast, form, and perspective to the painter. Feelings are

colors. They're twists of the tree trunk. Every analogy in nature is an analogy for the feelings and mind of Life.

Humans have a consciousness of self, of the art as well as the artist, and thus live in conflict between the created and the creator, the appearance of distance and the no-distance, the experience of time and no-time, of the God and the un-God.

We are in-between. We are in progress. We are what is between heaven and earth. What is between heaven and earth? Nothing. But there is where we are. And from this vantage point we create both ways. We create to the art and we create to the artist. We create toward heaven and we create toward earth.

Feeling and Thinking

Feelings, love, longing, loss, sadness, grief, pride, avarice, greed, lust, jealousy, hatred, anger, rage. All these are miracles of material at our disposal with which to work.

We have a faculty for intelligent thinking which is our potential structure. Intelligence, the structure; feelings, the form. With our intelligence we create critical thinking and discriminating judgment. We choose from an infinite pallet, from an infinite number of tools what we are going to

do with our feelings. What we call them, how we shape them, depends on our imagination and our experience and practice.

We are subject to sloth, to the necessary tendency of the wave to rest, to remain in climax. This is in order that it can hold form. We are subject to convention, to staying in one place too long. We are subject to caprice, when we do not stay long enough for form to come into itself. These are the shades we learn. These are the balances we discover like the dancer in her dance. How long does she hold a position? Just long enough. How long is enough? The artist in her knows. She learns, and she does it.

This is what feelings do. Feelings give us the material through which we become fully ourselves, fully the art that we are creating.

Calling Bad Wrong

Some feelings we call good, and then to retain form, structure comes in and it calls good right. It does this to maintain itself. That's what it's supposed to do.

Some feelings we call bad, and for the same reason, we call bad wrong. Calling bad wrong works from the material called guilt.

We build our picture of wrong by painting rules. Rules nail the wrong. We want so much for bad not to move that we mix it in concrete by sacrificing other colors. We throw other colors away and this we call punishing and killing. This is the great power at the peak, and the power of the rest to seek rest.

We throw out, and we keep. This is what the artist does. We accept, and we reject. In order to keep what we have gained, we build even more structure. We call whole swatches good and whole swatches bad. We make sets. Then we make halves. We say, This half is good, and this half is bad. This half is right, this half is wrong.

We do the same thing in looking at our living rooms. This part is right and that whole area is wrong. Sometimes we throw the whole thing out. We say the whole thing is wrong. We say nothing's right. We say everything's bad, like the Hebrew creation story, humans are basically bad, contaminated.

Or we separate by color or sexuality or belief or class, some are all bad. Or we say everything's good, everything's cool, like hippies and New Agers, and fifties families, and cokeheads; like sage followers and yogi students and army grunts; like idiots and dementia patients.

What is Wrong or Right?

But when we take a step back we see that everything is all the same. Good gets stuck just as much as bad. Right isn't any prettier than wrong. Then we're in a muddle. We can't remember what made good good and bad bad. Maybe we made a mistake. Maybe we got it backwards.

But no, no, we say. Surely one color must be better than another. Surely quarter notes are better than half notes. Surely day must be better than night. Surely light must be better than dark. Surely love is better than hate.

There, we say. That's it. That's the one thing that's better than another. Love is better than hate. We can say that and know it for sure. There's something we can nail. Here's some ground to stand on, we say, here's a bit of earth we can count on. We're not lost after all.

But we cannot, and we are.

Love is a Color, Hate is a Color

No, nothing is better than anything else. Life isn't better than death, the rest is not better than the pulse. You might as well say breathing in is better than breathing out,

or that morning is better than afternoon, or that one sparrow is better than another sparrow.

It is not good to love rather than to hate. Nothing is good but the steps in our art leading to our song, our picture. How do we tell if a move is right? We tell because the artist within knows. When we enter the wave and are carried to the top, the apex, and feel the perfect rightness of this step of our art, our move into the wave, and we are laid to rest on the shore, this is good.

But love and hate are part of the world, they are not who you are. Love is a color, hate is a color, valuable tools in our pallet. Love and hate are in the picture and are the picture. There is no picture of only love. There is no picture of only hate. In the picture of love if you look closely there is something missing. In the picture of hate you'll see something missing. You will suspect both pictures, just like you do about your hold on Life when you suspect your interpretation of it. Just like the set on stage that looks real but is only flats and backdrops. What is missing is consciousness, Life.

There is no love except that which has Life. Love is not exclusive of anything. Love and hate have Life, not one greater than the other except as we choose. We are the art and art is not moral, art cannot be exploited for our use any more than a character on stage or a song.

Pictures Without Life

EVERYTHING HAS SUBTEXT. EVERYTHING is about something else. This is the Goethe metaphor.

When I was little I used to look at the covers of Ideals magazine. They were perfect scenes of beautiful and serene and inviting and safe places. They were wonderlands where not a single thing was or could ever be wrong or damaged or useless or out of place. But while I loved to look at the pictures, they filled me with the deepest loneliness. The pictures were meant to be beautiful, but they were not. They were not beautiful because they were without Life.

When I was growing up, too, I remember the covers of children's Christian magazines. Pictures of the man named Jesus, the man with a beard who looked so pathetic, the man in a blue robe standing over a group of children sitting at his feet. What could he be telling them? There were no children playing, no children smiling, no children contemplating anything but the man standing over them.

The man standing over them, his palms held forward at his sides, his pale face turned slightly upward to the sky. There was no look on his face. Nothing was in his face but scrubbed white skin and sadness. This is the

storefront picture, the flat picture. This is the indifferent picture, the picture that contains the least contrast, the least shade, the least color. It is a picture without Life.

Love is a Stage

Love is often manipulated in such a way. It is trumped up and fluffed up so much it can practically stand on its own, it is so detailed with perfection.

We have made love a god, when what love is is a lamppost.

We do this to love for the same reason we reject hate. We want them both to be what we have decided they are and to stay that way. And they both end up in the same trap, and are the same trap.

Creating a picture of love is a stage of motion. Creating a picture of hate is a stage of motion, one always within the other. We think we do not like hate, and we think we like love. But we do not know what hate is, and we do not know what love is. Love is not the opposite of hate. Love has no opposite. Hate has no opposite. Love is love. Hate is hate. Red is red, green is green. They are the instruments of Life.

Hate is Nothing

All that is is motion. The dancer crouched and tightly coiled in one moment, and flung into the air the next. There is tension, there is freedom. The dancer does not remain coiled for a single moment longer than necessary. To do so is folly. To do so is false. To do so is wasteful. To do so is hateful.

Hate is nothing in itself. It is a consequence, an afterthought. It is unique to beings that are both the subject and the source of art. Hate is the artist grabbing for what she has created, the art escaping from what it has already been freed.

This shake-up, this tension in the middle, the source of what you have lost, is hate. Its experience is reaction. In politics hatred is often found in the old reacting to the new. In physics, hate is the shell of resistance, the echo after the sound has left the cliff and the cliff reaching back for it. But there is no hate in physics. When the sound leaves the cliff, it leaves with no regret, and the cliff with no rancor.

In the natural world there is no reaching back for what was. Hate is reaching back and losing what we think we have gathered, losing our self-confidence and our sense of existence. We react in such a situation with deep violence.

Hate is a violent reaction. It is a violent place packed with energy. What makes it violent is the change. Hate is the ghost of change. It is the old reeling off the back of the new. The desire of Life to create in and through us is great. Hate is an emotional way of responding to the material of us as we tear chunks of clay from the block.

Hate is Material

FEELING IS OUR MATERIAL for creating our art of Life just as notes are the material of the composer. When and how much feeling to express is the same question the composer asks of his notes. Hate is a violent emotion that goes into the character of our creation just as violence goes into the composer's notes because it is a natural progression of his score.

We want hate.

Hate is irreplaceable.

Hate has purpose.

Hate is a catapult.

Hate is a lamppost. It is a remarkable invention that lights our way like nothing else can.

Hate is the most profound heads up we have thought of so far to show us exactly where we are. Hate is a magnificent

gift of remembering who we are. Without hate, without the extraordinary power of hate, how would we get such a leg up to where we are and where we want to get to next?

※

Hate is a Description

Hate is not anything. It is a description. All emotions are descriptions. Hate is a violent no and a violent yes. In a storm the waves appear to hate the water. Violent no, violent yes. Violent thrust, violent heave.

Hate is how fast you have to get away. The composer says, No, I hate that note. The writer says, No, I hate that word. The painter says, No, I hate that bit there. He knows for sure what he does not want, what is not right. He knows he must turn a corner.

Hate is a shade of passion. It is a response against indifference, against oblivion, against non-existence. But in truth there is no hate, there is only change. There is only motion. There is only nothing. And there is only something. There is the power of love that excludes nothing but moves inexorably toward Life.

7

Stuck Out Here All Alone

THE TOOL OF PRIDE

WHAT MAKES HATE HATE, is pride.

Hate alone is a flash, a warning. It is not a thing, it is a place. What makes it a thing, what gives it structure so that it can be hate, is pride.

Pride is self-containment. It is clarity of form. In physical terms pride is the ability of an object or a system to remain in place. Pride is the independence of expression. As in all things, the pride of expression is in motion. We think of the pride of Mt. McKinley, or the pyramids, or of lions, the comfort of their longevity. Or the pride of a monarch butterfly that is expressed so fully in a briefer Life. Each expression that comes into fullness, has, in its finality, pride.

But the more the expression becomes conscious of itself, the more quickly and easily its pride, its integrity, changes. Humans, finding themselves in a position of

transformative change, question its viability. This is not very good, we say, this design. This is too much, it's overwhelming. How can we do all this at once?

Consciousness of self is consciousness of source. Where is our source? we say. But we cannot find it. We're stuck out here all alone.

Collapse of Pride Into Source

In the experience of altered reality, one is flung with no pride at all into one's source. In such a state we become no self and all source, no expression and all expressor, no something and all nothing.

This is the collapse of pride into the source, into nothing. Full collapse of pride takes one beyond the subconscious self and into the preconscious of all. It takes one into primal material, into nothingness itself.

In the experience of broken reality, the collapse of pride is the progression of uncreation, with the material of oneself becoming undone into bits. Once you get accustomed to what you are as fragmented bits of self, you progress to what you are as no self. You go on to see that you are no one at all, but that you are It. You are not you, you are It.

And this is the place, this is the narrow gate, the trap. It is the key to the trick. It is the end of the journey and the fulfillment of the purpose of journey. It is the end of time.

In this place of collapsed integrity and pre-pride is the experience of nothingness. What is it in nothing that can be experienced? How can something experience nothing? Something can and must experience nothing. This is the way. This is the motion of love. It is the love that provides for existence.

We Are Unfinished

Pride is a description, just as hate is.

When you are creating and being created at the same time, as is the case with transformative human expression, pride is unstable. We never know where we end and something else begins. We are always changing, always something different than we were a moment before. This is the painter painting his picture, the composer recording his notes.

We are unfinished just like all things are unfinished.

Where is our pride, then? What is our pride? This is the question that leads us into error. Finding our pride leads us astray.

We want pride, we want to know who we are. We are the artist looking for our shape. In this process, we mistake who we are for where we are. Instead of being pride, then, we project it. We express it in emotion. We claim it and grasp it. In frustration, because we can't be it, we try to create it. We make it up, and in this folly we become prideful.

Here we come walking by again, the emperor still with no clothes. The prideful creation, the mask and the over-sized costume and the bullhorn becomes our defense against remembering that we are not altogether someone.

Sameness Wants Itself

Sameness wants so much of itself. This is inertia, and it is what is in motion wanting to remain in motion. It is us wanting to change and wanting to stay the same at the same time. We want to stay the same, we want to change. We want to stay, we want to go. We want to move, we want to stop.

Pride is the strength, the bull-headedness of stopness.

Pride is one of our artists tools. It is powerful and stunning and arresting. It is fascinating. It has its own light, for it is a lamppost.

Perfect Pride

When Leontyne Price sings an Aida aria, every fraction of every moment has perfect pride. Every bit of every note, every shade of emphasis or subtlety, every violence or gentleness; every loudness or softness; every nudge and every wail of every emotion has perfect pride. This is greatness of art. This is bringing forth all that the art has within. It is the art of Leontyne Price, the art of Verdi, and the art of divine nothingness in complete integrity.

When we look at the sculptures of Donatello of David, or of Mary Magdalene, we see infinitesimal pride. Every millimeter bursts with pride. The smooth as well as the rough, the shadow, the light; the angst, the relief; the part, the whole. There is nowhere where Life is not. Life is passionately bursting, retreating, pushing, pulling into its own self, the absolute staking of its pride, the thrust of its pride into the heart of nothingness.

Pride Lives in Spontaneity

In human form, pride comes from moment to moment in spontaneity. Every moment is spontaneous. It happens

by itself, just like the water in the stream and the breeze that blows over it. Every moment is itself. Spontaneity is the explosion of the moment.

Humans are transformational expressions. Our artistic challenge is pride. As we awaken to the pride of the moment, we let go of the un-pride of the un-moment. We jump spontaneously, suddenly, into the moment of ourselves. It is a moment of all entering all, as if stepping through the backdrop into infinity. We leave the old moment and enter the new.

There is only pride in the moment because we only exist in the moment. When we walk away from the moment without leaving it behind, we make a mistake, we take a wrong turn. We make pride an idol. We make pride Godlike.

THE ANGER OF PRIDE

THIS IS ONLY THE naked emperor. It is making a building of a scaffold. But a scaffold is not a building. And when we think we have the power of who we are but we don't, we come off as fools and bullies and liars and thieves. We come off as rapers and pillagers and murderers and dolts.

Pride that thinks it is pride is an angry fellow indeed. And it has a right to be angry. It thought it was something and now it is not. It thought it was full and now it feels empty. Such a situation is untenable. It causes pride to flail about and knock things down. It wants to get rid of everything around it because what if it is not it? What if everything around it is really it? Then it wouldn't be itself, it would be nothing. It has a case of mistaken identity. It has amnesia. It eliminates everything around it to level the playing field.

It's a powerful opponent, this specter that looks like pride. You have to stay out of its way. It's been robbed and it's in a rage. It's full of hate.

This is how pride partners with hate. Hate is pride's thug. Hate is pride's grunt. But pride is the brains behind the outfit. The general is the pride, the soldier is the hate. The hate has to do what pride is not capable of. Because without hate pride is just a mediocre failure. Pride doesn't want mediocre. It wants what it wants, so it hunkers down into hate for fuel.

Pride is an Idiot

No matter how much mischief pride gets into, no matter how many people or animals or planets it kills; no

matter how much havoc it wrecks around it, it is still an idiot struggling in an over-sized clown suit.

It is pathetic, and the Hindu gods laugh. Ha ha ha. They laugh with glee and slap their knees. All the gods laugh, and the oracle at Delphi comes, the oracle of the Mother Earth. "You. You in there," she says, "Whattya doin' wearing yourself ragged like this? Look at this mess you made.

"Come on outta that suit and clean yourself up. Here, here's a comb. Comb your hair."

The Grasping of Time Creates Error

It is not pride itself in transformational expressions that creates error, it is the grasping of time, the tendency of our moments to gather themselves. This appearance creates continuity, it creates the form of time.

Our lesson, as artist, is to learn that time is not creating us, we are creating it. Our lesson is to see that where the pride is is not in the permanent time but in the impermanent moment. Pride is not extended. It is not finished. It is not a result, or an achievement, it is the full and complete expression of Life from moment to moment.

Enlightenment is Completion

The idea in any meditation practice, and in all of art, is the awakening of the moment. Enlightenment does not take time. Enlightenment does not depend on time, else it would be in time. And enlightenment is not in time, it is in no-time, it is in no-space. That is its point and that is what it is. It does not take nine years or forty years or a whole Lifetime or many Lifetimes. Enlightenment is fully in this very moment and in every moment.

Enlightenment is in and through every note that Leontyne Price sings, and in every point of Donatello's Mary Magdalene.

What enlightenment is is the very completion of us as art forms. It is not something we do not have, it is who we are.

The Spontaneous Moment

In acting on the stage, the actor's goal is to be fully in the moment and fully spontaneous. He has to know when to stay and when to go. This is the tension and the release of the wave, the pulse and the rest. It is the Life of a moment. What he learns is that if he allows himself to be fully

in the present, he can respond with spontaneity. The more alive he is, the more Life is given him. The more present he is, the more presence will be given him.

Spontaneity is catapulted from groundedness. The more grounded the actor can feel, the bigger a springboard he has from which to leap. Groundedness is the coil, spontaneity is the spring. Spontaneity is what happens in the moment when you are fully there. The moment completes itself then, without effort.

When the character of Shaw's Mrs. Warren comes on stage, or Bette Davis' Baby Jane, or Tennessee William's Serafina Delle Rose, you have characters that are great works of art. Each has been drawn into a vast multitude of characteristics. Each characteristic has a ground and an expression, a moment of inertia and a moment of action. Presence, spontaneity. A character fully drawn is a character that has been given Life. Like Pinocchio, the frame is infused with energy and moves of its own accord.

The Life of Passion

Spontaneity does not mean floating in air. No, it is shot from earth. It is driven from the ground like a tree, and it has the power of a tree. What spontaneity is is the Life of

passion. It is the Life of infinite possibility flashing itself onto the stage of expression.

Enlightenment, in the end, does not come from retreat or from silence or from long-suffering. It does not come from emptying one's mind or fasting one's body. It comes from the full expression of Life. To see the Life, to see that you are the Life, that the heart of you is not part of the world or its events, this is the joy of enlightenment, this is the desire of enlightenment, for Life to meet Life. What else could enlightenment be about but Life? This is the freedom of liberation from all traps our worldly self has presented. This is the place where every trap has fallen away, where what is left is only our true self of love in the midst of the presence which is love.

Love is the Calling

What is the reason for love? The power of Life, the intelligence, is the purpose of love. Love is the guide.

As we become enlightened to hate and pride simply as stages, simply as colors, we awaken to love as the Life we are called to create. Love is the calling of all of Life. Love calls Life to itself. Love calls something from nothing. We want to love because it is our nature as expression

to answer the call, to come into being. Love is not a good thing or a bad thing, it has no value and no description. Love is the calling which calls us home, it is the completion of us as works of art.

Love is not love because it is right, it is love because it is the container of Life. Love is not love because of how it feels to us, but how we feel to it. We are the light by which it creates, and it is the lamp. It is the lamppost.

The use of love is to bring all things into expression, into completion. The nature of love is the drawing power that keeps us in the world and through the world. And what is power? Power is what it takes the wave to get over the crest. It is the Life of motion.

Love is the Form

Love is the form of Life, power is the structure. Power is how love gets done.

What it means for us to want to love is that through love we get the power of Life. We get a sense that we're on the right track. We're finding the right colors on the canvas and the right moves on the dance floor, and that renders a sense of power. It makes us feel powerful

because the right way is powerful. What the right way is is a sense we have in ourselves. It is Life beckoning. It's that thing we know, the thing we suspect. The right way is choosing one note and not another, taking a brush stroke in one direction instead of another, and listening to the sense that says yes, or no.

The right way is toward the lamppost. Nobody and nothing knows the right way but the sense within you. And that sense is not a god. It is not and cannot call you to do anything you want to do or don't want to do. It is not a moralist, not a preacher, not a shaman, not a divinatory. It is not God, not Allah, not Jehovah, not Christ, not Brahman, and not Buddha. It is not divine, not truth, not sacred, not the answer, not the light, not the love, not the father or the mother, and not the prize in the bottom of the cereal box.

In truth there is no god, no ruler, no patriarch, no matriarch, no omniscient being, no omnipresent being, no omnipotent being, and no wizard of Oz.

There is no hierarchy, no above, no below, no lower, no higher, and no smaller and no bigger, no bad and no better.

There is nothing supreme that is supremer than you. There is no god that is more god than you.

You are God which is Ungod

What you want to do is get the idea of God out of your mind as soon as possible. Because as long as it's there you will think there is something in the world you don't have and something that you are not.

But it is not so. There is nothing you don't have and that you are not. There is nothing in the world at all, and you aren't either.

You are Expression. You are the divine heart of Life. You are the Zen, you are the Tao. You are God which is ungod. You are something. You are everything and no thing. You are it, you're the Life.

The idea that there is a God, or Goddess, or Allah, or Jehovah, or Zeus, or the Void, or any being or any power whatsoever that reigns over you or guides you or loves you or punishes you, or that has anything to do with you at all, is mistaken. It is a set up, and it's time to move on.

8

Great Creation Requires Great Resistance

BLUE IS NOT BETTER

THIS IDEA OF SETTING up something as different than something else and then calling it better is a ploy. It is, in the ploy move, in the ploy hand of the artist, a mistake.

It is a mistaken turn which is held in place by pride. We want the color to be blue. We make it blue. We bolster it with more paint. We fence it with other colors. We draw arrows to it. We bow before it. We bring incense and flowers. We sing songs to it and make promises in front of it.

But, in the end, if it is not blue, it is not blue. If it is not right, it is not right, and it won't work. We wanted blue to be better, but blue was not better. Blue is not better. Blue is not better than anything. Nothing is better than anything else. We accept at last that it is not blue we want and we start again.

We cannot make blue God and expect it to work. Blue is not God. No blue is God. God is the wizard behind the

curtain, the rattled old man telling you humbly that he is not God, you are God.

Life won't be Abdicated

Why do we make this mistake? Because it is the want of rest to rest and of pulse to pulse. Great creation requires great resistance. Great power requires great catapultion. The greater the coil, the further the spring. The stronger the connection to the earth, the greater the fly from its cliffs.

In our artistic form we use time. Time is the practice field. Time is the instrument. We carve time. We take time and mold it. It is our way to be found and our way to be lost. It is nothing but material.

In time we try many ways to learn which way to go. It is arduous, this structure we have brought on called time. It is a hard way. It is an ocean that refuses molding. It is an emptiness that won't let go its musical notes without a fight. And in the fight we falter. We give up. We throw down our tools and announce that we don't want to do it. We patch on bits and pieces and call it good enough.

Life is too hard, we say, it is not worth the fight. We try to abdicate. We create exile to assure our abdication.

In this stage of stuckness on the road, in the canvas, we put blue down anyway and call it right. This is the way we create the God of blue. Because inertia resists motion, because this artwork is hard. It's all the same.

Making Little Gods

We create a god if we don't know which way to turn on the road and we're too tired to go on. We create somebody different than us and call it the road god. We say the road god can go on for us.

We create many gods for many things, other beings to do what we resist doing. We make little puppets, little tokens and dolls and other projections of ourselves. We say, You be me for awhile. You be the god of me. Let me rest.

In this way we abdicate. We send out emissaries on our behalf. We say, Here, you gods go do the trip. You create the music. You paint the picture. We say, While you're at it, you be my pride too. You be my rage.

Our gods go away to play with our artistic materials. They go away and play at painting and play at dancing. They play at pride and at anger. We let them go and then we make them even bigger so that we don't have to continue on our journey. We make their anger into thunder

and into drought, into bad fortune and blight. They become about us. All that is becomes about us.

Then we are a god to them.

When We Want Our Stuff Back

But we put our gods together so they can take even more over for us. We give them everything, our minds and our hearts and in the end we make them one big god that we have made to take even our breath itself for us, we are so resistant to taking another breath, another step, so powerfully are we insisting that blue is blue.

And this is how we make God.

Then we can be nothing and God can be everything. This seems like a very good ploy to us. But in the end we turn on the little gods and make them bad. We say bigger is better, and we exchange them for one big God, and we make that God a very big and serious god indeed.

But they are all the same, the big God is just a big little god.

Then the day comes when we hear the call again from our station in exile, and all of a sudden we want our stuff back, the materials of our art. We get over it. We say okay, I want to try this again. We let the air out

of the big god, and dismantle all the little gods, and we go on our way.

GODS GIVE US DEATH

GODS ARE PART OF our art. They are a stone to show our path while we rest. They are a bookmark.

Gods are the reason for death. We want so much not to create our way home that we die to it. We give our Life to God and die. Giving our Life to God is death. This is what God is for. We turn everything over to the projection we have made so that we can die. We would rather die than go on with our next step.

In Beethoven's Emperor Concerto there are many deaths. Each death, each complete ending, each total relinquishing is the reason the Life can then emerge with such breathtaking beauty.

The night dies to the day, the day to the night.

To create God is a creation of great magnitude and great delusion. It shows that we are capable of creating beauty equal to Beethoven's Emperor. Because to create God is to create death. To turn yourself over is death. This is very brave, even though it appears to be cowardly. It is really not either one. It is just a part, it is just the way.

Making blue God, this is a big step. We have really made a commitment to the trap of the corner here. We push the envelope. We see just how far we can go to make blue God. We sacrifice everything. And the last thing is death. We die to make the blue god God.

Death is the Punctuation Mark

Why do we go to this apparent extreme? Because we have to. It's included. Endings have to be powerful in order to end. Death is the punctuation mark. It is within the very moment of Life. It is the confrontation of the wave with the crest, the orgasm heading for death because compelled by Life, it is complete.

There is no difference between Life and death. Because Life is not Life and death is not death. Life and death are only stages in time. Time is only a little bit of scaffolding. It's just a basic frame.

Blue is Not God Everywhere

In the west we have made blue very big indeed. But not everywhere. In Native American ways, blue does not insist

upon itself as God. There is a quote from Chief Seattle that goes, "Your God seems to us to be partial. He came to the white man. We never saw Him; never even heard his voice; He gave the white man laws but He had no word for his red children whose teeming millions filled this vast continent as the stars fill the firmament." (The World's Wisdom)

You made God blue, they said, but God is not blue.

Native American peoples understand that God is many colors, indeed every color, and that they themselves are but one. The Great Spirit, Wankan-Tanka, Mother and Grandmother earth, lives equally in and through all of Life, every human, every animal, every stone, every tree, every gust of wind.

In this way nothing stands apart from the whole. Life divine is equally everywhere present, loving and nourishing all things. All things are within the heart of the Great Spirit which I Life, the pulse that is the eternal and living motion of existence and non-existence.

Sioux holy man Black Elk said, "We use the drum in our sacred rites because its steady strong beat is the pulse, the heart, throbbing at the center of the universe." (The World's Wisdom)

The Native American, as other peoples who have remained close to the earth, have not separated from themselves. They have not been radical, throwing themselves into exile and creating foreign objects, building gods that they use for traps.

The Earth is Home

The earth is the home of us in this place called time. It is the structure for our form which is Life. We are the earth and the earth is us. The earth is our way to ourselves. When you are lost in exile with a god you have given all your power to, go to the earth and you will get yourself back. Your god will disappear because you will let it go. You will let it go because you will not need it anymore. Not only will you not need it anymore, but it will be released gently from you. You will feel no sense of loss but you will feel profound peace. Released from god you will in that instant begin to grow beyond it.

The god will be gone until there is no god at all. There will be just you, at home in yourself which is not you but you mother, you father, you earth, and you nothingness.

The Good of Gods

We say that creating gods is a way to explain the inexplicable universe, a way to give ourselves definition and importance and to provide us with a way to live. But this is not so. We create gods as a way to help us along the path. A god is simply a good friend or an evil adversary.

Great Creation Requires Great Resistance

We pray for one to fight the other as if yin could fight yang. We are misguided. It is when we abdicate our understanding of what we are doing that we become lost altogether.

Creating a God of All is suicide. It is extreme, and it should be used only when we become very brave or very stupid. Because to have one God, to have the blue God, is the Tarot Fool stepping from the cliff onto the jagged rocks below. It will and does create every manner of peril.

But when we understand gods for what they are, reminders and bookmarks and sticky-notes on different parts of our musical score, then they become but part of the way instead of the whole way. They become companions instead of con men and hucksters.

The Hindu goddess Kali is the goddess of death and of regeneration. She takes us through ego death and into the emergence of new consciousness. Gods are projections of Life experience. In mythology, gods and goddesses provide for a rich canvas. They outpicture the materials of which our path is made. What we want to do is not confuse the marker on the path with the path. And whether or not we pay attention to the markers or we go against the markers depends on what kind of artist we are. It depends on what kind of art we are called to create.

Just One Sparrow

LOVE IS NOT OPTIONAL

LOVE IS NOT A call from anything outsides ourselves to do it. Love is us calling ourselves to create our art which is Life. Love calls us to create our art because the completion of our art is love.

Love has purpose. It's purpose is to bring power into full expression. Full expression of Life is love. Love is the art that Life wants to complete. When we as human expressions are loving to Life, when we give all we have to give freely, then we are like the earth. We ourselves are the heart of Life.

The earth gives to all things. The rain falls upon the bad as well as the good, Jesus pointed out. So too you yourselves should give like the rain, and the sun that warms all things equally.

The reason we want to love is because we want to love. To love is the nature, the form of our art. All the things we do, all our love, all our emotions are the tools we have to build structure so that we may become who we are.

THERE IS NO OTHER POWER BUT LOVE

IT'S A PROCESS. IT'S a game. It's an activity. This is the reason we love. It is not optional. Love is the power of all that

is and all that is not. If you want power, you will eventually love. Because there is no other power. There isn't any anywhere else.

And you do want power because you do want to love. You cannot not love. But in our scaffolding of time, love is a walk. The joy is that we are not just love, joined together in one mass of love. No. We get to create our way to it. When we get to it we are born again and go walking all over again. We get to walk in an infinite number of ways. We don't do the same thing over and over again. We get to paint new pictures and sing new songs. We get to metamorphosize into infinity. Because art is infinite.

Choosing the Note

As we answer the call of love, and take turns between our tools of pride and hatred and greed and avarice and jealousy and covetousness and sloth, we discover different ways that we find are effective in getting what we want. If we are kind, if we are patient, if we are trustworthy, if we are long-suffering, if we give instead of take, and let go instead of hanging on, we get a clue. The distinct idea comes to us that one way feels more right than another way. One note feels better for our score than another. We see that

if we are kind instead of cruel, if we use yellow instead of blue, it feels right and we say, Yes, there it is.

This is not to say that yellow is better than blue because of something inherent in yellow. It is that like every artist, we know that one note on the musical score works better than another note. But there's no value in the note itself. There is only value in it as its function in leading toward the whole. We are kind because to be cruel is not a true reflection of what we want. We are honest instead of dishonest because to lie takes us down the garden path. It's the wrong way and we know it all along. But we have to find out. We need to go through our tools to find the one we want.

What is the Lie?

How much of the I of me is a lie?

I cannot take pain medication and when I had necessary surgery the resulting pain was beyond endurance. In this extreme state of consciousness where I lay day after day with relentless pain, I came to a moment when I realized the extent of myself as a lie. Everything around me, my bed, my room, my body, my pain, was a lie. And the lie was that it had to do with me, that it was about me and was me. The lie extended itself and went on and on. It was beyond

itself, so intensely did it hurt me. I felt it deeply, clearly. I had stepped into the maw of Kali. I saw nothingness then, then I became nothingness and knew nothingness.

I had seen the lie of it, and as time went on, in my mind I was able to crawl back up onto dry ground. I began to let the lie go. I dropped it. I had seen that none of it was about my self at all. Not the surroundings, not the body, not the person, not the pain. It was given to me that what I am has nothing to do with these things whatsoever. What I am is the nothingness that came to me. With no sound, no body, no surroundings, no world, I came to know nothingness.

I let go of the lie. I dropped it spontaneously, altogether, like the stage backdrop letting go its anchor above and falling with a great clang and thud onto the proscenium floor. And what is behind the curtain as the dust settles? Nothing. This was the presence which was nothingness.

This experience was an illumination, a reminder of the truth of what I am. It was a lamppost, a way of love beckoning me yonder.

Light Cannot but Come from Darkness

All artists materials are infinitely shaded, the materials of lying and cheating and all things related. It is

not easy to build a house that will stand the test of time. We cannot be kind or honest out of their context of form. Great kindness comes from the experience of great cruelty in Life. Great enlightenment comes from great darkness. Great peace comes from great conflict.

Otherwise you do not have a real house but only the picture of a house, a stage set of flats. Whatever work you create reflects exactly the kind of work with which it was created. In "King Lear" Shakespeare took the self-centered Lear into a hell of conflict, into ruin, into a raging and a shattering of the foundation of himself, and when he was transformed in the storm on the moor he grew into his truer self and died in profound humility.

Great human beings come from great humanness.

Humanness comes from entering into Life. It does not come from divine providence or from destiny or morality or religion. It does not come from goodness or fairness or generosity. It does not come from studying letters or speaking in words or from abstaining from reading letters or from speaking words. Humanness comes from Life. It comes from entering into Life fully from one moment to the next. This is the way to build a human being, the way to release a human being from the stone.

WHO ARE THE HUMAN ARTWORKS?

WHO THEN, ARE THE great artworks of humanness in Life?

Who can decide if not you? You can see with your own eyes. You can see the beauty, you can feel the beauty. A human work of art is the same as any work of art. What is art is beauty, and what has beauty, has Life. It is unmistakable. It shines forth and radiates to all who are capable of seeing.

We do not tell a human work of art by what people say, or by what they do. We do not see the beauty of the painting by the frame, or whether it is oil or acrylic. The beauty does not come through because of its subject or whether or not it feels pleasant.

When we see Sister Wendy Beckett interpret great painting, or Oscar Arias, the Nobel Peace Prize leader from Costa Rica, we experience great beauty in them for no other reason than they are passionate and they are strong, and the fires of strength have honed them into humility. The turbulent waters of their passion have turned them into compassion.

John Keats said "Truth is beauty, beauty truth,
This is all ye know on earth and all ye need to know."

We don't know anything but what's beautiful and what isn't. There isn't anything else to know. We go toward Life or we don't. The great artworks of humanness exude great beauty, and the beauty they express is none other than the beauty that is Life itself.

The Middle

"God is nothing.
No thing.
God is nothingness;
and yet God is something.
God is neither this thing nor that thing
that we can express.
God is being beyond all beings;
God is beingless being."

Meister Eckhart

9

Sitting In Presence With Those Around

Humans are Transformational Art

Humans are transformational art. We are not beautiful in concrete. We are expression expressing. We are not beautiful or not beautiful. We are beautiful when we are beautiful. We are beautiful when the truth, the Life of us, is revealed. Each of us sees many people being beautiful. When they are beautiful they are being fully human. They are laughing, they are playing, they are working; they are crying, they are wailing, they are raging; they are suffering, they are dying; they are helping, they are caring, they are listening, they are sitting in presence with those around them.

What we see is not the form, we see the beauty.

Ugliness is a human creation. It is that which we call ugly not because of its form but because of the degree to which it is removed from us, the degree we feel it is different from us. Nothing in nature is ugly because nothing in the world lacks Life.

Just One Sparrow

Turning to the Earth

After a major fire in Yellowstone National Park there were miles and miles of burned forest. Nothing but black stalks and blackened ground. This devastation that went on and on, made me weep. The trees, the animals, the babies, the mothers, the birds, the flowers, they were all gone. This was tragic, but beauty lies in the truth of all things. Ugliness is only a stage in transformation. The burned forest was a death of Life, but it was not a lack of Life. It was the beauty of great ugliness and total destruction that is the birthing ground for renewal.

There is no beauty apart from the earth. All we are is of the earth. Our beauty is the beauty of the earth. When we let down the lie of who we are not, we turn to the earth. We turn to the earth and we remember who we are. We are children of the earth. We rest upon the earth and she takes us in, she takes us home.

Truth, like beauty, is the revelation of nature, of reality. We speak of truth as if we know truth, as if truth were a set of ultimate edicts. But there is no such thing. What is true is what is beautiful. That's all truth is. Truth is beauty.

Not God but Life

WHAT WE TRY TO do is create truth and make it work. We create reality and say it is so. Like calling blue so. But this is not true. What we need to do is put it the other way around. We need to see what's beautiful first, then we will see truth. This is what Keats was talking about. Poets know these things.

We cannot make truth be true. And we cannot make truth without beauty. When we are told it is true there is a God, we say, I have found God to be a most disagreeable individual, having made his acquaintance quite sometime ago. I have made considerable efforts to locate the interesting part of his personality, but to no avail.

Here is a trap. We cannot see that this traditionally violent and often hateful God has much to do with us. Yet we created him. We just wanted a leg up. We got carried away.

Then when one day we feel the truth, when we see the real truth, we say, there it is. I see. But we don't see God, we see Life. We see that the truth about God and that what we thought was God was not God but Life. And the way we see Life is because something beautiful happens to us.

Beauty Is Truth

Beauty is not a bill of goods. It's not rules, it's not conditions, it's not punishment and reward, it's not heavenly light and streets of gold and union with the divine, and it's not a matter of opinion. It's not exclusive and it comes at no expense. It does not come because we have learned the truth or been shown the truth or discovered the truth or had the truth handed to us through illumination.

We get truth when we experience beauty. Whatever we experience that is beautiful, that is the truth. Whatever is not beautiful is not true. It's as simple as that. How can we experience beauty? How do we know what's beautiful? We know what's beautiful by staying close to the earth. The further we get from the earth the less we can know what is true because the less we can experience what is beautiful.

Sequestered from Life

The reason we don't know what's beautiful is because we are sequestered from Life. The reason we are starved for truth is because we have separated ourselves from the source of it, the earth. We make up an all-knowing God

because we have forgotten who we are. We make up God because we have become vacuous. We make up God so that God can be God in our stead.

Human beings early on knew the earth was the source of all sustenance and of love. It was the un-god. It was Tao. It was Brahman. It was moksha, liberation. We knew the earth was the Mother-Father. We knew the earth was the giver of Life and we knew the earth was sacred, living with a Life that cannot be extinguished. We knew that the earth, the sky and the heavens were all part of the Great Spirit which is Life. And that we were in it. We ourselves were part of it.

The Tarot Fool

As we went along our journey in the western world - here we go, the Tarot Fool down the road – we veered off and walked away. We walked into the bushes and into the trees and off on other paths to see what was down there.

Then we got so far away that we couldn't find our way back. We got involved in the moment and forgot that we had come from anywhere at all. We got confused because it seemed like there was something we had forgotten but we couldn't remember what it was.

It set up a nagging and the nagging turned into a longing and in the night we had dreams and nightmares of things we suspected but didn't understand. Our longing made us angry and we kicked the dirt and tore limbs from the trees and waved them at the sky.

We started to shove each other and say, What about you? Do you know what's going on here? We said, I don't know so you must know. Let's have it.

Then we had an idea. We thought if we built something and called it the fulfillment of our longing, maybe that would work. Beauty was leaking away from us in a steady stream but we couldn't figure out how to stop it.

So we built things on the earth. We built things and gave them names to try and make our longing for where we had come from go away.

Turning To Pride

We built mounds and put hills of stones on top of them to help remind us of what we had lost. But that didn't really do the trick. So we turned to pride and said the buildings were not just buildings but they were the thing themselves. They were the truth and we would call them beautiful. This was the first god.

Our pride liked this idea and even when our building was destroyed we could call out our instrument of hate and say our building really was there anyway whether you could see it or not.

We made more and more buildings and we gave them names like temple and mosque and shrine and cathedral. We built all kinds of structures. We built scrolls and slabs of stone and books. And we said, Here, here is what we lost, in here. Here is the truth.

But there was no beauty anymore. We just went ahead and made truth without it.

We tried to force a square peg in a round hole and we kept working at it, Sisyphus up the hill. Pride was always by our side to help us think we could get away with it.

Greed Joined Us

Greed came to join us. The more pride we had, the more greed had to feed on. We grasped onto everything in sight, we could not build fast enough. We could not get enough materials with which to build the growing monument to our longing.

Greed was good at grasping. It could hold on to whatever we wanted and would hold on even after we died. Oh yes, greed was a good tool.

As we continued on our road of treachery and ruin, we looked around us. Covetousness and avarice and jealousy came to help us along. We looked at the buildings of other humans and in the unhappiness that our longing for beauty made us we said, Maybe those buildings are the ones with the truth in them instead of mine. I will take those buildings and make them mine.

And greed said, Take them all. How do we know if one has the beauty more than another? If we take them all we cannot lose.

In time we became better and better at taking and gathering and building. Our anger at our sense of loss turned to rage. In the day we raged and cut down every obstacle to the prize we wanted, and in the night we lusted for the things we knew were still out there that were not yet ours.

The Land of Cognitive Capacity

We killed and destroyed with ease as our practice became more skilled. We became trickier and more clever with each gain.

We taught ourselves to work with our brains instead of our muscles and in this arena we came into our own.

In the land of cognitive capacity we came to rule to such a degree that we nearly succeeded in convincing ourselves that our longing had at last subsided and that it was we ourselves who were the fulfillment of our longing. God was not God, we were God. We were the God we had been looking for all along. We were the center after all. We were the emperor, clothes or not. We ourselves were the source and the answer to our longing.

So we discarded the old God, the God that had served in our stead before we knew God wasn't anything else but the expression of us. We said that God had been good for awhile. God had gotten us quite a bit. But a god is a god, we said. It's only a god, an invention that we came up with in our early building days. God could be replaced like everything else.

Yet God was a useful sort and could help us push our agenda. Let us keep some sort of god, we said. A god will help us jimmy things around a little. Let us add something since Life itself is rather weak and distracted at times. It is unpredictable. We need something that will pay attention and come running like the family lab. God could do this.

It didn't occur to us that Life could get along perfectly well without an assistant. No Gods need apply. Instead we said let us create something our enemies can't deny. Let us

create God in our image. Thus established, God came forward, was interviewed and tested by the tribal council and found to be the most powerful and most destructive of all the gods, and that was that. God began a long and enjoyable career doing what he wanted.

The New God of Truth

We had a new God now and we called it Truth.

Our whole journey had been meant to find truth anyway. If we make truth God then we won't have to bother with what the hell it is. Of course, there was that beauty thing, but now that we have truth we can make those decisions ourselves about what's beautiful and what isn't. Yes sir, truth is the answer. Truth is cool.

We sat back and thought about how to protect truth, how to make truth more god-like.

Let's hide it, we said. Let's put it away where no one can find it. Let's make it an obstacle course. In fact let's give it other names and in the end, if we get caught we can say we never had it in the first place. We can say we lost it.

But for now, we said, we can lose it so well that no one will ever be able to find it. We can call truth so many things

and obscure it in so many ways that we'll hardly be able to distinguish it ourselves.

But we don't want people to start questioning the value of truth. We need them to keep looking, to think it is the biggest prize of all.

The End of the Journey

Nearing the end of our journey we have succeeded in confusing everyone. We have put up gods and taken them down, we have called truth everything and nothing. Our pride has become ruler and our greed has become respite for the veritable abundance of the land. Our jealousy has become assuaged because we have learned how to take whatever we want. Our avarice sits waiting for something new to covet. Our anger has been redesigned. It has been tamed and domesticated. It serves only our needs now and so hardly ever lashes out. The rage we once knew seems only a vague memory, it is no longer of use to us.

We have made the Truth God now and we can sit back on our laurels. Now that we know what's good our pride has given us the capacity to be kind. We show others the way. We write many books that are filled with suggestions

about how to find the truth as we have done. We provide the basic rules and we illustrate the steps and we even come right out and say truth is God.

Excluding the Truth God

We try and be tolerant, to show people different ways they can come up with the truth. We can present it in such a package that it's absolutely undeniable and believable. We got it, they can get it too, is what we say.

We turn to the early buildings like the stone statues of Mother Earth, and the stories of how all things are. We turn to the writings of the Egyptians and the Persians and the Greeks; the Arabians and the Chinese and the Indians. We make changes then according to what we have learned since then. We turn Sophia into Logos as we refine truth. We turn the Earth Mother into Athena so she will be of service to our war god and handmaiden to our greed. We take away the divinity of all things around us and throw it so far away that it has nothing to do with anything. That way we can manipulate all things to our advantage. We take the Truth God and exclude it so it won't interfere and won't have any say at all.

The Rules of Truth

We turn what were once songs and dances to the heart of our longing, into rules and laws. We make of them commandments and edicts so that people will be able to see clearly that the truth has come and that the truth deals with violators in strong ways. We give people the rules and explain that if they don't follow the rules to truth they will be eliminated. They will be eliminated through their own hand. Because to not follow the Truth God is to be expelled into a disaster of one's own making. Now that we know and use the Truth God, we are expelled into disaster and then into exile if we violate the rules. Truth is inviolable. We've gone to all this trouble to discover it and it has to be protected. We can't have rebels and wisecrackers.

But all along, we never tip our hand. We never let on that truth is so illusive that we made it up. We go to any length to not let it be revealed that sometimes, in the night, or even in the height of day, our longing calls to us. We have gone to all this trouble, built up all our pride and greed and avarice and jealousy and lust and none of it wants to let go now. We have a nearly perfect building. There's only that one difficult spot left. That place that keeps breaking apart. We've dammed it up in so many different ways it's not funny.

The Patched Place

It looks good though, the place of truth. It's fixed up real nice. It looks like the Taj Mahal. It looks like one of the seven wonders of the world. No one would ever guess that it's a breaking up place. No one would ever figure that such a thing could happen. A hole in the truth. A weakness in truth that would not be satisfied. No one could imagine that truth in its very self could break down and long for home. How could truth itself lose its concentration to some calling from somewhere else? It is just not possible. Truth is truth and that is that.

That's what we say. And it would be foolproof except the funny thing is is that we're getting tired. In fact we are so tired we're exhausted. Something about this trip and all it has to offer is falling short on the strength of will and purpose of mind part. It's all in place but the thing weighs a ton and some of us have half a mind to drop it.

A Heavyweight Contraption

We grumble all the time and say, this sucker sure is heavy for truth. We start to say, what in the hell good is it

if it's going to be this godawful heavy? We lag under it. It's a heavyweight contraption.

We feed it but we find it's gotten tired of the same old food. Some of us are starting to wonder if the whole thing was worth it in the first place.

Some of us are starting to wonder how it would be if we just gave up the truth of the truth. How it would be if we just said okay the jig's up, this isn't the truth?

What if we told our pride and all its henchmen to be still and go away? What if we just decided to dismantle everything, to let go of it all and start over. What would it hurt, really, if we admit we don't have the truth? We could let it go. We could let this god go off and do something else, it's a damned nuisance. Some of us want to get free of truth. We think we might have left it somewhere behind.

Some of us Remember

The truth is some of us are starting to sneak away from truth in the middle of the night. Some of us are starting to take forays back into the places where we have come from. We have made a discovery that the further back we go the lighter we get. The further back we get the less truth we have to carry and we like it. Some of us don't even come

back now. Some of us have left the weight of the Truth God and have gone back altogether. We have gone back and we say we hear a call again sometimes. And it's a call we think we remember from long ago.

We Go Back

So we go back and that's where we are. We hear the call and as we go, as we listen, the call is touching. Our minds awaken as we recognize the call. We run and run, our longing is so great. And one day we see trees that awaken a memory in our hearts, and we see bushes and we go through the bushes. And on the other side, there is the earth. We are filled with joy as we behold the earth. We stare and gape and stop breathing. Finally we say, Beauty. This is beauty.

The beauty of the earth is beyond comprehension, we are so stunned and filled with awe. We realize our longing has gone away. We begin to rest and to lie down on the earth. We release ourselves to the earth and lay our faces upon her breast. The tiredness we had felt, the exhaustion of our burden of truth begins to disappear. In time, we do not even realize when, all our weight, all our burden, all our tiredness has gone away into the earth. Finally truth is

gone without a trace, and we barely remember what it was or how we became so intent on its pursuit.

But it does not matter. We have found beauty, and here we are one with ourselves again, here with this beauty that is called earth.

10

Look To The Earth

Truth Knows Nothing of Beauty

It is not truth that creates beauty, it is beauty that is true. Truth knows nothing of beauty. It is in beauty wherein lies truth. There is no truth apart from beauty. We cannot create truth without beauty. There is no truth without beauty. Whatever is beautiful, is true. There is no other.

How do we know what's beautiful? We look to the earth. We look to the earth, the sky, and the sea. We look at all things of the earth, of which we are one. We are of the earth and cannot be but of the earth. There is no truth apart from the beauty of the earth.

Everything of the earth is our family. Every animal our sister and brother, every tree our shelter, every river our living water, every mountain our guide, and every blade of grass our humble gratitude.

The Life of the earth is the beauty, and when it is gone, as all things that are will be gone, we as human expressions will be no more.

We Are Not Human

But Life is not dependent on earth, Life is the power of love. Love does not depend on anything. Love depends on nothing, and nothing is nothing.

The truth of beauty shows us that we are not human anyway. And the earth is not the earth anyway. We are art becoming art, the earth is art becoming art. The beauty of the earth is not itself, it is love. This is what is true. The truth of beauty is love.

Humans are transformational expressions. We create toward the art and toward the artist at the same time. Our form is heart and our structure is mind. In our exploration we have separated one from the other. We have created two for the adventure. One we call yin and the other yang. This is a risky business. But danger is our business. Contrast and conflict are our instruments and the dance we are creating is Life.

Duality is a description of Life's action, the manner in which it expresses, but in truth there is no duality. There is not something and nothing. There is not night or day or male or female or breathing in and breathing out. But in our outpicturing duality is Life's structure. The motion of Life counts on balance, the rise in the crest finding balance

at the point of contact, the top of the wave, and releasing balance as the wave laps upon the sand.

We are out of balance. Our sculpture is too much technique and not enough art, we say. Where is our substance? What happened to what motivated us in the first place? Where is that heart that we started out with? We've lost our form and now we don't have what called us into being to start with. We don't have beauty now, only a bunch of scaffolding.

Deconstructing

We see now where we've gone wrong. Damn it if this doesn't happen every time. Momentum likes to take over, it likes to fly. It loses its head and runs without knowing where it's going. We've got the structure down pretty good we think. We can do that part. But we've made a mistake and called it form. So we have to go back and find the form. We have to deconstruct until we see where the form has left off.

It feels easier to build the structure than to keep the form. In male and female we have structure and form. They must exist in balance. If male holds the female to the mat for too long, then female, out of safety and depression,

retreats to a lower position. In time she forgets who she was to start with. The male thinks he finds this weaker place of the female favorable, for he likes this vulnerable position of the female. He likes that he can do what he wants without interference.

This is heavy structure out of balance with form. If form becomes dominant then it loses its meaning because it lacks the structure of conveyance that gives form all it can be. In Life, structure and form are balanced perfectly. In our species, structure has dominated from the start. Thus we have violence and war on a continuing basis. Structure falls out of control without enough form to give it wholeness and heart.

We push our luck regularly, trying to see if we can substitute male for female, structure for form. The old square block in a round hole effort, trying to see if we can make science art. But it's no good. We know that science is not art, but that art is science. Science makes art possible, but it is the art form that limits structure's necessity.

The Formless Nothing

STRUCTURE FOLLOWS FORM. IF we add structure to make up for form, we can be assured that our form will collapse. This is a sure thing that we can count on. Form leads. Form

is the image-maker. Form is a thing's nature. It is expressed by discovering its boundaries. Boundaries give formlessness form. All creation is made up of form which has been made possible by its structure. Without form there would be the formless nothingness, which in fact, is what there is. Form is only form. It is not solid and not permanent. It is the way of Life. When the form is expressed it is already done.

Form gives way like a house upon the sand, ad infinitum. This is all we are. What we want to awaken to is the depth of Life, the true self beyond form.

Our Structure is Falling

WE TRY AGAIN TO juggle structure and form. We keep sitting with our clay, forming and reforming, looking for the balance that will give our work the voice that it wants, the beauty that it is. It is not a casual process. It is an earth-moving and monumental struggling process. It is like a baby wrenching itself from the earth which is its egg.

But without balance of form our structure is falling. It's caving in on itself. And as it caves in, the resulting manifestation is without structure or form either one. Our species is devolving because our male and female are out of balance and of limited intelligence. Over-programmed to

procreate we sacrifice all. We have the urge to fulfill our calling for offspring and we do so for the most part without awareness, without knowledge, without concern for others, without any compunction at all.

Our mother the earth cannot withstand a species over-procreating. She will destroy it in order to restore balance. Overpopulation requires culling. But we have overtaxed her and perhaps we will achieve total domination. This is the danger of structure, of how we attempt to overuse structure so that it dominates form until form cannot exist anymore. When we achieve total structure no living thing will exist, all having submitted to dominance and limited intelligence. Existence is these two apparent opposites, this duality in which we live. When yang dominates, existence is out of form. When yin allows over-domination it immediately begins to die. This is what our picture looks like now. It is the consequence of a mistake in nature, a genetic oversight on the part of evolution causing our devolution and our demise.

Soon the earth will be gone. We will have destroyed it by forgetting it was our foundation. While our yang got head-strong and thought it could fly away by itself, our yin continued to drowse, and spaced out that its wings had slowly been bound. Even so, this is the illusion. All of reality is illusion, maya, and yin and yang are safely what they are, the backdrop of our lives.

Listening to Feelings

But we are lucky because we have feelings. We have feelings to guide us whenever we are ready to listen. So we sit down with them. We either sit down with them before the disaster or after, before the collapse or after it has all fallen in a heap. It doesn't matter. If we save it, we save it, if we don't, Life will start over or it won't start over. But we are artists and we'd like to make progress. We'd like to save it because we've put a lot into it. But the situation is serious. So what we start to do is listen to our feelings, those feelings in the center of our heart.

Those feelings tell us to change our mind. They tell us to cut back on our pride, to stop fear-based aggression. They tell us to to quit grasping, to let go, to realize that the dance of Life is the dance of yin and yang, of Tao. As the Tarot Fool, we must let go of the cliff, the structure, in order to fall freely into new form. If we do not, then structure's grip tightens and form cannot come into being, and thus Life strangles to death.

A Bottomless Well of Goods

Our feelings tell us greed has got to go, it's outserved its purpose. They tell us to stop covetousness because there's a

well that hasn't even been tapped yet. In fact it's a bottomless well of goods, of materials. And that's what we want. We want material. Our feelings tell us that we forgot that our original material had come from the bottomless well, that where that came from there's more. There's an endless amount of material.

Our feelings tell us that we don't need hate anymore, that hate's use is even shorter than greed. Our feelings call us to give now instead of take, that we have to let go of the structure so we can receive the form. Form is receptive. That is its function. Structure is assertive. That is its function. In this way, form is nothingness and structure is somethingness, just as the moon is nothingness and the sun somethingness. This is the way of art and of Life.

The form won't come from taking it. We cannot build form. Form comes from itself and we receive it, we receive our art.

We can't get it any other way. As we listen to the feelings of our heart we experience an inflooding of love. It is the power that is beyond form and structure altogether. It is the power of love that calls us to come into being in the first place.

LOVE IS THE ART IN THE ART

THE REASON WE WANT to love is because love is the power that brings our expression fully into being. We don't love for

any other reason. There is no reason to love except that we cannot bring expression into being without it. There is no expression outside of love. Love is the art in the art. There is nothing else in art, and there is nothing else outside art.

We love, in the end, and we create our humanness in love because without it we've got a bad picture. We've got a lousy picture. And we don't want a lousy picture, we want a good picture. We want a real picture. We want a real picture because we are the love that fuels us. We cannot live without a real picture. So we love. This is why we love.

Mozart's picture is perfect symphony, our picture is perfect love. Love is the picture. When we are loving we say, There it is. That's it, that's what I want. We know it's what we want because what it is is beautiful. Its beauty is true. The truth is how we know we have found the thing we were looking for. It is how we know the form has emerged. Because we recognize it. We recognize it by its beauty. And the beauty of it is love.

Spirit is Life's Material

If you really look at every single thing you will see that it is beautiful. Nothing that is does not have beauty. Every bit of everything has beauty. Every part of every quark,

every part of every planet. Every part of all things pretty, all things ugly, all things permanent, all things transient, all things done and undone, alive or dead. All things with no exceptions have beauty, because all things are of Life and are Life.

Nothingness is Life, somethingness is Life, love is the cohesion of Life. Nothing that is is not material for the work of the artist. There is nothing spiritual. All that is invisible is visible, all that is not known is known, all that is absent is present, all that is void is form.

What is spiritual is the material for Life. Spirit is Life's material. Spiritual, the unknown that is known, the invisible that is visible, the presence without presence, this is material. Spiritual is not without material, it is the material with which somethingness is created from nothingness.

EVERYTHING THAT IS IS SPIRIT

EVERYTHING THAT IS IS spirit. There is no material that is not spiritual. Spiritual is what somethingness is, and all things that are are somethingness and only somethingness. All that is is expression, spirit.

What is expression? It is the wave. It is the wave in its journey to the crest. It is the crest in its catapultion. Every

expression is a release of the trap door. We design our way to freedom.

Humans are transformational expression. We are beings conscious of self. As transformational, we are capable of challenging expression. This challenge, this stone wall, is depression, and the gift of depression, as we step from the trap, is freedom.

Depression is Motion at a Standstill

Depression occurs in all degrees, from day to day depression to a drastic brain chemistry illness that causes severe, immovable depression that results in catatonia. This extreme is a variation. Extreme depression is intensified normal depression, just as psychosis is intensified neurotransmitter imbalance and not merely everyday confusion. In this way we all have the shared experience of depression, and of confusion.

Because of shared experience we come to an understanding of depression. Yet we have imposed limits on our tolerance. We have rules. One of them is that depression is not allowed except briefly. If it goes on and becomes more severe it becomes suspect. Our response is to label it as unacceptable, lacking in character, integrity, and

respect for Life. Brief depression is overlooked and long term depression is condemned as weak. This is so, even though severe depression is a dangerous and disabling illness. It is the unyielding dominance of structure, the ego, that keeps this picture unpainted. It keeps this picture cold and Life-free.

Doctor Rachel Remen, the well-known oncologist and author says,

"We are a culture that values mastery and control, that cultivates self-sufficiency, competence, independence. But in the shadow of these values lies a profound rejection of our human wholeness. We have developed a contempt for anything in ourselves and in others that has needs, and is capable of suffering."

When we reject one of our artists tools such as cancer or depression or suffering of any kind it is a reflection of our puritan and military values of strength, quick recovery, intolerance of illness, discipline, and self determination, rather than investigation, nurturance, and compassion. Suffering is easy to dismiss, to judge and to reject. Why do we behave in such a way? Because we want to be acceptable in a world filled with the unacceptability of illness. We must have acceptable illnesses. We want to reject depression and all serious illness and

disability as beneath us, certainly beneath the ego's desire. In this way we lose the value of depression, the point of it. Depression is darkness. The point of depression is to stop us completely. It is a broken brain that hits us like a car wreck, as if our brain were shaken and smashed like a piggy bank.

WE DO NOT TRUST THE UNKNOWN

WE CREATE ILLNESS IN one another, there is no one else to do it. We kill each other with illness. It is a reminder that we have left the attention to our Life undone. We deny ourselves and each other and create illness and death instead.

We want to gain control of others so we won't be threatened. We do so by creating disease and discomfort. We could provide food and water and shelter and education for every child in the world if we wanted to. But in our consciousness of lack we feel we cannot spare it. No food and water. In consciousness of lack there is not enough to go around and never will be. People suffer and die unnecessarily every minute of Life. This is the sculpture we have created thus far in our art.

We Want to Control Life

Yet illness has purpose. Illness is simply one of our tools. What serious illness is for is obliteration, the annihilation of self. For this reason, because self is our means of identity, we cannot stand a change that presents us as something different than we perceive. The self is too valuable, we feel, too important to be changed involuntarily and in extreme ways. We want to control Life which is our Life. Serious illness implies a deep lack of control. This lack of control is structure's fear. Without it we feel we will perish, we will fall into a hell of no individuation where we do not exist.

Yet the tool of illness and depression is transformation. We must not exist before we re-exist. Depression is meant to break one down altogether with nothing in reserve, with all of self-disintegrated. We are some thing giving way to no thing. This transformation cannot occur until all our tools are laid down. We do not like this in our over-structured state. We want to keep a handhold on the cliff. We do not trust the unknown, the creative form beckoning. But until we let go absolutely we will remain in the trap. We will not fall into the goodness of Life that is ours.

Depression is the way of structure attempting to maintain itself without interference. But it doesn't work. It is us stripped of brain capacity and those around us stripped of heart. Severe depression is meant to take everything, all trace of us. It is meant to take us back. In depression we are altered as nothing else can alter us. All has been removed, all taken down, the sense of self, the solid earth, the light in the air and the love drained empty like wine from a gourd.

Depression is Motion at a Standstill

Depression is the wave, the rest, having run into a dam. It is a direct hit on Life. It is the ultimate trap. Not pain, suffering, abandonment, exile, or death equal the trap of depression. No active trap equals the passive trap. No seen trap can equal the unseen. This is depression. It is the very last stop, the very best trap of all traps. It is motion at a standstill.

At one time as I reached this extreme stage of illness, my mind was emptied like an hourglass. My head and shoulders felt layered with chainmail. No move I could make freed me from its weight. I had not a single inch, a single spot that was not heavy with unshakeable weight on my body and my self. My arms hung Lifelessly at my

sides, drained of all strength. My hands lay in my lap, inert and formless. I could not walk from one side of the room to the other in the end. I could not speak or read or write. I did not know who I was or who anybody was. The weakness crippled me, I could not move. This was the weight of depression, the sadness, and despair and loneliness, the physical buckling and wrenching. Weeks, months went by but I knew nothing of time.

I was filled with indescribable anxiety. It was the deepest feeling of dread and horror, of guilt that ripped at my heart and sucked up my breath. It was relentless, the guilt. It could never for a single moment let me alone. It worked madly to gather up whatever it could get of me to throw down and obliterate. I could not think a single thought of Life or light or hope or any thought at all that was safe or comforting or not pushing anti-Life into me and through me.

Ravenous Guilt

In my feelings, guilt and hopelessness were ravenous. They ate away even at the emptiness, even the nothingness they wanted. This was the void thinking it could have nothingness.

I could not sleep at night or in the day, the depression wanted so much to take me away. It wanted so much to rid me of every trace of myself. I could not eat. Food was ugly and foreign, so much did depression want to be rid of me. Then depression took my voice. There is no corner that depression will not take. Depression had its way fully, and there was no me of me left. I was awake in an empty shell.

This is a world where you are left awake, conscious, fully feeling, yet you yourself are lost. Everything around me was what I was not. Everything appeared to have substance and meaning, yet as self the meaning could not be translated.

What I did not have was integrity of heart. Guilt had succeeded in taking every notion of value that I had ever had, away. This is the awesomely affective tool of guilt.

Months later as my brain restored itself, a teacher came to teach me how to learn the letters of the alphabet again, and to read again, and to fulfill the simple requirements of each day.

GUILT, AN INCREDIBLE INVENTION

THIS IS WHAT GUILT does. It is a most incredible invention. It is a creation that annihilates form. It annihilates the heart. It convinces the heart that it does not exist.

Altered reality is a condition of fragmentation, and depression is a condition of rejection. Guilt and hopelessness go directly to the heart and convince the heart that it is not heart, that it is not only a contrivance and a hoax, but that its falsity is the opposition, the enemy of Life. This is the handmaiden of control in its attempt at self-elevation.

No Hope in Death

Depression is not threatened by anything, with not any part of Life is it concerned. And when you want to die, there is no hope in death either. There is no looking forward, there is only oblivion. Suicide in depression is not about running away, for there is nothing to run away from. It is releasing into the call of rest, for Life is fragile and deep illness exhausts the spirit and body. Catatonic depression is somewhat rare, but extreme depression to any degree is too hard for most people and in the end they die from it. The brain is too damaged. Suicide is a logical relief. It is death caused by severe illness like any other illness.

Depression is not like a plague, like altered reality, where there are fragments to create fear from which one wants to get away. In depression, there is no such fear to

run from. There is nothing left to run from. Depression is the void's expression of itself. Profound brain chemistry illness causing altered reality is somethingness in tatters. What remains untouched in all this? Nothingness. Nothingness remains untouched because nothingness is nothing. This is its value. It never will and never could be anything but nothing.

There is no Option in Depression

In this depression, death becomes not even an option. There is no way out. That is its point. There is no way anywhere, not out, not in, not anything at all. This is void and this is the point of void. The point of void is not only non-existence, it is non-existence with no hope of existence.

It is not oblivion. You don't get to do oblivion in this best of all possible traps. It is you absolutely feeling, in a trap of feelings trashed.

Death through suicide is not so much a victory of void, as it is a final relinquishing of the last bit of Life that you are holding out. You are hanging onto the cliff and depression tears your hands away. You fall but you do not fall into Life, you fall into the apparent void of death.

Death Is Depression's Only Adversary

Depression wants all of your Life. It has no limits, that's the beauty of it. When I kill myself in depression, it is only a response. It is just a little step in the end, all processing and all hope having long ago come to an end. It is not a giving in, because there is nothing left to give in. It is an acknowledging. You are acknowledging that every bit of you, every bit of Life has been taken from you, and it is time to die.

Death in suicide is the mercy of Life which is hidden in depression. This is so because not even depression is outside of Life. As good as depression is, it cannot take death. It cannot have death and you too. Death is depression's only adversary.

When there is no more Life, death comes. It's over. This is the good of death. This is what it does.

As much as I wanted Life, even in the severity of illness, depression equaled me in its desire to take it from me. My brain was compromised. Would I be able to hold onto Life or would depression find a way to wrench it from me in the end? Would depression win this dark game? How capable could this experience be of carving me from the stone of Life? Would it be a Bach B Minor Mass? Would it be a Rembrandt? Or a Titian? How great would the art of this depression be? What would it add to my canvas, to my dance?

Depression is as Powerful as Life

This depression that manifests through wrecking havoc in one's brain chemistry, and coming out the magnificent Life-devouring thief that it is, is the nemesis of Life. It is Life's built-in way of rendering itself absolutely unable to express.

Why? Why this seemingly self-defeating arrangement? Because depression in non-expression is a response, it is the indicator of the degree to which Life must express. There is nothing casual about Life. Life is not casual about expressing. Life does not know indifference. Life does not allow what does not care.

This degree of depression that is a monstrous gaping vacuum of Life, is as powerful as Life itself. It is as powerful because it is the power of Life calling to itself. It is the power of Life calling itself to come into being.

Life must express. Life is the love of somethingness, and it cannot be not something. In depression Life has created the ultimate trap, the trap of no-Life, and not just the trap of no-Life, but the trap of no-Life in Life. Depression is living no-Life.

Life Cannot Be Not Life

Life cannot be not Life, so if it cannot express, it creates a living form of itself that is no-Life. No-Life

describes most people of the world, the starving and abused or killed people. It describes most animals, and now most forests and oceans and most of everything. This is the no-Life that we have created. And yet it is all part of our picture.

As human art, we are individual expressions of the art of Life. And each individual has the capacity to create individually. We create individually and we create together and we are being created, all at the same time. All things get to be both the artist and the art.

Every human is absolutely individual art expressing and is absolutely part of the big picture expressing as well. Every human, every animal, every tree, every flower, every ant is an absolute individual expressing individually, and is at the same time part of the expression of all of Life.

Think of your dog or your cat or your bird or your horse or your fish, or any animal that has gifted your Life. Think of each one of your cows, each one of your sheep, each chicken, each pig. Every single animal, like every human animal, has a Life to live. Every animal has an individuality that has its own expression, its own style, its own quirks, its own ways; its own preferences and choices, its likes and dislikes.

Maude

My little dog Maude has been with me for thirteen years. I got her when she was five weeks old, too little to be taken from her mother, but I got her and became her mother. And as she grew she came into herself. She loved to play with the little stuffed animals I bought her, and we played with them all the time, every day. And today, each time someone comes to our door, Maudie gets one of her animals and takes it to them as an offering. It is an offering to the honor of you, to the respect of you coming into our home. It is an offering that comes from pure love. She knows each toy and will choose one of them to give you as a greeting, as a warm welcome to our home every time you arrive at our door.

Maude Is My Teacher

Maude is a gentle, quiet, conscious, humble, loving little person. When people ask me who I admire and who inspires me and who teaches me I say Maude. Maude is my teacher. She teaches me and reminds me every day of all I need to know about how to live

Life. She teaches me to be loving, to be patient, to be humble, to be pure, to be light, to laugh, to stay in the moment and to not worry.

She teaches me to be alert when it is time to be alert, and to rest when it is time to rest. She teaches me to give without holding back, and that it is all right just to be myself. And perhaps above all, she teaches me that no matter what, everything is all right and that everything is going to be all right. She teaches me peace.

There is nothing else in the world to know. This is the teaching of every animal. Every animal is a direct expression of the heart of Life. If you want to know the great truths of Life, look around you to everything great and small. All living things are the truth and is the truth of Life.

We Turn to the Love

When I am tired, when I am weeping, when I am in darkness and confusion, when I am forlorn and forgotten, when I am collapsed in grief and I am lost; when my heart is broken in despair, I turn and I see that Maude is there. She leans gently against me, nudges me gently, abides with me in love.

In the depth of his anguish, King David turns from his grief and says,

"I will lift mine eyes unto the hills, from whence cometh my help. My help cometh from the Lord, which made heaven and earth. He will not suffer thy foot to be moved: he that keepeth thee will not slumber. Behold, he that keepeth Israel shall neither slumber nor sleep. The Lord is thy keeper: the Lord is thy shade upon thy right hand. The sun shall not smite thee by day, nor the moon by night. The Lord shall preserve thee from evil: he shall preserve thy soul. The Lord shall preserve thy going out and thy coming in from this time forth, and even for evermore."

Who do we turn to when we are in need? We turn to love. I turn to Maude as Maude turns to me, David turned to the Lord as the Lord turned to him.

WE CAN TURN TO LOVE

How do we get free from the most awesome of traps, the trap of creating illness and tragedy in others and ourselves? We get free because there is love in Life. It is present for us, it is part of us and we can turn to it. Love is the key, the heart of Life that cannot but give of itself ad infinitum into all eternity.

We get free by letting go absolutely to the moment of love. Every moment is a moment of love, and if we release it to itself without holding back, love comes and floats us home, downstream, floating so gently we are not aware, like the nearly imperceptible softness of the warm trade winds. We get free of every trap of every kind by letting go to the moment of love. No trap can hold the power of love. This is the way to freedom, the astounding beauty of the truth that there is not and could never be a trap that can hold love.

No matter the degree of illness in your Life, or the skill of your trap, nothing can resist love. Love frees all from the straight jacket of suffering to the free-breathing of expression. Love frees Life to Life.

11

The Mistake of One is the Mistake of All

Sparrows at the Feeder

When I look out my window and see the sparrows in the bush and at the feeder, I see that each one is a perfect expression of itself, a perfect expression of Life. Every move of their head, their feet, every flutter of their wings is a miracle. The softness of their breast, the shades of brown and gold of their wings, the beauty of this is beyond belief.

When I see them share at the feeder, I see that each one is given time to feed before he is nudged away by another. Each one takes time, takes a turn. And in the bush each one has a place to be, a branch upon which to perch. And when they fly away, even as they fly together they give each other space to fly. However much space each one needs to fly, that much space he has. In this way, together, each is fully realized into the beauty of their being.

CREATE FROM THE GROUND UP

As transformational beings, humans depart from the wholeness of the sparrows. Humans depart from their own picture. This is what we are meant to do. We are meant to create from the ground up. Illnesses are places we create through our departure. Through our departure, through our searching for the right tools and learning about what it is we want to create, we make many mistakes, we ruin lots of material. We create fragments and we throw away things we wish we had kept. We make huge mistakes that break us. They shatter us and beat us. They pulverize us.

Illness and suffering are the outpicturing of our mistakes. And because we are creating one at a time together our bigger picture, the mistake of one is the mistake of all. We all have the same materials in different degrees, in different shades and textures. But it's the same material, this material of Life. Our mistakes add together to make bigger mistakes. My pride adds to your pride. Your despair adds to my despair. My anger becomes your anger, your greed becomes my greed. The outpicturing of these mistakes create the art of suffering.

The Mistake of One is the Mistake of All

CREATING THE ART OF SUFFERING

SUFFERING IS THE ART of our mistakes.

Suffering is that which is not right in the picture. Suffering manifests all over the picture and points out our mistakes. We see suffering in different places of our picture. That's the beauty of suffering. It shows us where we have gone wrong. We can look and see. We see where our rejection of others has caused Life-threatening illness. We see where avarice and self-seeking has caused us to lie and to deceive and the suffering of this was cancer. In another place our pride caused us to be eaten away by rage and here the suffering was heart disease and lung disease.

We create suffering in one another, in our larger picture in the world, because one wrong turn overflows its boundaries. If we are a very bad artist or an equally very good artist, we make giant messes. Colossal messes. We create disasters that we can find no way to fix. We start to look like Beethoven, scowling and irritable and we tiptoe around because he's liable to tear what he's made of his Ninth symphony to pieces.

We've got our world in a mighty jumble and it's perilous.

Just One Sparrow

USING OUR TOOLS

How far will we go to make our tools do the job when we are only using part of them? When will we see that for every wrong instrument we use, there is a right one?

Perhaps we could watch Beethoven sitting at his table. He is shivering from the cold, the small fire in his grate having gone out days, maybe weeks ago. His hands are wrapped in rags so they won't freeze as he marks deeply on the sheaves of paper in front of him. He holds his quill up close to the point, drawing carefully. Hastily he dips his pen into an inkwell of heavy black glass and returns to his score.

His breathing is ragged and his chest tightens as he scratches out a series of notes and replaces them with others. His candle flickers and he holds closer to the page in the dim light. Suddenly his hand drops the quill. He grabs the paper and wads it into a ball and shoves it off the table. He begins again immediately on the next page, listening carefully for the notes in his mind, calling to his heart to give him the skill and the endurance to put them down. He records them quickly, frantically making room for new notes as they emerge from his birth canal mind.

The Notes Must Be Heard

Will he complete his score, or will he destroy it?

He will complete it. He will complete it because the heart of his notes to be heard is greater than any other power in the world. His notes must be heard no matter how many other notes and pages he crosses out or whether he destroys the entire pile before him. The notes will be heard and it is him that they want. They cannot and do not settle for anyone else in the entire universe for the expression of their Life but him.

There is a Right Note

Our score is our world, the earth. Will we destroy it, or will we turn to other notes? Will we turn to stronger notes, deeper notes that are pushing forward, struggling to be heard?

We do not know the answer to this question.

We do not know the answer, but in our deepest hearts we know that other notes are there. We know that right notes will come to replace wrong notes if we allow them to

come forward, if we stay still a moment, if we listen, if we stop running and hiding. We know this.

Because for every wrong note there is a right note. For every wrong bit of light there is a right bit of dark, for every move left there is a move right. We are the artist, and the art of us tells us this is so. We have the power to choose. We can choose letting go, accepting, honesty, generosity, patience, kindness, tolerance. And these instruments have a powerful voice. They are not loud and clambering, they are deep and strong like a river. They are gentle and sustaining. When we listen and we try them on for size we discover a new kind of strength. It is a strength of freedom, a strength of courage and an inflowing tide of self-regard.

Over-Built Scaffolding

We can choose our freedom, but we cannot make freedom. We are free in love the same way Beethoven is free in musical notes. But at this moment in our art, we are out of balance. We have allowed ourselves to be taken over by structure, by what we called in the twentieth century, ego. And as I have illustrated, it is the job of the ego, of structure, to go to whatever extremes it can to manifest form in

the world. But it is our job, the job of love, to bring structure into the service of form.

We over-build the scaffolding because if it does not hold up then nothing will hold up. Then we take down the excess to fit the idea of what we had in mind. This is where we are in our art of the world at this point in history. It is time to trim the scaffolding, to bring it down, because what we have built is built, it will hold up on its own. We stand before it somewhat obtuse. We are reluctant, even defiant about bringing it down, but we know it is time.

THE ORANGE SEED

FORM DOES NOT EXIST in truth. Form comes and as soon as it arrives it is gone. Form comes, structure greets form and form becomes structure. All that we see is structure, we see somethingness. Form, nothingness, does not exist in language. It can be located with poetry. As form recedes into nothingness, poetry reaches in with a hand and grabs it. I got you, we could say. Found by poetry. But even poetry cannot find form. Poetry ad infinitum, yet poetry sidles up to form. Even poetry cannot get to nothingness or the formlessness of Life that is hunkering down there. This is the orange seed. Form is at the core

of the seed. The core of the seed is endless miles deep and it eludes us forever. Yet we have access to it as we desire. Life is about looking. If we are committed to looking for the heart of the core we can find it. This object of the core is awakening.

Awakening is form realized.

Form holds our artists materials.

The dance around the core is Life.

Attachment to Frame

We have built a frame for our art that has disabused its form. We didn't notice that our art has become merely a backdrop, our form having disappeared over time, and we don't know what to do about it now. We'd like to fix it we suppose but we have grown attached to this frame we have built. We have come to think of it as permanent. We have almost come to think that the frame is the art. Our picture really does have Life, we say. Isn't this Life here, we point. No. but I'm sure there's some over here. Well, maybe not, as we continue to search.

We've got good tools in our musical score, pride, selfishness and greed. I guess there's no love, we say. Perhaps that is what's missing.

The Mistake of One is the Mistake of All

THE GOOD PILE

WE KNOW THAT WHEN we demand the appearance of permanence, and put our foot down on the object of desire, this frame that is nothing but frame, we call this control. Then we refine our control by separating the victim of our control into how it can behave to suit our purposes. This we call approval and disapproval, yea and nay, attempted to disguise the reality that approval and disapproval were the same.

We have effective instruments at our disposal to reinforce our foothold. Guilt and shame, laws, approval and disapproval, judgment and consequences, all which fit into one pile or the other, the good pile or the bad. What suits our purpose of attempting to control this frame which is really only a point in time, we call good, and what threatens it we call bad. We call one right and one wrong and use guilt and shame and intimidation and consequences to give it mortar, to cement it.

APPROVAL AND DISAPPROVAL

APPROVAL RENDERS POWER. THE Hebrews have Abraham and Moses, the Christians have Jesus and St. Paul, the

Muslims have Mohammed, all secure in approval. We make many things right and wrong. We make Islam right and Christianity wrong. We make men right and women wrong, the head right, the heart wrong, left right and right wrong. And we hold them into place with the approval foot or the disapproval foot.

We find approval and disapproval to be effective because of the power of guilt and shame. Guilt and shame are good instruments, great instruments. But there is a problem. There is the square peg in a round hole problem. Our premise starts to break down. Because the truth is that we make it all up. We have fabricated control and approval and disapproval and put them into what we call moral systems that we think will disguise our notions about what we think we can achieve.

In our hearts we know better. No matter how many people and animals we beat, coerce, dominate, starve, isolate, create suffering in and kill, it won't work. We cannot make one behavior or one type or one style or one anything better than anything else no matter how we dress it up. The presence doesn't know about our approval or disapproval. Presence, the truth of us, is beyond all our conceptions of being and non-being. To approve or disapprove of another being is to live in the illusion of self-righteousness. This myopic position which enjoys complete ego attention will

bring all under control with the threat of dominion, suffering and obliteration.

Self-seeking through self-righteousness is a powerful tool. It is a stuck place. It comes from a place of blindness to the awakening that is before us. It is a futile attempt to mold Life into what we want it to be instead of noticing that it is the mold which wishes to make us, indeed to set us free.

We cannot put one over on the heart of Life. Revenge and punishment create anti-Life. This is what they are meant to do, to show us the way from Life and the way to Life.

Value all the Notes

Bach didn't choose one note over another because he called the note in question bad, and layered guilt upon it with disapproval. If he had done this he would have thrown them all out eventually. All his notes would have turned out bad sooner or later. Eventually they'd show up somewhere he didn't want them and he'd have to disapprove of them and there they'd go, squashed under his foot. But Bach didn't disapprove of any note. What he did was see and use the value of all notes. He wanted all the notes he

could get, and he was given all the notes he wanted, and he had all the notes he needed.

An actor working on stage uses different behavior according to what her character requires. Morality, approval and disapproval cannot exist in the art of the stage or in any art at all. An actor must have every behavior and every emotion at her disposal, just as Bach must have every note.

There is no morality in art. There is no morality in nature, there is only the love which is Life. No need to worry, Life knows what it's doing. Life is the intelligence of being.

Denial is a Way of Life

Approval is not the business of the actor on stage, or the musician or the dancer or of any artist at all. Approval is a natural feeling within oneself. It receives a nod by the artist when the sculpture or the character is right. Only we know when the work is right for we are the only one who knows. Approval, criticism is an irrelevance to all but oneself. It is connected to denial and these work hand in hand, approval-disapproval and denial. If we deny the content of our picture and approve of it for self-seeking and fearful reasons, for reasons that make us deny our picture, then that is where we are stuck, at this level of denial, and of

Lifeless relationships, Lifeless work, and Lifeless and false existence.

It is through our tool of denial that we approve or disapprove of something we have not investigated and know nothing about. We cut reality short by making a unilateral decision that our picture is fine with no form. We proclaim that something is right or wrong, good or bad.

Denial is so common that it is a way of Life. In most of our lives denial accompanies us until death. It is a tool of fear, of turning away from reality. It is designed to bar the door and keep us safe from a too difficult world. It shuts us down in mind and body. Our sight, our sound, our touch is no longer sensitive because denial has taken us away. We no longer think and no longer feel because denial is afraid feeling would tip off the truth of our picture. It is not surprising then that we treat one another on a daily basis without regard for directness or honesty.

Nothing Better on Earth

What we are committed to is bringing out the Life of the picture and are not concerned with any evaluation at all but our own. Our ear is to the picture, to the score, and not anywhere outside it. Understanding all things as equal is

the artist's business. Remaining open and receptive, emptying at the same time one fills, this is the business of the artist. It is the business of us all as we create the art of our lives.

What is ungod, what is Tao, what is Brahman, what is the Great Mother judges nothing and excludes nothing, but embraces all and includes everything. The Tao of our art of Life is coming into the awareness that nothing is dispensable and nothing can be judged. Not because of moral consequence, not because of the illusion of a hierarchy of good and bad, but because there is nothing better than anything else on earth than awakening to the nature of one's being.

Imposition of Morality on Art

The imposition of morality onto art is a formidable trap indeed, and it is so for a reason. It is the tendency, the urge, for nature to retain form. The difference between the human way and the earth way is a difference in materials. The art of humanness is to push away, to create. Creation happens with motion and motion pushes away from itself.

The earth pushes away in all things great and small, from the tiniest ripple in the stream to the deepest shifting

quake of itself. It pushes away winter for spring and spring for the fullness of summer.

It is the rhythm of Life to push away and to draw near. It is the motion, the rise, the climax and the release. This is the dance of Life. But the dance of Life is not infused with selfish motive. The dance of Life is not to diminish but to fulfill, to reach its peak. Life does not and cannot approve or disapprove any part of itself. Every part is part, every part is crucial.

This is the lesson of human expression, that nothing can be rejected without compromising the value of the whole. To accept all of Life's instruments, all the possibilities, all the differences, all the contrasts, all the colors, this is Life's gift of itself. And the joy of Life is its infinite abundance of creative materials that go on without end, forever unto forever.

We are Not Dropped by Life

What if Life knew what it was doing? What if it knew and we didn't have to add anything to it? What if we are a part of Life that can never be separated, never cast into the void, never interfered with by God? What if we had no reason to fear anything. What if death were not the end of Life?

We are the beloved expression of Life that cannot by nature or by the love of Life be unloved or cast away. We come to realize we are never dropped by Life. We awaken to this miraculous awareness that we ourselves are Life. We cannot be separated from Life. And go where? We don't go anywhere at death, we change form. Death is not the end of Life.

We are so much more than we know. We are the light, the air, the water, the sun. And we are beyond all physical form with not a trace left in the phenomenological world. We reside for all time and no time in the love of Life, in somethingness and in nothingness.

No One but us Chooses

THE LOVE OF LIFE is all we ever need. It is not a hateful place where we are thrown aside at the end. No. Life is the artist and we the art. We are singing our way to our art, creating our score as we go along. Many deaths accompany us as we go along in the delusion of time, many changes of form. This is not reincarnation. No one but us chooses who we are and which way to go. There is no one else to do it, no one who knows which way we will turn in our art.

We are nothingness as all is nothingness. In this state we are expressed into somethingness. This is what Life is.

The Mistake of One is the Mistake of All

We cannot be taken away from the dance of Life. We are it. We are Life. All we have to know is that Life is for us and not against us. Life is for us in every way without exception. Have faith in Life. We are a great symphony being created as we ourselves are creating it. Don't accept anything less from Life. It is not any god at all or any divine being that gives you Life, it is Life itself. Turn to Life. Honor Life. Be happy in Life because Life is on your side. Be still. Be humble. The truth of yourself will come and you will see. You are the very love of Life itself.

Don't Judge the Pause

When we at last let go of what is false, that which is true can and does come into being. No part of Life can hold back

itself. When we feel a sense that inspiration has abandoned us, it is a time to pay attention, it is a clue about where we have gotten to. We have reached a pause. But if we call it a bog we will cut off our nose to spite our face. We will cut ourselves off from Life when what we are being shown is to let go, to be still, to breathe.

A pause in Life is not a place to judge. We fall into the temptation to judge the pause and call it a bog or a failure.

We give it a negative value and push it away. But what we are meant to learn is that the pause itself is part of the picture. While we are learning this way of art, we place value on our tools that don't exist. A screwdriver is not better than a wrench. A skill saw is not better than a hack saw. The temptation to make one better than the other and then to canonize it, to make it a god, is a challenge that has been given us as artists. It is a gift to understand that all tools are equal, even love and hate. Let each tool come and then put it aside. We cannot collect anything or evaluate our tools. We cannot bring them out when no one's around. No, we cannot control anything but the content of our own minds. Let go of control so your Life can come to you.

Control, A Slippery Slope

Control is a juggling act, a slippery slope that is full of the game. In the art of sports, control is everything. Every champion has an extremely high control of the game. Michael Jordan, Monica Seles, Tiger Woods, Katarina Witt. Every champion has fine-tuned the instrument of himself or herself into an artwork of control to a degree that releases itself into astonishing beauty of form. This we can see and love to see. We see the power of control and the release.

The Mistake of One is the Mistake of All

Champions are champions because they use this gift of control for themselves, in the spirit of the game. They cannot use their control in the game for anything outside the game. Arnold Palmer was a master of control on the golf course, Mia Hamm is a master of control on the soccer field. These venues, these canvases, are the art of the sports champion.

When one turns away from her sport, her art, and lacks attention or fortitude or courage, or imposes fear or faithlessness or pride over her art, and control is frustrated, then it is its temptation to extend itself. It is the wont of control to control, and if it is misguided, it will go to any and every length to regain itself, to over-control. If it does not have the form to hold the control, the structure will collapse. This is given to us and it can be counted on absolutely that our creation will fall without equal balance.

Control Loves to Control

In the game of sports control cannot take this dominant stance. It cannot call itself what it is without being what it is. This is its beauty. But in the sport of Life, control has a hay day. It reigns supreme. There is nothing as grandiose as control in the game of Life. Control loves to control, and it will wreck every manner of havoc creating itself.

When we look at control in the world as we have created it, and we see we are over-controlled, we can't find the benefit, the reward. In fact we feel what we see may not be in control at all, but out of control. We see women controlled and children controlled; animals controlled, and rivers and forests controlled. We see our food controlled, and our water. We see the poor and starving and ill controlled. We see huge blocks of people controlled by religious systems. We see everyone in the world controlled by economic systems. And we see virtually everyone controlled by the mistakes we have made with control in our communal picture.

We have given free reign to control and it's made of itself a fine monster. It is a beautiful picture of itself out of control. In its name, it chooses what it does not like and punishes what it does not like and kills what it does not like. It has gained impressive expertise and has gained subtlety and audacity. It can coerce, manipulate, distort, degrade, diminish, humiliate, dominate, and isolate with no apparent effort whatsoever. It's gotten good, this instrument of over-control. It can bruise and break bones, maim and cripple without being caught. It can kill without being accused.

Misguided control is a master of disguise. It gives itself names like truth, and it gives itself titles like laws. It gives itself rationale and calls itself order. It co-opts the name of

love and calls itself kind. It gives itself moral righteousness and calls itself God.

We Overbuild Because of Fear

All our artists tools can be misused. They can be glorified, apotheosized, and idolized; or maligned, bent, smashed, stepped on, and tossed into the trash, each in turn, all depending on our degree of consciousness. This temptation to judge, to make permanent, is the realm of control. Effective control is putting the skill into place and then knowing when to quit. It is the effort to make sure we did what we thought we did, or that we are who we thought we were. But we often over-control both ourselves and those around us. Over-control is a defending fortress. We are most controlling when we are fearful of our surroundings, of people and events, as if every object in view were continuously disintegrating. Over-control is our threatened self diminishing all through control. So that no one can get one up on us, others can be kept weak and confused. The less of themselves they express the better, less for us to be vigilant over.

We feel if we don't control every detail we can be bumped out and will never get what we want. If we don't

control all reality it will move in and cut us out of the picture. We put great effort into making certain we exist. The more controlling we are the less Life we can be a part of and the less we can move forward. Over-control is another stuck place in our picture. It is the dance attempting to stay mid-air.

A Suit too Tight

It is the same in the physical world. A bridge must have infrastructure built to control the forces working with gravity to bring it down. It must be strong to have enough control. But with over-control the bridge does not work well because its form, the bridge itself, is hampered by a suit too tight and too heavy for it. But if the bridge is under-controlled it will not last. Instead of creating the control that we are afraid we need, we miss the mark. We create over–control and under-control. Both are a result of fear, depression, and a consciousness of lack. This is the challenge of structure. Control is a tool of structure that must be learned and practiced. Every artist knows and learns this way of being.

Structure and form work together exactly. They are in perfect balance. When form is released structure is released at the same moment. Neither exists without the other.

The Mistake of One is the Mistake of All

Let Go, Move On

THIS WISH FOR CONTROL is the temptation of the artist to look back at himself, to look over his shoulder. It's the story of Lot looking back at the city from whence he had come. He looked back, and he turned to stone because he failed to believe in and stand behind his creation, his experience before he had to move on. He failed to let it go, to stay in the present.

When you look back at your art it ceases to be. It reverts you into what you were instead of what you have become. When Orpheus looked back toward his beloved Eurydice she disappeared and was taken into Hades forever. There are many stories that warn us of turning back. It is the ego's desire, the self, to hold on moment to moment. We look back wanting to find meaning, but Life isn't where we look for it when we turn back. It's not there. It's not there because it's here in the present. The present is all there is.

Control Is Just Control

BUT LIKE ITS FELLOW instruments, control is just control. It is nothing more than what it is. It is not the source of

power as it contrives in its delusion. It is a plaything in the hands of The Tarot Fool, and as he discovers its value, he will learn to put it to its right use. A screwdriver is to screw, a wrench is to wrench, control is to control, and letting go is to let go.

Time carries with it a mirror of itself. The mirror turns forward and it turns back. Time is only something to happen in space, it is not real. Time is so that Life can move through space creatively, so that we can be made manifest ourselves and make manifest the art we wish to become.

Time is the Structure of Space

Time is the structure of space. It is the pegboard from which space hangs all its tools.

The nature of time is illusory. It is filigreed in transparency, and sways in the breeze like a spider's web. It is magical, it is a trick. The presence of time leaves prints, like a thumbprint on a drinking glass. The prints we give the name of past. From print to present we give the name of future.

In this way time is strung, like lights at Christmastime, like the stars in the night. Time is strung, like leaps of a frog, like the cliffs of seagulls down the coastal wall.

Presence carries a mirror and calls it time.

Time is Sad

In our experience of time, once in a while we catch it. We catch it and take it out of its place in presence. Once in a while we can step out of time. We always have a sense of the willowy nature of time. We call it fickle. We call it irredeemable.

There's something sad about time, not the loss of anything really, just the fact of it being. It's a fragile thing, time.

When we feel we are going to run out of it, it makes us afraid. We do not want it to end, even though we don't understand it. We do not want to die to it.

And yet, time is comforting, the way it seems to roll forward inexorably like the waves on the shore. Comforting, and lonely. Time is inaccessible. We are forlorn before it.

The shadow that time leaves, the print and its mirror of the present which is future, creates a recoil to us, a sense of halting. It is in this place, this motion of time, that fear is created. This fear is to take note of and to use. This is the right note of fear. This is the fear arising in the lion as she scents a male drawing near to her cubs. This is the fear of the rabbit as the coyote pursues. It is the fear of us when the cold of the night begins to approach too soon.

Time Is Opportunity

As transformational art, we do not take time at face value. We can take it anywhere we want. In time is our opportunity. Time presents the challenge and we respond. In fear we begin to take time. We want to gather it, solidify it. But we sit before it miffed, and our fear deepens.

We limit our lives, seeing death as the end. Once we do this, we've got our trap in place. The fear that we create out of these imagined beginnings and endings, birth and death, these two walls, is incalculable. What if we had five hundred years to be children, five hundred years to be adult, five hundred years to grow older? Would we fill those years with fear too? If we did not learn the truth of time, we would.

Time is the Gift of Space

Time is not a trap, it is the gift of space.

There are no beginnings and no endings, there are only starts and stops. There is no birth and no death, there are only twists and turns. There is no time, there is only motion.

Time is not linear. It is not vertical or horizontal. It is not narrow or wide or full or thin. It is not long or short.

There is nothing in time. There is not air or fire or objects of any density. There is not Life in time. Time is just a board nailed up upon which we stick notes.

Putting Time in a Box

But what we have done is make of time a box, and in it we are claustrophobic as hell. We want to put a lot in that box and there's not enough room, it's crowded. We elbow each other around. We want what we want and there's not enough room for what everybody else wants. We brick up what we want. We're afraid what we want will get confused with what somebody else wants. There's only so much that will fit in this box and we want a good section of it.

The proximity of others irritates us and we stack more bricks against their intrusion. Our fear intensifies and where we used to share we now hold back and take an every man for himself stance. We start to make weapons. We will not even entertain reason now. Not only that but if others don't watch out we'll take what they have too just out of spite. We've gotten very afraid and our fear has fed not only our greed but our pride. We have gotten to the point where now we say not only do we have more than others but what we have is better, even though it's not. We

say it anyway and in secret at night we blame it on not having enough.

It's so much easier to just shoot someone than to deal with them. We don't want to try and communicate with people who don't understand what we want. It's too much trouble, so we have guns instead and other killing things handy. We don't really care about saving Life, we care about getting it out of our way so we've got space to get what we want.

WE LOVE WEAPONRY

WE ARE FAT AS sultans and fit as sheiks. We sit in houses extruding from cliffs above all the things we have gathered in our sizable portion of the box. We've managed to secure what we think is the best of everything, and we've gotten sly about the rest. We've reached a new high. We decided to take over the ways others get what they want. Our fear has made us glorious.

Around the world of our box of time we sail and fly. We scour the corners for things we might not yet have. We seem to never run out of ideas about how we can get more and take more from what others hold onto. We have learned to enjoy their insistence on what they want. Their

insistence gives us challenge, it provides our entertainment. Sometimes our enjoyment wears thin when things come up like starving children. This is distasteful and we steer clear of dealing with it directly. But we have learned how to ignore people's debasing qualities such as this need for food and medicine. We have gone beyond the boring basics and upped the stakes. We have concentrated on weaponry. We love weaponry. We have many weapons and now that we are in control of the whole box of time we can enjoy rearranging everything in it like pieces in a dollhouse.

Changing Mother Earth to Yahweh

We've learned how to use destruction in positive ways, to suit what we want. We have destroyed geographic sections of the box called countries, and expressive sections called cultures. We took the vast matriarchal civilization of Minoan Crete and obliterated it. We replaced the Great Mother with Yahweh. We replaced Isis with Osiris, and Gaia with Zeus. We eradicated Native American cultures. We made a grand show at eliminating European Jews, a hundred percent effort. We've made other honorable attempts all over the box, from India to South Africa to Southeast Asia.

Our sophistication grows, and our fear keeps up with us. It provides us all the fuel we need. We have even forgotten that we once felt we could share with others, before the box of time closed in around us. In fact we have forgotten the days when there was enough room in the box for everybody. We have forgotten that at one time there was no box at all.

Fear Hasn't Failed Us

The truth is, there are days when we get irritated just like before, and it makes us mad. It pisses us off. And furthermore we are stumped at the reason why we still feel afraid.

We feel afraid even though we've garnered the box of time. We've done everything we thought there was to do here. We've taken things, manipulated them, and put them back. We've done the dance in a variety of ways. Yet there feels like something we haven't found, haven't tamed. There's something yet to get that escapes us, that keeps our fear close and fresh. We're not worried about death, we say. But sometimes it makes us mad. We feel slighted. We should be able to take death too. Take death too and put it in our box of time.

The Mistake of One is the Mistake of All

We're older now but our fear hasn't failed us. It has grown deeper and we can see it clearly in the mirror. It has changed from defiance and now looks quite vacuous. It's done a good job. It's given us reasonable pride and casual indifference so that we can die with dignity and even charm. We think back on the few encounters we had with love. Love was good but it didn't lend itself to taking. It was a failed commodity really. Fear long ago turned our hearts into bastions, into instruments of reason. Not even bastions really, just rather indistinguishable, rather insignificant appendages, we suppose. Rather a waste, that heart part. Not very practical at all.

FEAR EATS EVERYTHING IN SIGHT

WHEN WITH FEAR WE set up time in a box, it sucks the Life out of itself. The beauty of mistaken fear is that it eats everything in sight. Mistaken fear, fear with no apparent purpose, leaves nothing undevoured because to do so would expose it for what it is. Fear is a magician. It can turn anything into something it is not.

The separation of reality from itself is drastically, deeply fearful. In brain chemistry disorder, altered reality is time having come unstrung. We don't get to experience this in

everyday consciousness. In everyday consciousness time slips by imperceptibly, but in altered reality time breaks down like a landslide. It opens up into huge gaps. Since you yourself are in the time continuum, you are lost in time with everything else. It is in this state we realize time does not exist. It is as collapsible as a thrown rope.

Fear in our lives serves to get our attention. It is an announcement that something is about to change. It is a warning of impending peril to our idea of the meaning of ourselves. We experience the fear, make the adjustment, and our integrity remains in tact, or we do not make the adjustment and our integrity is destroyed. Either way the fear is dispelled.

FEAR IS A TOOL OF REALTY

IN A STATE OF altered reality, the warning comes, but there is no way to make the adjustment because you have gone outside of time. There is no adjustment or non-adjustment outside of time. The adjustment is in time. In time, what you adjust to is the reaffirmation of your safety and reality as a cohesive being.

Everything in reality is in the time frame of reality. Fear is a tool of reality. It is a tool of the integrity of expression.

Integrity of expression occurs in time. In Life, integrity of expression has the capacity to respond to perceived challenge. Fear presents itself and thus the adjustment is made. The point of fear is to make the adjustment and to make it quickly. The bigger the adjustment required, the greater the fear.

Fear, A Warning of Losing Integrity

IN THE COLLAPSED REALITY of no-time and no-place, there is no defense because the adjustments of time have gone down with the landslide. You don't get to adjust and you don't get to be destroyed. This is very great peril indeed. It is a fear that knows no end because it is fear unassuaged either by restoration

of integrity or destruction of integrity. Integrity is the union of form and structure. It is fear that keeps on warning and keeps on intensifying because it is met with no possible response. The desire of fear is to become louder and more insistent with each moment until it is dealt with. The gift of fear is its incomparable strength. It is warning you that you are losing integrity, that you are disappearing and you must respond if you want yourself back. But the self of you, your structure in time, has fallen out of time along with everything else.

Adjustments require time. You are falling with no capacity for adjustment because there is nothing where you have gotten to to adjust to. There is nothing to adjust. There is no way adjustment can be made because there is no time. In no time, you are no one. You are no one and not-one outside of time. In a brain altered by illness or through meditation practices, in no-time, you do not exist. You do not exist in any form whatsoever. You do not exist to the slightest degree. You do not exist in some way and not another way. You do not exist in any way. You do not exist and cannot exist outside of time. In no-time, there is no you. You don't get a line, you don't get a hope or a memory or even an afterthought. You and the you of you are gone into non-existence.

Pure Nothingness

WHAT IS IT THEN, in no-time that is afraid? It is you in the process of disappearing and reappearing, pieces of you floating and crashing. You have come undone like pearls flying without their string. The magnificence of the fear becomes beyond anything you can endure. You have no center, and you have nothing upon which you can make a center. You get no reference. Each time you think you

have gotten somewhere you are cast off instantly, quicker than an instant. You are absolute mind with absolutely no matter. You are form with absolutely no structure. You are nothingness without somethingness. What you are is pure nothingness.

This fear that is felt in brain breakdown, in this place of no-time, is the most astonishing of experiences. This fear is a fear incomprehensible in time. It has no opponents in time. It has no match. It has no end and no limits and no mercy. There is no way to hold out against this fear of the fall of self.

The Narrow Gate is Open

In meditation one may go into deep consciousness, into the awakening of the ungod without losing oneself, but this does not mean that self is not lost. Self is lost. This is the reason wee are there. In here, in this state, one goes through the disintegration of self no matter how we got there. The difference is that through the way of a broken brain the self is lost without you. In a healthy meditative brain the self is released by you. More easily put, in a broken brain the ego leads and thus fails at finding self. In a healthy state, the new self leads the ego. When the self

leads the ego, the way to awakening, the Zen moment has been given, the narrow gate has been opened.

This place of no-time is not a place at all. It is no-place. It is not as though one gets to come to somewhere as if at the bottom of a well. No. you don't get to come to, you don't get to land. There is no place to land in no-space, and there is no self to land.

You In Freefall

Fear leaps forward in the in-between place. This is what it is meant to do. It is a tool meant to save the perceived self. It is a place between time and no-time, and space and no-space. It is a place between nothing and something. It is you in freefall with nowhere to be. It is you with no location. Fear of this colossal magnitude is how much nothing does not want to be something, and something does not want to be nothing. It must be this way so that form does not fail.

In this no-land that is recognizable by nothing but form and structure bouncing off each other, one has reached and created an altered brain. Whether through a broken brain or a healthy one, you have become released to the no-mind, the nowhere and the nothing.

The Mistake of One is the Mistake of All

Awakening is not meant for the healthy brain alone or for those devoted to meditation practices. Awakening is the destination of all Life. It is meant for those in suffering and those in joy. It is meant for all who search in earnest. Awakening is not hidden. Awakening cannot hold back. It is presence itself. Presence blesses Life. You cannot and will never be excluded from its embrace.

12

Life Creates Time for a Single Moment

A Glimpse of Me by Life

The I, in the involuntarily altered brain, is I as an expression and an unexpression. It is I with no me. It is I, pre-me, and pre-me over and over again with no time upon which to rest, no time in which to become. What happens in this no-place at some point is a glimpse of this no-place. The glimpse comes from Life searching for itself and creating the me of I for a single point in time. Life creates time for a single moment in which the me of I comes into existence and makes a space in no-space. Then I see a glimpse of what it is because there is a glimpse of me by Life there to do it.

And this is how the I has done it and how the I of me has done it to me. In the glimpse I have seen this nature of no-time and no-space. This nature is the dance between nothingness and somethingness.

Pure Awakened Life

This destination, with its experience of pure awakened Life is the trip of us all. Existence cannot withstand obliteration. This is the reason for time in the first place. Time holds us up so we don't go crashing to the floor beneath. Time is the structure. With time, and in time, we will awaken.

We will come into awakening because awakening is the fulfillment of time. It is the purpose of time. Pure awakening is the full expression of Life. It is the art of Life having become art. It is the revelation of the art to the artist, and it is the art as artist. Pure awakening of Life is the artist of the artist. It is Beauty itself, and Beauty is Life's masterpiece of itself.

We use time because we can see that it is a frame. We can see it holds all the materials we need. We know it is a gift of Life. This is why the great artists, the great writers and poets and painters and composers and musicians and dancers take time and spend their lives learning how to use it.

As much as we want to part the backdrop of time and escape through it, we are artists of Life. We cannot abandon our materials, because we don't exist anywhere else.

Life Creates Time for a Single Moment

What we learn is that we can use our materials. We learn that we are not lacking in materials, that all we need for the fulfillment of who we are and what we want is right here in this space and time. We want to stop treating our instruments as if they were disposable, as if they are not what they are. We want to stop treating our own artists instruments as if they were against us. Time and space are not against us.

Time and Space are for Us

Not only are time and space not against us, they are for us. They exist for the very purpose of us. They come to us through great and endless and unfathomable love of us. And their only function is to serve as the fulfillment of our expressions in Life. Their sole function is our fulfillment of the art of who we are. The art of who we are is Life. Pure awakening is Life fully having become Life. It is Life absolutely free.

No matter how smart we get, no matter how many short-cuts we try, no matter how many tricks we have up our sleeve, we cannot fool time. We cannot go to extremes and expect them to replace what must be learned through the humility of the moment. We cannot throw away our structure and say we didn't.

The ways of extremes that create conditions that shatter reality are not the way. They're not it. There is no way that way. That way is the Tower in the Tarot Deck with lightning flashing and people being thrown out the windows. That way is an undertow, a vortex that we think we can get out of, but we can't. What we end up with is not the secret door we had imagined, but a dead end.

Beethoven didn't go to extremes with his work. He knew not to throw away a symphony because a few of the notes were wrong. He did not go to that extreme because he realized that the symphony was not the problem. The materials are never the problem. Beethoven knew that he himself was the problem. He knew that he had to try and listen again, to listen more carefully and to exercise even greater patience because he knew what would come. The right notes would come if he waited. And he waited, and they came.

The Nine Year Cave

We like to push extremes. Children and artists push extremes because we have to see how far we can go before we learn how far we can't. Spiritual seekers push the extremes of asceticism and fasting and meditating and prayer and

poverty and chastity and silence and sacrifice and physical rigor. Gautama sat in a cave for nine years. But then he came out, ate some food and sat down under a tree and was still, and by dawn he had reached an awakening. He wasn't enlightened in the nine year cave, he was enlightened outside the cave sitting under a tree.

The nine year cave is representative of a time apart. It is represented in extremes to make the point that one must go there first. Jesus fasted in the desert forty days, the Hebrews wandered the wilderness forty years. You have to go there first to test the extent of your materials, to see what you are made of. The time is symbolic of how long it takes. Four and nine are numbers of completion. However long it takes to awaken is how long it takes. For most, awakening is a discipline of Lifetimes.

Being a Dare Devil

Being a dare devil is part of the trip. When I was growing up my little sister and brother and I dared each other all the time, every day. We'd do very stupid things on a dare. Jump out of trees and off cliffs and walk across logs high above raging rivers; climb over fences into pastures and walk up to the bull while waving a red tee shirt. It's

a lot of fun going to extremes sometimes. It teaches agility and instills bravery. It scares the Life out of you and teaches moderation.

I was the kind of person who always went to extremes. I learned after forty years that the reason I went to extremes was because that's only way I could learn. I couldn't learn through reason, I had to learn through experience. When my genetic predisposition for brain chemistry disorder came into play, it was a good thing I had some familiarity with extremes. It was a good thing I learned through experience, because broken reality is the most extreme experience of all.

Experience Instead of Reason

In Zen, experience is the idea. What you want to do in Zen practice is to put reason aside all together and go for the experience. The reason for this is because what is rational is not the experience. What is rational is instead of the experience, it is an interpretation of the experience. What you want is the experience itself.

The question in Zen is how can I experience something without thinking about it? How can I look at something and not give it a description? This is the trick, as Alan

Watts used to say. The trick is to experience the table before me purely, with no idea whatsoever about what it is. If I can do this I will realize not only that the table is not a table, but that it is nothing and could not be anything but nothing whatsoever.

Extremes Do Not Bring Awakening

Extremes do not bring awakening. No matter how much reality you break down, through whatever means; no matter if you meditate in lotus position for a thousand years, and even if you disappear altogether through disordered neurotransmitters, you will not awaken through it.

All these places are ways to take time from reality, to retreat for awhile from the barrage of sights and sounds that we experience through our senses, and from ways and patterns of thinking that have settled themselves in our mind. We want to retreat for awhile from ideas and perceptions that, as artists of Life, we might want to let go, we might want to change. We retreat because we get overwhelmed by our materials and want a chance to consider if we want to use other materials.

Every artist takes time away. Yo Yo Ma does not work with his cello twenty-four hours a day. He does not practice

a Hayden piece without pausing and sitting awhile in stillness over and over again. Just so, we must take time away from our instrument of Life in hopes we will see it with fresh eyes when we return.

Taking Time Away

Taking time away does not create new instruments, or new realities, it strengthens and clarifies the sense of the one we are in.

The idea is not to walk away from your cello to find another cello because your cello doesn't do what you want. This is the misuse of extremes. It is misuse because it does not work. The reason to go to extremes is to extend our awareness of the nature of our reality. It opens us to new possibilities for the use of our instruments of Life, but except through them there is no other one, there is no different reality.

There is no Shangri-La anywhere else but here, in this reality. In this reality is Shangri-La. In this reality is nirvana, and heaven, and the awakened state of being. I was not awakened in the world of the injured brain, I was awakened when I came back, when I got the me of I back. That's the way it happens. You cannot stay in unreality and reality at

the same time because in unreality you do not exist, in reality you do exist. Total unreality, the reality of brain alteration and the reality of the normal brain does not exist. You cannot be there because there is not there. Only here in reality can you live and have a Life. This is what you are supposed to do. But awakening happens in a myriad of ways, not with a perfect brain alone. It comes as well to anyone with any kind of brain who is lead into the nature of reality.

WE THINK LIFE IS HOLDING BACK

WE TREAT THIS PLACE, the reality of our world, our earth, as if it were phony, as if it had something to hide. We treat it as if it were a magician or a disingenuous friend who says they have something for us and then doesn't give it.

In the movie "The Days of Wine and Roses," Jack Lemmon, in alcoholic craving, tears through a greenhouse looking for a bottle he thought he had hidden. He gets more and more desperate, upturning plants and boxes of plants and tables until he destroys the whole place. He destroys every seedling, every shoot, every plant, every bit of Life in the whole place.

This is the way we treat Life. We think it has what we want and is holding back. Where is it? we say. Where

are the goods? What is the reward of this thing called Life?

I am an alcoholic. Like Jack Lemmon I have torn through rooms looking for bottles I thought I had hidden. I drank for twenty-six years. I could never get enough, I was an empty vessel. At the moment I was swallowing the thing I wanted, I knew it was not what I wanted. As soon as it hit my throat I needed another swallow. The illness of addiction is the illness of lack. We feel empty in Life. We feel separated from Life. We feel clueless and hopeless. There seems to be something going on that we don't know about that excludes us. We feel isolated from all that is good.

We're addicted to cigarettes, alcohol, drugs, sex, work, food, gambling, religion, power. We're addicted. We're addicted to ways of thinking, to paranoid perceptions. We react defensively as if in any moment and every moment we will be accused or robbed.

Addiction, Stuck in Extremes

We're addicted because we have created a picture of limitation in Life. We've created a void where there is none, so we fill ourselves with whatever we can find to fill the

non-void of us. The reason we call it addiction is because it's a description of trying to fill up what cannot be filled. Like myself with alcohol, the abyss I had created had no satiation. It could not be filled and could not even be partially filled because a void is a void, reductio ad absurdum.

We think we lack, because we don't know who we are. We go to extremes to find out. Addiction is getting stuck in a place of extreme when there is no place of extreme. Addiction is the experience of extreme without the substance of its purpose.

We go to extremes in addiction because the extreme gives us a sense that we are something. This is the attraction of the place of extreme. The purpose of extreme is to reveal to us new material, to reveal additional information about who we are. If we do not have enough information about who we are in ordinary reality, the pull of extreme is very great. Each time we go there we get a sensation, no matter how slight, that we are more than what we thought we were. We go back over and over and over because we want to get that same sensation again, that same feeling that we really are something. In addiction we keep going back there we think there's nothing of us here. The more we go to extremes, the less of us is here.

What we discover eventually is that the extreme is no good any more either. The extreme is not what it used to

be, the attraction is gone because it's not extreme anymore. But we keep going back there because now we are not anywhere but there even though there doesn't exist anymore. We're back where we started, we're nowhere at all. What to do now? Go back where we started and look again. We got hooked on what we thought was a little bit of real, but then discovered it was not real. We thought we were going away from what was false when instead we went toward what was false.

Learn to Practice

We are humbled before reality. The reality of our art cannot fail us. It cannot not be the instrument that has been given us for Life. If we try and stay in extremes, Life will spit us out, back to our ordinary practice of living Life in time. We learn to practice, to get where we are going one moment after the next, just like Yo You Ma reaches the heart of the Hayden concerto by going back to his instrument over and over again until the heart comes alive and the beauty can be revealed.

Reality is what is real. What is real is only Life expressing. There is no other reality. Reality is reality, it is what is. What is the purpose of Life? The purpose of Life is to

express and to be. There is no other purpose. What is Life expressing? Life is expressing the art of Life, and the art of Life is Life having become absolutely fulfilled and free.

The art of Life in completion is the pure awakening of itself. When will this happen, this pure awakening of all of Life? Never. It will happen never. Art belongs to nothing. It is the end of time, and there is no end of time. There is no time at all. There is only nothingness, and there is somethingness. There is only the material of nothingness and somethingness and that material is love.

Finding New Ways

STILL, WE WANT TO know how to find the materials. We don't want to feel cut off from the right musical notes and the right colors. We feel inept. We feel like amateurs. We don't feel like we can create anything at all. This is where we are. We are like Matisse when he realized he was going blind. We are at an impasse. What do we do now that we feel helpless, tied up in our traps of inadequacy?

What we do is what Matisse did. We find other ways to paint. We create new ways to put form on canvas. We cut out colored shapes and stick them up there. We are artists, transformational beings that can make anything

out of anything. If we cannot find meaning in our art, we try a new way. Matisse paused only momentarily in despair. How would he respond to the information provided him by the extreme of his experience? Would he perish, or would he use new materials given him?

THE CALL OF ART TO EXPRESS

THE CALL OF ART to express is greater than any other. It is the call of Life itself, and it will be heard. When Matisse could no longer see shades, he made his colors brighter. When he could no longer see shapes, he made his shapes differently. It did not matter what color or what shapes Matisse used. Matisse was Matisse. Everything he created was Matisse because the call of Matisse was undeniable. One set of materials are given over to another set of materials. The materials do not matter.

When I was in the Honolulu Symphony Choir we sang Beethoven's Ninth Symphony. Beethoven's Ninth is nearly impossible to sing because the notes are so high and reach higher and higher. But Beethoven didn't care whether or not anyone could sing his notes. It was none of his business whether anyone could sing his notes. What mattered was the notes. All that mattered was the notes. The notes

wanted to come out the way they did and they would not have it any other way.

Rosalind Turret can play Bach on a toy and it would still be Bach unmistakably. The art of Bach comes forth. The instrument does not matter. What matters is the art. The power of the art will transform any instrument into the voice of itself. No matter how new we feel to our art of Life, no matter how badly we feel we have botched it; no matter how little of it we think we have, and no matter how confused we feel about it, or how much of it we feel left out of, it does not matter, there is no escaping the art that you are.

LIFE WILL HAND US THE TOOL

LIFE DOES NOT CARE about where we are in our art. Life's only call is to do it, to live, to express. Every time we think we have run out of Life, or identified it so don't need it, or walked away from it, or pretended to be indifferent to it, it will come to give us what we need. It will hand us the tool. It will provide the exact thing we need to move on, to progress in it. The very feelings that we feel about Life are the tools themselves. The feeling of lack, of emptiness, is the exact tool we need to move out of emptiness. The

feeling of indifference is the exact tool we need to move out of indifference.

Life does not require enthusiasm. Life does not require joy. It does not require diligence. It does not require attention. It does not require work. It does not require hope. It does not require faith. It does not require trust. And it does not require love.

Life does not require anything from you.

Life is not a requirement.

Life is not meant to get or to take anything from you. It is a gift to you. It is a gift that you can do whatever you want with, no strings attached.

THE GIFT OF LIFE

THE GIFT OF LIFE is itself. The gift is the sustaining, abundant, unlimited, joyful, peaceful, and ever-transformational fullness of itself. The gift of Life is the love of itself. The gift of Life is you loving Life. It is you in love in Life.

The gift of you is Life's love. You are Life's love. You're it.

You cannot and do not live outside of the love of Life. If you feel alone, feeling alone is Life giving you the exact tool you need to not feel alone. You will not feel alone

forever. You will not do anything forever. You will not feel emptiness, inadequacy, rejection, hatefulness, pride, depression or indifference forever. All these things are gifts. They are given to you through the love of Life in you, for you.

NO ONE HAS A CORNER ON MATERIALS

WE ARE ALL MURDERERS and thieves. We are all shiftless and lazy. We are all selfish and irresponsible. We are all lost and discomfited. These are places in our story. They are descriptions in the playbill. They are characters on the stage.

When an actor works on stage, she uses everything she can to bring her character to Life. If her character feels dejected by Life, the actor finds the dejection inside herself and lends it to her character. The actor has felt feelings of dejection and she gives it over. She gives her dejection to the character so the character can use it the way she uses it, not the way the actor uses it. If the character is also a murderer, the actor finds her own murderous feelings and lends them to her character.

None of us have a corner on materials. None of us have feelings that others do not feel. It is not a matter of materials, it is a matter of how each individual uses her materials.

Some people use murderous feelings to murder, others use murderous feelings to withdraw from the world. Feelings are the materials of human art. If an actor allows her character to come alive on stage, then the actor is not acting at all. Who's to say who is the actor and who the acted? Who is to say so in Life? We are all actors portraying our character-in-progress.

Transforming Into the Character

On stage, if you are a good enough artist then you use no artistry at all. You transform into the character to whom you have given Life. That's not acting. That's not pretending. The mistake actors as artists make is to attempt to act, when the art of acting is not acting. The art of acting is bringing another Life to Life. The art of acting is creating Life. The goal of art is to uncover Life so that it can be revealed.

The art of acting is the art of Life. You are to one degree or another acting your Life. As art, you are a work-in-progress just as the character on stage is. How much reality, how much Life, how much you can not act but be your self in the moment is how much you are not acting, is how much you are real.

On stage, an actor understands she is a transformational vessel. But how well can she provide the structure for her character to have Life? This is the question. The actor reaches within herself to see what materials her character is asking her for. If the actor is a good enough artist she can give Life to any living thing. She can transform herself into anything within her realm of experience. It can be anything with which one has intimate knowledge.

We Are All Actors

WE ARE ALL ACTORS on the stage of Life. Whatever materials we are given we can use. We feel dejected from Life. We feel lonely. And like the actor on stage, we must use what we have. We must use alienation to create our way back to belonging. Alienation is the way back to belonging because it is belonging in search of itself. Dejection is the way back to feeling valued. Loneliness is the way back to feeling welcome.

If you want your way back into the meaning of Life, you have to go to Life. You have to open your eyes and see how Life does it because Life is the guide. Life is the lamppost.

LIARS AND CHEATS

WE ARE ALL LIARS and cheats. We lie about the way back to Life. We say Life does not want us. We say Life has lead us astray. But in our hearts it is us who have strayed from Life. We think we can cheat Life. We think we can get it without opening our hearts to the truth.

But Life does not exact honesty from us. We lie because lying is one of our tools. It is ours to use as we wish. And we use it all the time. We use it to disparage Life, to disrespect it. Lying is one of our tools in creating our picture. We think we use lying to get away from being honest in the tight spots. Lying obscures truth but also points to our dishonesty. Lying is a gift. Every tool we have is a gift of our art. How would we know the truth if we didn't know the lie? How would we know a lighter shade if we didn't know a darker shade?

In fumbling with our tools we lie about ourselves. What is it that is true about me? What is true is that I am the love of Life creating itself. This is the truth that I know in my heart, beyond a shadow of a doubt. What I have lied about is that I do not have what I need and that I am not up to the task. What I have lied about is that I am really nothing at all, and not only nothing at all, but nothing with attitude.

This defensive move of lying puts us in another stuck place. Lies don't keep us safe or protect anything, they simply paint over the truth. But in our musical score and our painting, when an untruthful part emerges it can be seen. It can be felt and known. The truth will never go away. And when the lie is revealed the truth can be restored and our sculpture regains its strength and is filled with Life.

Truth Lay All Around

I have lied to myself and said these things, all related to the feelings of inadequacy, uselessness, and failure that rendered me unable to fully express in Life. Lies strangle Life and leave it cold. I lied and said these things weaken and limit and even destroy the potential of my materials.

When I stopped lying about these things and let go of the lie from my heart, I didn't have to do anything because the truth was right there before me. The truth had no trouble arising from Life. When the lie was gone it was just gone and truth lay all around me. I could see that the truth of Life is not and never can be covered by a lie. The lie is a tool of fear. A lie is really nothing to speak of. It's so light it floats. It's just a trick fear came up with. But lies wreck havoc because they lead in the wrong direction as designed.

We live somewhere between truth and lies. How different would the world be if we didn't lie on a daily basis? We lie to ourselves and to one another. Imagine if we felt we never had to lie, how different would our lives be?

The Transparency of Lies

Even though a lie is thin as film, it has a long reach. It's a bastard, a lie is. And yet, the transparency of lies astounds the truth. When the lie vanishes like fog in the morning sun, the beauty of truth arises.

Life is not indifferent to you and you are not indifferent to it. You can spend your whole Life acting indifference, pretending on the stage of Life, but death will not free you from Life's calling you into truth and the passion for truth, nor will it leave you unrevealed as a bad actor, an actor who lied her way through the show.

Limited Ideas of Mind

Frequently people with depression and other serious illnesses die from suicide not only because of the insufferability of their illness, but because of the lie told against

them. What lie is greater than being dismissed because you are inadequate in mind? What lie is crueler?

To say I am inadequate in Life and lesser in the eyes of mind is to say the unthinkable. It is to say that my illness does not exist in the world at all. If my illness does not exist in the world at all then where is it? If we have no sense of what mind is except a narrow and limited and predetermined set of ideas that are couched in standards of acceptability and non-acceptability, then what is mind except a rigid structure that we cannot help but be rejected from? This is ego's point of view.

And who are we then in this left-brain arena? If we are judged by our ability to conform to this rigid mold, and if we have an illness that doesn't exist due to its unacceptability, then not only what we are but who we are does not exist at all. We are expendable. We are caught in an immeasurably untenable trap. We feel we must get back to the self we know in order to remain in Life.

Mental Capacity Reigns Supreme

Mental capacity, the home of ego, reigns supreme in the world as it is, even though we don't know what it is. We think it means being organized, and figuring, and logic,

and reason, and moderation. We have given everything over to this brain function.

If we are unable to produce effectively in these areas and through the acceptable means of deduction and linear thinking, we are devalued. This has at its source malicious intent. Its intention is to chastise and to alienate. Its energy is rejection.

There is no such thing as mental illness. There is nothing in mental to get ill, and nobody there to do it. Mental is descriptive of a function. To call brain disorder mental illness is like calling lung disease breathing illness. To call the situational depression that we all share intentional and hurtful of others and incompetent and weak and ugly is our cruelest treatment of each other. All these terms we use in responding to unacceptable illness.

We feel denial of suffering in ourselves and others helps protect us from rejection. Unacceptable illnesses are those which we are deemed to have created ourselves. Illnesses such as depression and cancer, STDs and AIDS, all the conditions that deserve neither attention nor sympathy or compassion nor research dollars. Suicide becomes an attractive option quickly, when we are unloved to this extreme. We are the goat being driven into the desert so far that we cannot get back. There we suffer and die, casualties of one another's choices.

13

The Invention of Mental Alone

MENTAL DOES NOT LIKE DEPARTURES

WHAT IS MEANT BY mental is leading with one's head alone without connecting to the heart or to the pursuit of self-realization. It is the left brain attempting to take over, the ego attempting to take control of what does not belong to it. What is considered mental in our world does not like departures. It does not like imagination. It does not like space. Its purpose is to take space. It takes space and arranges it, and gives it a name and a function. This is what mental does and it does not approve of adventurers.

Mental is a Scrooge. It wants to reduce space and everything in it. It is like the businessman on the fourth planet of the Little Prince. The businessman counts, "five-hundred-and-one millions-" and the Little Prince says, "Millions of what?" The businessman says, "Millions of those little objects which one sometimes see in the sky." The Little Prince finally realizes the businessman is referring to the stars.

"Yes, that's it. The stars," the businessman says.

The Little Prince wonders why he counts the stars and the businessman says he counts the stars because he owns them. He says, "I administer them. I count them and recount them. It is difficult. But I am a man who is naturally interested in matters of consequence."

It is the business of mental to administer the things in space. Mental does not like to be contradicted and does not like to be disturbed. Mental is impatient and has no tolerance for deviation. It is the most irritable of instruments, as well it should be for it is continually being challenged.

Mental Can Hold a Grudge

Like all good instruments, what is mental, or that which structures, has consequences for that which opposes it. It is capable of divisive action and it knows how to hold a grudge.

If you do not fit into its guidelines it will not only discard you but it will do so with vengeance and call you a pox. It will call you not real at all and will use you as a scapegoat and call your inaccessibility recalcitrance and false pride. It will turn the truth around and make it your fault. It will

attempt to diminish who you are by giving you names like uncooperative and difficult and female and childish and stubborn and selfish and uncaring. It will dismiss you as stupid and worthless. The ego has no temperance. It gathers all things to it. It will use any means it can to take more. That's its job.

MENTAL'S FINEST INVENTION

IT WORKS VERY WELL. It works so well that mental disposes of what won't stay in its guidelines and what won't conform to it. It cajoles and bribes and hangs around. It often kills when it doesn't get what it wants. It calls out to come, like Gollum in Tolkien's <u>Lord of the Rings</u>. Gollum is like an external ego. His total being is eaten up by the call to have what he wants. Nothing else matters, nothing else exists. This is the function and the power of ego.

Mental has caused us to believe in it so thoroughly that many believe to the exclusion of their hearts and presence of mind that mental and heart are separate and that mental is clearly superior. The heart can be dismissed as an unreliable guide. Many conform to this standard. But those on the outside of this kind of consciousness do not. Artists, sick people, educated people, poor people, young people,

old people, animals, earth, these are the kinds of things rejected by ego because they do not serve it. The ego feels the sooner these distractions can be disciplined the better. The world will run much more smoothly when interferences can be eliminated.

The ego's goal is to get rid of what is not itself, and nothing is not itself. It has no capacity for temperance. It is a gathering machine. And without heart in balance, ego floats immediately into Fascism. What it can't have it casts away. This has worked so well that through illness and suicide and isolation, much has been and continues to be gotten rid of. After all, why not design Life so that it has an escape hatch, a way to get out of itself? Disease, suicide, these are mental's way to get rid of what doesn't suit it.

The Brilliant Design of Ego

When is suicide murder and who is the murderer? We are. We are Mental, all of us. It works so well. People have believed the lie so thoroughly that they die of disease or they get rid of themselves through suicide. They kill themselves and the ego is glad for it. How is that for a job that only Mental can come up with? If you can't use materials like I do mine, then the ego sets up a system where

the person or the earth destroys itself. That way mental doesn't have to be bothered with trying to kill everything it needs to. It is much more efficient when ego devises the destruction of living things so that it appears as if the suffering of Life was created by itself instead of us, instead of ego. Mental does a lot that we don't have to take responsibility for. The ego is not concerned with matters of the heart, only the counting of important things like the Little Prince's businessman. Responsibility is easy to deny and we do it every day.

But mental is just a machine, the left brain. All it is is our artists tools. It does not usually become a dictator but is guided and moved in purpose and in wholeness by the right- brain. But the world is not balanced. We do not have a balance and because we are inadequate to the task of living here, our left-brain has taken over and lives in a survival mode continually.

The small self, the self of the world, ego, cannot give up. It is not capable of giving up. What it does instead with form it cannot structure is transform it so that it destroys itself. In this way the form Mental cannot form becomes its form, becomes its design. Its only possible design, the only way it can design form it cannot form is to build it to destroy itself. What Mental cannot form in itself becomes form.

This is Mental's defense and brilliant design. This way it wins anyway. Suicide is Mental's finest invention.

The Invention of Mental Alone

Suicide is the invention of Mental alone. It is the last ditch effort of the scaffolding to stand on its own without form. It is pushing the lie beyond what it can endure. Lies are meant to be revealed in time. Suicide is what happens when you push the lie of Mental too far. Mental without heart is a cold and desolate picture. The lie of Mental is that it is the driver, the god of Life and that all falls beneath its control.

In the exclusion of others we cast them out into the desert. Our hearts chose the name of mental well. Its vagueness keep those who we put there floating in space without meaning. This is the exile of that which we do not yet comprehend. All our unknown materials go out into the desert, out into space while we hold onto what we've got here. Like the businessman, we are concerned with matters of consequence and cannot be bothered too much with unknowns. We have enough to figure as it is.

The Invention of Mental Alone

Mental With Heart Can Kill

The trouble is that unknowns won't be kept at bay. They keep bumping up against our space and irritating us. And that makes us mad at heart. We demand unknowns step forward and give it up. What do they have that we might want? If you have what I want I may decide to kill you, your neighbor, or your country. Even if you might have what I want I might kill you to find out, to pull the lid off your unknowns. Of course we do so only necessarily and with regret.

We only kill with the term 'regrettably', because we cannot kill with absolute freedom. Killing is a bother and there's something about it we don't really like. We don't really like to kill anything whether we know it or not. Mental alone cannot kill, but mental with heart can kill. Killing is just an exclamation point to the heart of mental, it's just the last straw of irritation. That's all killing is. Killing is just another tool in our tool belt of creation.

Most humans don't kill other humans for food or art, or for sacrifice. We save killing and dole it out in war and in the execution chamber and for individuals we object to. But we'll kill anything when the time is right. There are conditions under which any living thing or set of things

can be killed with justification. We have reasons if none other than sometimes it's the expeditious thing to do. Other times it's a mistake but we live with it. We have reasonable responses to killing usually. Regrettable, is what we say. And since we usually kill through laws, our response is mostly righteousness, and self-righteousness, vengeance satisfied, and pride in obeisance to the law.

We Like to Kill With Drama

We don't want to kill too much or too often because we feel the effect will wear off. We like to kill with drama, to use that emphasis, that sense of climax. But when we kill with suicide, that is another level. Suicide is Mental's killer gone underground. Suicide is mental and it's heart gone corrupt.

Suicide is killing's lie.

When we reject our materials and throw them in a heap in the desert and shoot them full of holes, to our dismay they do not stay shot for long. They do not get killed for good. Then we realize the limitations of killing. We see it is not fool-proof, not as effective a hammer as we thought it was, just looking at the thing.

So the heart of Mental alone comes up with an alternative. If it lies to the material and calls it ugly and

unrespectable, the material itself will take over the killing roll. The killer hands the gun over and the material tries it itself, logic being if one kind of tool can't kill the excess material perhaps another tool will work just as well. What difference does it make which hand the gun's in?

This is how suicide was created by the heart of Mental alone. It simply abdicates responsibility for the killing to a deeper lie, another level of lie. The lie gets more sophisticated and says this is how killing can be even better. It adds a new veneer and calls it suicide instead of homicide. It calls killing sick instead of well in this new level. It calls killing sad instead of necessary.

Killing Gone Gluttonous

Suicide takes the punch out of killing. But it does the job for the heart of Mental alone that is now resentful and begrudgingly gives up the thrill. This is killing gone gluttonous. Killing one another through suicide is us learning the use of our tools called cowardice and rejection. It's us learning the use of our tool called strangling love at all costs by the heart of Mental alone.

Suicide is us killing ourselves because we can't get our clay into shape. It's our left hand cutting off our right. The lie loves

it, the lie goes along. But the lie begins to get weighty. The truth is starting to show through here and there and the lie has to scramble. More and more people commit suicide, it's such a good subversive instrument. We suspect the jig's nearly up.

Even so, we must remember that ego is not more powerful than any of our artists tools. It only gains power when we have limited awareness that we are not our ego, that we are not the hijinks of our ego. As we reach greater awareness and move toward awakening we see that our self comes from a deeper place inaccessible to ego, a place that is not of reality but which reaches up to us through awakening.

The mental part of us, the ego, is essential. It is not an option like living without an arm or a leg. Ego is us learning to find our true selves. Ego is for us not against us, but we have to be the ones who decide who we are. The ego is an idiot without us. It is we who must be aware, who must guide Mental so that it can grow without slicing through every boundary in existence.

Accessible to Structure

More young people die of suicide than in any other age group, and more boys than girls. Boys die of suicide more often because males at this point in time, at this

stage in our art, represent more of the tools of structure than of form. Females represent more tools of form. It is easier for females to deal with the heart of Mental alone problem because females have a natural alternative and that is their feelings. Feelings are more accessible to females at this point in our art because we've made females that way and we've made males more accessible to structure.

But what good is head without heart? We've seen what good it is. Males are more susceptible to our killing technique called suicide because they have fewer developed tools to take care of heart. They have less resilience, less opportunity because without feelings they can't get out of the tragedy they're in. They're allowed access to their feelings only to a point. But the ego won't stand for deviation. Their role as provider and protector was not much used past the Stone Age. Modern men are not into such antiquated ideas. Women and children are on the whole left alone to sink or swim. Males are in a very tight trap. It's airtight. But they can't tolerate it. It's out of balance. Males have to be able to feel their feelings or they will die. They will perish. So they do. They kill outright, or they kill subversively with rejection and suicide.

Females Have More Form

Females have not much more of an edge. In a way, females have less of an edge because just as we have gone to an extreme with males, we have gone to an equal extreme with females. While males have too little form, females have too much. Females are inchoate masses at this stage in our art, too receptive, too passive. They are submissive to their own destruction.

But all we're doing is leaning to the left in our boat. That's all we're doing. We're capsizing with the over-weight of structure and form. We need to come back into center, each with equal structure and form. Then both will be able to be active and receptive in balance. We won't have the huge, out of balance picture we have now which is overwhelmed with activity and lacking in places of fullness and rest and peace and well being. We've got a picture that is staggering in conflict. It looks like the seven of wands in the Tarot deck.

Working in Tandem

Every picture that is a natural picture has balance. It has a point which acts as a fulcrum for the scene. This is

true of all Life in the natural world. The male does not overwhelm the female but works in tandem.

Since we are transformational expressions, humans create and recreate. And in the process we swing to the left and swing to the right. We use more of one thing and less of another and then reverse. We go like the wave. Up and then down, in and then out. This is the dance.

FIRE IN A RAGE

OUR PICTURE AT THIS stage is fire in a rage fueled by the wind, with no water to cool it and no earth for it to come home to. We have energy and aggression and enterprise, without love or home or foundation to serve as guide.

The female is not subject to the male, the female is the home of the male. The female is the receptive instrument of the active instrument. Females and males are both victims of themselves in our current picture. As artists, we create the male from the female. We create something from nothing. Nothingness is female, somethingness is male, just as the moon is female in its creation and the sun is male in its expression.

But in the dance there is no separation between one expression and any other expression. There is no duality. There is not two. Indeed there is not even one. There is only the motion.

There Is No Duality

In nothingness there is no duality, there is only nothingness. There is not potential, there is not void, there is not anything in nothing. There is also not anything that is that is not nothing. There is not nothing and something. There is only nothing. What is is expression. Expression in itself is not something, it is only expression.

There is no duality, and there is not one.

There is no such thing as oneness, or oneness of all things.

In which case there would be one what?

No, there is no one, no thing, no anything.

There is not one anything.

There is only nothingness.

This is the gift of Life.

A Body With No Heart

We have made materials and called it female, and we have made materials and called it male. With these two we create more of the same. But the ways in which we create is unlimited.

We suspect that the lie of Mental is being discovered. In the meantime we pour more and more material in to bolster the lie. We pour in more self-righteousness and moral indignation. We pour in more justification and facts to support it. We pour in more rejection and more hate and more fear and more pride. We try everything we can to keep the killing, keep the eradication going. Because that's how bad Mental wants to be true.

But what is not true is not true. There is no Mental by itself. Mental by itself is a lie. It's the frame calling itself the picture. It's a joke. Mental by itself is the Tarot Fool without the cliff.

There is no only Mental. There is not somethingness without nothingness, and there is not either without love. Mental has run away with itself and caused a big mess on the field. It has to come back and get its feelings, it left its heart in the starting gate and it's out of control. It's a body with no head, and a head with no heart.

Life is the Art of Nothingness

A DANCE IS A dance, and sooner or later what is up must come down, what is out must come in, what is suspended must fall, and what is beginning must come

to end. Every part of the dance works together, it cannot be otherwise.

Life is a dance. It is a work of art that comes together inexorably. Nothing can kill the dance. Nothing can kill anything. Something cannot kill Nothing. Nothing can kill, nothing can die, nothing can be living. Nothing can be created, nothing can be destroyed, nothing can do or be anything.

Nothingness is nothingness.

What is living is Life. What is living is the somethingness of nothingness which is Life. Life is the art of nothingness. That's it. And the motion of the somethingness that is the art of Life is love. Love is the lamppost. We know the lamppost like the back of our hand. We know love. We want to follow love and we will follow love. But we are not the death of love. We do not go to love and end up there. We do not stay in love. Love is not a place, it is a guide. It is the truth of who we are calling to us. Listen. Listen to your heart.

Beauty is the Picture of Life

We do not die in love, we live in it. We are artists creating in it. What we create in it is the picture of love because love is the motion of Life and we're it.

The Invention of Mental Alone

The more we create the better artists we become, the more Life we are able to reveal. It is our desire and our fulfillment to create the masterpiece of Life, perfect balance of form and structure in love.

What is love? Love is the Life. It is the Life of Life. We recognize it automatically. We see it by design, because we ourselves are the heart of it. We are the love of Life. We recognize it by its beauty. Everything that is Life truly and has Life is beauty. It is beauty itself. Beauty is the picture of Life. Beauty is the complete symphony, the fully expressed painting. Beauty is the Life flying fully free of the mold.

14

The Earth is our Teacher

OUR ART IS OF THE EARTH

WE FEEL CLUELESS AT times because we do not open our eyes. When we open our eyes to see, beauty will reveal itself to us. There is beauty in everything on earth. If we want to get free, if we want to be enlightened, if we want Life, we open our eyes to see it.

Our art is the art of the earth. Our heart and our mind is the mind of the earth. If we want to free up the use of our materials we need to turn to the earth. Every structure of the earth is our teacher revealing our art to us. Every sound is our teacher to compose our music and sing our song. Every movement of every bird, every animal, every tree, every river is our teacher to dance.

The earth is our mother and father, sister and brother. Everything on earth is our family.

I am Not I

The earth, the sky, the sun, the moon, the stars, the universe, all this is our family, all this is us. There is nothing that is that is not our Life and our teacher. Nothing that is is not Life.

I am not I, you are not you, we are not we. There is no they in Life. There is no other. There is only the art of Life creating. There is only Life expressing.

We Can Never Not be in Life

You cannot remain in the rest forever. The pulse will have itself, and you will be shot free. It is through the motion, the rest, the struggle, the pulse, that we are molded into the art of Life. Our hearts are pulled into Life to be, and through its passion, we are drawn in, molded through suffering and elation, time and time again, free, caught, free, caught. This is the way of art and of the art of Life, and as the material of Life, we are not and can never not be in Life.

In our picture of today we have gathered a set of materials and created duality, female and male. With these two,

Life in us creates more of the same, we procreate. But the ways in which we create is unlimited. We are only barely male or barely female. We can change female to male and male to female with body parts and hormones. We are free to create sexual exchange between female and male and between female and female and male and male.

This is the transformational beauty of Life.

We are not our physical bodies. We are not our personalities. We are not our selves. We have no reference in the world at all.

Bending Metal

Since I discovered how to bend metal I have continued to ask the Love of Nothingness, which I call the Heart of Life, to show me more, to show me how I can use this matter-changing power for more constructive avenues. A few years ago I saved Maudie's Life by doing the same thing I do when I bend metal. She was very ill and dying. The only hospital that could help her was an hour's drive away. During the drive I held my hand over her body, breathed in energy as I do in metal bending, and released the energy into Maude's body, saying over and over again, "In the name of Divine Life, you are healed."

Her white count had been down to six before I started asking for the Heart of Life to help. She was nearly gone. But by the time we arrived at the hospital her count had gone up to fourteen.

It didn't matter what my words were. It didn't matter whether I had called to Jesus or to Divine Mother or to Demeter, Diana, Titania or Puck. What mattered was the focus of the attention and energy. I released the form of her body from its state of illness, and it re-formed into its state of wellness. In this way she began to heal.

Ancient ways of healing in the cultures of the earth manipulate and transform energy in this way. Ki Gong in China, Reiki in Japan, Yoga and Ayurvedic in India. The healer moves through energy with intense focus, releasing imbalanced or confused or broken form and allowing it to regain its natural state.

The Power of Awakened Life

With Maudie I served as her shaman by calling upon the help of Life. Thus I spoke the words which connected me and Maude to the awakened Life of being. I spoke to awakened being because I could, because anyone can speak to awakened being. I spoke to awakened being because it brings all

things to itself. It is the direct power of Life. All things are healed in the source of the awakened being of Life. To speak its name is to call forward its power. It will come forward each time it is called, and cannot not come forward.

Awakened being is the Awakened Heart of Life. It is the picture itself that we are creating, completed. It is the Art and the Artist.

THE FORM DOES NOT MATTER

THE FORM DOES NOT matter, the Life matters. We can change form from ill to well, from male to female, from Life on earth to Life on another planet, from death to Life and Life to death.

During the years I was going to extremes in my Life, until I was about forty, my energy would blow out electrical equipment, toasters and blenders. Once my energy threw a row of circuit breakers. I would blow out alternator-generators and tape decks in my cars. When I was living in London I blew out the wiring in half of a house. I had ignored my situation quite successfully until the house in London blew its circuits and it was no longer just me who I distressed. And it was distressing. The year before I had gone through two alternators in my car.

Just One Sparrow

FEELING FEELINGS

When I returned to the states I got in touch with the Colorado Psychic Center in Denver and started taking responsibility for what was going on with me. I learned how to channel my ability by using it. What I was was telekinetic and empathic.

One night when, as a student of psychometry, I got up on stage to do readings at one of the pay-five-dollars-and-get-a- reading nights. There would be a room full of people, a hundred or so. Psychics or student psychics would get up and do readings for people in the audience.

What I found myself doing onstage immediately was holding my right hand out to whoever asked me to read. I learned in retrospect that this is how I get information. It was a response I made naturally. When I focused in this way I could tell in an instant everything about how someone was feeling and how they had felt all the way back to the beginning. I could feel the age of their soul, and I could feel how they would feel in the future. I could feel how far they were from their feelings and I could feel what feelings were challenges for them. I felt what feelings held them back, and what feelings they had that helped them survive and that strengthened them.

I learned a lot very quickly. Some people I could not read because they had blocks and were protected behind them. They would ask me to read them and then wouldn't let me. I started referring those people to the clairvoyants. I was not good at clairvoyance. I could not see events. I was not good at psychometry, but someone who was could tell people who were blocked about their future or past anyway. It didn't matter whether they refused to feel their feelings.

Serving as Reflection

As an empath what I had to offer was comfort and reassurance. I was good at what I did and many people came to me. What I did was serve as a reflection of everything they already knew about themselves. I would look at them and hold up my hand and I would join with them and they would feel my joining with them in an instant. And this was my help to them.

Once in a while when my emotions run intemperate, I create electrical damage, usually to my automobile. When you get in your car, it's a small space between you and it, for a lot of energy to fit into. What I do is shake out before I get in. And I learned to buy heavier cars. Heavier cars can take more energy. So I drive a truck and it hardly notices me.

Talent is only a Dash

Of course, we are all empathic and telekinetic and clairvoyant. We each express our materials individually and to different degrees. We have talent and we admire talent, but talent is only a dash, a toss of one material more than another in time. There is no corner on talent. We bring certain materials into each Life experience with us, but no one and nothing has fewer materials than anything else. Life cannot be divided. Life cannot be withheld or portioned. Life is fully available to all expression all the time.

Where is the Mind?

Nothing is solid in Life. Nothing is permanent. Nothing is anything but expression. Nothing is anything but motion. The shape-shifter Oto, where is the he of he? Where is his mind, his consciousness?

When we experience the energy of one another, we recognize its great variance. Energy is the power of Life expressing. Every expression is its own expression and has its own energy. Some people's kind of energy is so light they nearly float, they are nearly not here at all. Others are solidly on the ground like a bull. The most physically

earthy kind of energy I have experienced is the western astrological Taurus.

But while Taurus is physically grounded, the un-evolved Taurus has her head in the clouds. She is here on the earth but doesn't know what to do about it. She is like the seven of pentacles in the Tarot deck who has grown an abundant garden but stands over it, leaning on his hoe, looking directly at his abundance but not knowing what to make of it.

Every element has its canvas upon which to grow. Every astrological horoscope is a map of how to get from one place to another. If it is Taurus' challenge to learn how to use her earthly abundance, it is another's to learn how to do the opposite.

Sun in Water

In western astrology, my sun is in a water sign and I have no planets in earth. It has been my challenge to go the other way of Taurus, to create my way from having a sense of what to make of the world but having nowhere to hang it, having no earth upon which to manifest - to creating a solid bit of ground upon which I can stand with safety.

During periods of altered reality I have been unable to put my feet on the ground. The ground is hugely too energetic for me when my brain chemistry has gone awry. The ground hurts my feet with its solid energy and races up into my body and shakes me like a rattle. The ground is like a gaping hole that sends shocks through me in great jolts. When I am in this state where reality has broken down, my feet feel that the ground is not ground at all. I can see the ground but my feet do not experience it. According to my physical body, there is nothing solid. I hold my feet aloft, and sit in space in terror.

It is my challenge in this Life to create viable earth. It is not a choice. It is not an option. It is the imperative of form to seek structure because it does not exist otherwise. This is a terrifying proposition. When my brain chemistry breaks down and I experience altered reality, the experience of my physical body is of vertigo and claustrophobia at the same time. I cannot judge distance or depth. I fall often in space because my feet cannot judge a step.

Each Breath a Dance

Wherever one is in the process of creating Life, no matter what tools are not there, other tools are there and they create whatever it is you want. Whatever it is you need will

be created by you in time. When you leave one physical form you take up another, just like ending one dance and beginning another.

When does one dance end and the other begin? At the climax of the crest, the orgasm of the pulse. The dance begins and ends with each breath. We leave physical form and take up another, just like putting one canvas aside and beginning another, or singing an old song and beginning a new one. All of Life is a singing voice.

Illness is Mistaken Application

What is it in our singing voice that can fall ill?

Illness is a perception of lack. Illness is a misguided idea. It is a mistaken application.

There is nothing in Life that can be less than itself. There is nothing in Life to get ill. We think that illness is a lack of tools or defective tools. But there is no lack of tools and there are no defective tools. Illness is a tool like any other. Illness is a gift just as wellness is a gift. Illness is not a matter of degree. Nothing can be disabled by illness. Nothing can die of illness. All illness is part of the play on stage, no matter what name it is given, no matter how it expresses in the world.

Wellness has no Opposite

Illness is not the opposite of wellness. Wellness has no opposite. Wellness has nothing but itself.

Wellness is a beautiful word. It is a description of Life. Life cannot lack itself, Life cannot be ill.

Nothing that is ill is in truth ill. Nothing that is broken is in truth broken.

All things are already well. All things are already whole. Nothing that is that is has ever required healing.

We are the Artist

When we see that we ourselves are the artist, we are set free from the art. It is then that we are awakened.

We are the Music

When we see that we are not the notes but the music, we see that we cannot and never could be ill or disabled or broken or anything but absolutely well and absolutely whole.

We are not the noise, we are the song. Illness is the noise, wellness is the music, and in the symphony of Life there is no noise that is but noise.

When we see that we are not we, and I am not I, illness disappears. Lack disappears. This is enlightenment, when we see the light, when we see the truth of who we are.

WE HAVE OBJECTIFIED ENLIGHTENMENT

IN OUR PICTURE OF Life to date we have made enlightenment the most prized of all possessions. We have made enlightenment an object and placed it upon a pedestal for all to see but none to touch. We have hidden it in the deepest cave and disguised it in the most complicated puzzles. We have made it the answer to all questions and we have even given it the question because we have forgotten the question.

We lust after enlightenment and buckle down and go after it with our finest greed. We exempt enlightenment from all the rules. However we go after it is fair game. Then we say whatever it is is it, is the thing, even though we don't know what the thing is. We lie about it. We say we have it and offer up proof. We're magicians. Here it is, we say, here is the true thing.

Enlightenment makes us angry. We have over-billed its illusive nature and now we have lost access ourselves.

We have made enlightenment the rarest of the rare, and we take great pride in how we find our way to its excavation. We talk to others about our find and like to boast that our way will take anyone there who's got it in them to do the work.

We have made maps and we're willing to show others how to use them at nearly no charge at all.

Big Game Hunting

Many of us have set ourselves up as guides for this big game hunting. We have fish stories. We stretch the truth at the very end. We say we caught the big fish, it doesn't really matter that we exaggerate some.

We have lots of false prophets, lots of gimmicks, deals that seem too good to be true. We've gotten good at the con over time.

We Were It

It is true that enlightenment is the narrow gate. It is true that it's hard to get. It's true that you have to work

for it. But you have to work for it only because we've gotten so far away from it. We were right up close to it in the beginning. In fact we were so close to it we couldn't tell the difference between it and us. This is because we were it. We were it and are it.

We are the awakened state of being.

We are enlightenment. There is no such thing as unenlightenment. Life cannot withhold light. Life cannot hoard. Life cannot reward.

Life cannot retain the intelligence of itself.

Life cannot close its eyes.

You are enlightenment. How could you not be? Who do you think you are? You're it. Enlightenment is the truth and the destiny of all of Life just as it is all of art. Art that is art has light, and this we call Life. It lives.

The Light is Right Next to You

AND THIS IS YOU. The light is right next to you. It is all around you and in and through you. The reason you cannot see it is because you think you don't, and you feel you don't. But thinking and feeling are the ways of your art. They are the ways you have created away from the light because that's what art does. How can it be art if it doesn't start in

the dark? We have put ourselves in the dark on purpose because we are expressive beings. Expression begins in the dark and ends in the light. It begins in nothingness and expresses into somethingness.

Of course there is no such thing as dark or light. Nothing actually begins in the dark or the light. Nothing is nothing. But we use the dark and the light to represent degrees of awareness. In Tao there is dark in light and light in dark. There is no one without the other. All things are infinite, expression within expression within expression, form within form within form, ad infinitum eternum.

15

Art Will Call you with a Cosmic Power

Enlightenment Calls us to See

Enlightenment is not nothing. It is not a figment of the imagination. It is a new place of awakening. It calls to us to see. Its voice is our guide back home. It is Bach listening for the heart of the B Minor Mass, and Leontyne Price listening for the heart of Aida. It is us listening for the heart of our Life.

The heart of our Life is pure awakened being.

The search for enlightenment is part of our work of art. We can practice our art of the search in many ways. Meditation, yoga, prayer, silence, chanting, Tai Chi, Ki Gong. Anything can be made a spiritual practice. To make the search for enlightenment an art is to put one's creative attention to the work just like in any art. You must want it badly enough to make it your art, just like Beethoven wanted the notes of his Ninth symphony. This is an

all-consuming task. And once it has your attention it will shout. It will call you relentlessly. It will call you with a cosmic power. It must call you in this way, without ceasing, because else you will not listen, else you will turn toward easier tasks, toward lesser effort.

The Power of Art

You cannot make enlightenment your search casually. There is nothing casual about art. Art is a gargantuan, colossal, monumental task that is the power of volcanic eruption. It is the power of the earth to quake and the skies to create tornadoes. The power of art is power itself. The expression of art is power. That's what power is. And it's immeasurable. It is the power of a blade of grass to work its way up through the cement ceiling above it, and the chick to break through the wall of its egg. It is the power of babies to be born and of Life to endure death.

If awakening has you in mind, it will call, and you will make it your art. You will make it your art because the call of art will not be denied. The Divine Mother Karunamayi could not deny awakening. Buddha could not, Jesus could not. Spring cannot deny awakening.

If awakening does not call you with a voice like a god, you will not go. Your calling will be from another art. It will be from music or dance or design or whatever it is that calls you to express.

Whatever is, has Art and is Art

Whatever is, has art and is art. Anything can be made art realized. It doesn't matter what it is. Music is not a form of art, it is a form of Life. Dance is not dance, it is Life.

Whatever you express can be revealed into the art it is.

Art is not activity. Art is Life. Whatever you do, you can learn to do it so well that the art of it is revealed, and you will have made that effort art.

The art is not the point, the expression is the point.

Art is nothing in itself.

Nothing is art because it is art.

In truth there is no art, there is only Life.

Art is only the structure of the form of Life.

Art is not the desire of Life, expression is the desire of Life and it is created through Art.

Just One Sparrow

Awakening will be Yours

W̲h̲e̲t̲h̲e̲r̲ ̲y̲o̲u̲ ̲a̲r̲e̲ ̲c̲a̲l̲l̲e̲d̲ to express through the search for awakening or not, awakening will be yours in time, because awakening is the art of you, and the full and utter expression of you cannot be denied.

Nevertheless, the search for enlightenment is serious business. It is as serious as Titian creating Titian, and Reubens creating Reubens. It is no walk in the park. It is the narrow door of every artist.

It is real, this place of pure awakened being, and it is unmistakable. It leaves its mark on everyone who has discovered it and entered in. We know of a few people in time who have been there. We have been told. But others have been there who we do not know, others whose names have not been used to establish religions and whose lives have not been claimed as exemplary for illustrating the way.

Enlightenment is not a claim. It is not a title. It cannot be coerced, co-opted, or be made sacred. Enlightenment is not holy. It is an experience of mind. It is a place part learned and part dragged through to the far side of the endless dark night.

Enlightenment is Description

Enlightenment is a description. When we face an enlightened one, we do not do so in name. We do not know they have awakened, indeed we never know. We call them infilled with a certain peaceful clarity. We see that they are not troubled.

Awakened ones are not peaceful because they are at peace, but because they are peace being itself in human form. They are not joyful because they feel joy but because joy is the energy of their motion. They are free unmistakably. This sense, this lightness, a certain stillness, is what we experience in them. They are free no matter what because they are bound to nothing in the world. It is this freedom that we see, this presence of light. And this is what light is, freedom. Light brings freedom to reach and to grow. Freedom is complete unfettered expression into the being of self.

Within freedom there is presence and the presence and the awakened one are the same. In presence is the heart of love, and it is compassion. It is the passion of the world realized in the compassion for Life. Its expression is profoundly humble. It is humility without limitation, with no stopping place. This is how we experience one who is awakened. She

is unstuck. She has sprung the trap. Even though she sleeps she is yet awake. This is Amma, this is the Christ, Atman, Buddha. This is Brahman, Life's realization of itself.

Compassionate Love

THE COMPASSIONATE LOVE OF the awakened one is a reflection of the passion of one's journey. Compassion does not come from deduction. It does not come from expedience. It does not come from attitude. It does not come from finding a center and remaining there. It does not come from moderation. It does not come from churches and synagogues and mosques.

Compassion comes from struggle. Compassion comes from suffering. Compassion comes from a great ongoing struggle to learn and to understand the suffering of Life. It comes not from an empty mind or from a lofty level of intelligence, or from being caring or temperant in Life. It does not come from ridding oneself of desire and putting it away somewhere. It does not come from not wanting.

Compassion comes from desiring to know Life fully, and wanting fully. It comes from entering into Life. It comes from living Life with free-reigned passion, from entering passionately into each arriving moment.

The Heart of Passion

Compassion is the heart of passion. It is the mother of passion, the home of passion. It comes from the depth of the struggle and the endless night of suffering. Struggle, suffering, pain, these are the instruments of compassion. The more difficult the struggle, the harder the suffering, the harder pain, these are the things that bring compassion to fruition, into full realization.

When we see people with great compassion, we see those who have known great suffering. An awakened one has known the suffering and the redoubling of suffering over time. She or he has shed tears, has fallen at the Wailing Wall again and again, has been heard keening in the night beyond a time anyone can remember. She has cried in pain in her body and her mind and her heart. She has known pain in every part of herself, and has endured pain beyond possibility, and then beyond impossibility.

Whether in this Lifetime or in another, whether in human form or in another, the awakened one has gone into the heart of passionate suffering. She has gone through the heart with all of her heart and with all of her consciousness.

Just One Sparrow

There is No Way Around

Passion cannot be abdicated. It cannot be circumvented. It cannot be diluted. It cannot be ignored. The purpose of passion is passion, there is no way around it. When we talk about mental and its heart alone we are talking about fear of passion, contempt for passion. We talked about the pride control takes in itself. The instrument of passion is meant to break through control.

The 1960's in America was a time of passion. It followed the 1950's, a time of intellectual repression, emotional control, strict guidelines of behavior, and a narrow interpretation of what and who were acceptable. It was a time of anti-passion. It was a time of strangulating restraint. By the mid-sixties, the dam that had been building for fifty years was broken. It had been perforated, and its contents gushed forward and spread in every direction.

Suppressed Passion Revealed

Passion chafes at imprisonment. It struggles to death in its trap. The passion that was unexpressed exploded into the sixties. By the eighties the flat passion of the fifties was

revealed as infected passion, spoiled passion. Suppressed passion of post World War I and II that went underground was fed in perversions. Incest, rape, molestation. One of three girls was raped or molested in their own homes, and one of four boys.

The statistic is the same today. Our perversions are spilling over. Perversion is accepted today on a multitude of internet sites and programs throughout the world. This tells us that standards are lowering and broadening, or that child abuse and pornography have been the same all along and more men are finally gaining expanded access to it. It is more all right today to make sexual objects and prostitutes of children. This is partly so because the head of the largest church in the world shows his enthusiastic approval by keeping silent and has continued to do so for over a decade. Given this length of time, Catholics as well as millions of men who respect the Pope feel their propensity for raping children is not a problem and certainly justified by the Pope himself and the Vatican.

Dimwitted Sidekicks

This is not denial, it is gripping one's place in the universe as tightly as possible to the degree you feel you do

not exist in it. It is perhaps the most elitist and most hateful event of our times, the un-acting Pope, the arrogance and fear and self-aggrandizement. It is reaffirming one's elevated position. It is self-loathing. It has pushed conscience into a box and buried it. What does this sound like in our symphony? You see, we are not out to save anybody or to provide a happy ending in our art. The rape of girls and boys and women in our artwork over the centuries is just what it is, as is the molestation and rape of myself today or of you. This is the suffering that holds one's face in the dirt where there is no air and no water and Life bleeds out, flowing over the gravel and into the night crawler tunnels.

WOMAN AND DOGS

THE CHURCH WAS APPOINTED by God. Under such appointment he and other men, superior beings such as himself, with his brother Allah, were born to control and punish, to dole out and withhold. God and his two-digit IQ gang see that woman and dogs must be controlled and punished lest they think of themselves apart from man and God.

The Pope and the church are approved by God himself. This chasm of delusion, this world of terror is a tumorous growth. And in Islam woman is murdered in disobeyance to Man. It is the way Allah can keep all that is his to himself. Man serves Allah and woman serves man, to be disposed of as they wish, as God directs. This is the way it's been. Siddhartha Gautama felt woman was less able, less valuable to Life than man and was created by Brahma the Creator god to serve Man and to deserve nirvana through the illumination of Man. Mostly women and animals are disposable and easy to replace once they've served their purpose. Because there must be only one God. The existence of woman interferes with man's image of himself and his special God nature. An inferior interloper proposes compromises and Man doesn't want a deal.

This description is not about the misguided male or the weak female but about our species living at a limited place of being, at an intellectual level that remains on an astoundingly lower plateau. Ours is a mistaken species that sees Life and all things in it like John's head on a platter, like a playground and a bar and a landfill. We have not gotten further than this. Today we are on the slippery sides of a bottomless hole. We remain there, kicking and scraping and not getting anywhere. We are Sisyphus rolling without eyes.

CREATE YOUR OWN GOD

THERE IS NOTHING ESPECIALLY interesting in our art of terror because terror strikes down its threat quickly and with passion. Rape, punishment and killing are straightforward. In our picture it is there. It is the betrayal and the hate. It is how far adrift we are from ourselves. Man makes God and if what Man sees offends him he is appointed to destroy the offender with divine approval. This is the advantage of creating your own God. He's your candidate and has whispered that he'll be happy to work with you. You make a good team, God and Man, and you get what you want all over the world. That's how good your God is.

Who was the first killer or the first rapist or the first denier of water for children? God. He presented the first excuse, the first rule. I am God, whatever it is, I do it first. Where else would the original come from? And God and others have thought these approaches useful and effective ever since.

The disguise of anti-passion creates trapped passion. Passion trapped can only come out looking trapped. It is passion made ugly by twisting, by trampling its aspect. But passion will not stay forever behind a facade. Passion does not like traps and it does not like lies. Passion wants direct

expression. That is how it shows you what you want. It wants action. It is a flash of light that requires response. It's flashing red, a siren. This is the color that passion inspires. It is the energy of power and of action.

Art is Driven by Passion

All art is driven by passion. Art cannot exist without it. Many of us know only the simplest-formed passions, for sex, for food, for possession, for righteousness, for power in the world, for dominance. Because this is where we are in our art. We start from gross and move to fine. This is the nature of Life. We make this move over and over again, each time adding new material.

Sexual passion has the potential for joining forms so that the combination yields greater expression. As transformational art, humans express sexual passion beyond procreation. In transformational expression procreation is transformed into creation. We are used by creation, in other words, and we are the users of creation, the artist and the art.

We use sex as a venue for our passion to be expression in one another. Heterosexuality, homosexuality, hermaphroditic union. Body parts do not matter. We are not defined by

body parts, just as music is not defined by notes. It is instead the other way around. The notes themselves do not matter. We are defined not by body parts but by the expression of our lives. The passion of sex can be about sexual union, and it can expand its materials into the union of consciousness.

The Recognition of Souls

The recognition of souls we call falling in love. We recognize the heart with which we wish to be united in another, and we fall into the space between our recognizing and our recognition. We fall in love. Falling in love is passion motivated by recognition. It is a recognition of a quality in the other that we want. We see it and we want it. How could we know we want it unless we recognize it? We most definitely recognize it, it is clear. Sometimes we recognize it instantly, other times we recognize it over time. What it is, is a call for reunion. It is love as we have known in expression, and it comes to us through the form of another.

We fall in love with many things. I fell in love with Beethoven's Emperor concerto, and Handel's Water Music, and all of Bach. I fell in love with the dance of the Joffrey Ballet and with Madame Butterfly. I fell in love with Maudie when she was a tiny puppy. I fall in love with both

women and men in my Life. I fell in love with the Divine Mother Karunamayi as soon as I saw her. I fell in love with the Hawaiian Islands the instant my eyes came to rest on the aqua blue shore.

I fell in love with Joan Plowright, Wordsworth, and Sir Michael Redgrave's Henry IV. I fall in love a little bit again every time I hear Roberta Flack sing, and when I hear anybody sing "I Wish You Love," or "I'll Be Seeing You."

Love is a Reunion

Falling in love is a reunion, not of what was lost, but what was known and expressed in love. Falling in love is the way love expresses itself to us. Our pheromones, our genetics, draw us together and love creates a bond to keep us together so that the family unit survives and adds to a healthy gene pool. In this way we can procreate effectively over extended periods of time.

We fall in love with things for reasons. What drew us was recognition. Recognition doesn't mean we get the whole symphony right, it just means we get a set of notes right, or even a single note. What we do with it is another thing. We go to the extreme of falling because the call of the love we recognize is powerful. It's meant to be

powerful. But we are often intemperate. Sometimes we are called only to fall enough to use the recognition, to become aware of it. But we fall headlong instead. We fall for the note as if that one note were the whole score as if we were babies upending the raisin bran onto the floor.

A Great Clue

We fall in love because we fall after the thing we want. We want it with passion, we want it mightily. We want it mightily because it wants to be wanted mightily. It wants us, and what it is is the gift of a great clue, it is the expression of love expressed in form. We want love more than anything else, and love wants us more than anything else. So we fall.

We fall no matter what. We fall for murderers and scoundrels and crooks. We fall for liars and cheats and lazy bums.

We Can't Fall out of Love

Why do we fall out of love? What is it that leaves us? Does love leave us? Or do we leave it? We fall out of love because it is the motion of love to crest and to rest. It is the

motion of the wave to rise and to fall. But it is not the love we fall out of, it is the stage. We can't fall out of love. We can't go from love to no love. There is no such thing. There is only love. Being in love is love at the crest, being out of love is being out of the recognition. Being out of love is the experience of love dashed, of love faded. It is love in the rest, but it is not the presence of less love in Life.

Passion Requires Release

Love cannot be and is not less present anywhere than anywhere else. Love is not subject to the void. There is no place that love is not. Love is all love everywhere complete in all things. Falling in and out of love are stages of love's expression. They are stages in love's art. And love's art is us.

Passion cannot be passion all the time, else we'd be blown off the canvas. We'd be blown out of the audience. An actor on stage feels and releases passion to various degrees in different parts of the play. She is not expressing passion all the time. If she did she would lose her art and her audience. Passion makes the point and then recedes. If the actor were passionate every moment, she wouldn't be passionate, she'd be an idiot, she'd be out of control. Passion requires release. The pulse requires the rest.

Falling in love illuminates love, it does not change the materials that we have created. When we fall in love, it teaches us about the nature of itself, that no one is exempt from love and that all things are worthy of love. Every being, all of Life, is worthy of love. Falling in love is presentation of the note on a silver tray. It is the arrival of the step with a flourish. But it is only a note, and only a step. When we see this, we are relieved, and we can move on. We move on, allowing love to be love in its infinite forms.

Continuing the Symphony

If the note is the right note, the step the right step, the person the right person; if it fits in with the person of us, then we go on in love, in the beingness of love, continuing the symphony.

As we grow as the artists of our lives, we gain perspective, we see with more open eyes. We learn to put aside shades of color that we fell for but were not right. We learn that what we are doing is not casting away the shade, but only that another shade fits the shade of us in a more compatible manner at this place in our picture. We learn that the picture of ourselves is not lacking because we do not

have the shade of another, the shade of intimate relationship. No picture can lack anything.

Every bit of art is a work in progress. In our human picture, we wish to be mated with others, with intimate partners, with friends, with family and community. We are notes on the score that wish to be with others like themselves. Quarter notes like quarter notes, whole notes like whole notes. Shades of red in our painting like other shades of red. The pulse likes what is pulsing, the rest likes what is resting.

We seek out reflections of ourselves. We seek out what will work with us. We desire companions, others who have trodden similar paths. We are attracted to reinforcement because we are compelled to continue our line. Groups keep it safe. All art requires reinforcement of structure. Similarity reinforces, contrast reinforces, what is rough reinforces what is smooth, what is out of balanced is offset by what is in balance. Companions, mates, friends, partners, these are helpers to us in our transformational expression.

Beauty is ours to See

It is not that we lack anything we need alone. We cannot lack, we are Life expressing. But the reason we are not alone is that all things on earth reflect the beauty that is in us.

This is beautiful, we say of the flowers and trees and rivers. We say, you are beautiful, to our friend or mate. How can we know this beauty? How could we know if the beauty was not already inside us? How could we recognize beauty if we did not have it to start with? When I was growing up I thought my little sister and little brother were the most beautiful thing I had ever seen. They had big thick golden curls all over their heads. Their features were fine and their eyes were a beautiful, serene blue. I thought they were beautiful even as they grew up. I have always thought so. How could I see their beauty if the beauty was not in me to see?

We see the beauty of one another and the earth because the beauty is ours to see. We see some things that are more beautiful than others. Some people and some places and some times are more beautiful to us than other people, places, and times. We fall in love with one particular person over another. Sometimes in our recognition it may be powerful and clear and we hear "Some enchanted evening you may see a stranger across a crowded room." Instant recognition is a blast from the past. It's something we know unequivocally. It is a clue to the truth of our existence.

Form Within Form

Every form is form within form within form. It does not die or go away somewhere, it is reborn. Mary Cassatt did not disappear after painting "The Bath," she painted many more. Every form has a thread connecting it to all its forms throughout all times. There is no form in disguise or incognito. Every expression is the expression of Life. That's all there is.

Life cannot and does not come to an end. Some of us feel that when we die we will be reincarnated in the same place in our art as we were before we died. This is not so. The reason is because of the death experience itself. The death experience is a completed pulse that catapults us into another wave, another motion. The death experience is another climax of the crest. It is not nothing. Some of us see death as the rest, but it isn't. It's the crest. Death is not the end of breath. There is no end to the breathing of Life. Death is the beginning of new breath. It is an X Games sport and we know how to do it. We wait at the starting gate.

The idea that we might as well stay alive because we'll be in a worse mess in another Life is the wrong idea. We

don't want to stay alive out of pressure and fear. It is a set-up to think so. Rather we want to stay alive because Life is the place where we can find ourselves, where we can find our expression. We can get what we want here. There is no other place.

DEATH IS ILLUMINATION

DEATH, NO MATTER HOW it comes is a gift. It is a gift of new materials that we take with us. We learn from death, and that learning is made up of new materials. It's not the same notes that we've already used and tried. Every experience is an illumination. Death is an illumination, and we take that light and go forward to a new place in our musical score. Death does not eradicate our materials, it opens our eyes to more.

Why would we use every other experience and not death? Why would everything else be Life, but have Life end at death? There is no end. There is no death. Death is a changing of form. Winter doesn't kill Life. It is Life at pause, but it is not dead, it is alive. When spring comes the tree does not start from where it left off in the fall, it grows new leaves and grows bigger and taller and stronger. You see, you are not the leaf, you are the tree.

The Darkness of us All

Suicide is not individual darkness, it is the darkness of us all. Suicide is just a fancy way we have to try and get rid of each other.

Suicide bears no blame itself. Anything that tries to kill bears no blame in itself. Life cannot blame, and Life cannot punish. The art cannot blame the artist, and the artist is Life.

Life holds no grudges and does not have a chalkboard where it records bad marks. Suicide is an experience of the tools of lack and rejection. All attempts to kill are experiences of lack and rejection. But it is not Life that lacks, it is a stage of our art. It is fierce and dark to be sure, but it teaches us where we want to go instead.

No killing is blamable in itself. It is a reflection of where we are in our human picture. Nevertheless when we kill no matter how, it is a part of our individual picture too. We cannot say that anyone or anything else made our picture. It is our picture and our picture alone. When we try to kill we are mistaken. We don't get it. We are in the dark. But we are in the dark working toward the light. This is the nature of Life.

What You do About Death

What you do about death is not my business. What I do about death is not your business. It is my business to love. It is your business to love, because to love is my art and your art. That's what our work in progress is. If we want to stop killing, then the thing to do is take responsibility for our contribution to it. You think Timothy McVeigh, the Oklahoma bomber, killed in a vacuum? Do you think serial killers kill of their own accord? Do you think the Nazi holocaust, or the Inquisition, or the extermination of untold numbers of Vietnamese women and children was carried out by evil? Or the ideology of a few, the insanity of a few? Do you think the millions of people who die of suicide are defective?

No. We kill each other, and we cannot kill each other and then blame each other for dying. We cannot say, you have bipolar disorder, you have major depression, you have cancer, you have AIDS. You are a communist. You are standing on my property. You are in my way.

Killing is a creation of us all. We are all Cain killing Able. We are all connected in our picture of Life.

What's in Enlightenment is Love

Awakening is seeing that the picture of our lives is love. If you want to know what's in there, in the place of enlightenment, its love. And the love that's there is beauty. It's the beauty of peace, the beauty of harmony, the beauty of the whole.

The love that brings moksha to consciousness is the art of Life in full. It's the completed symphony, the completed painting, the completed sculpture. It's the form gotten free, is what it is. It is freedom from all things of the world.

The place of enlightenment is seeing not only that nothing can be killed, but that there's nothing to kill over. There's nothing to kill about because there's nothing lacking. In fact there's nothing in the world at all but the complete picture of Life. All enlightenment is is a dance, a song, a poem come into fruition, Life arising in perfect beauty.

Life Does Not end in the Light

There is not one enlightenment. Life does not end in the light. Dance does not end at the end of the dance. Song does not end at the end of the song. There are infinite

dances, infinite songs, infinite enlightenment. It is a true completion. It is the eaglet lifting off the cliff-edge for the first time. He was born, he grew, and now he flies. This is the awakening of Life to itself.

Awakening is awakening. It won't stand being conned. You cannot cheat awakening. You can't take anything in there. You can't take anything at all. You leave all your tricky tools out. That's the whole point. You leave out pride and fear and greed and lust. In awakening, all those tools disappear. You don't need any of them anymore because your dance is done. The dance of this particular dance, is done. You are freed into a new Life of itself.

Awakening is Freedom

THE ENLIGHTENMENT OF THIS particular dance is its beauty, and what its beauty is, is love. It has nothing to do with being loving, or the qualities of love. Awakening is not a place that is caring, or giving, or kind, or peaceful. It is freedom from the world and awakening to the truth that you're not it. You are not the world. You are not your body. So all those tools you needed before to make yourself and to get yourself, you let go. You drop them. And among them is your old self, your struggling and blind self. This

self of the world graduates into new knowledge of who you are. It's a growing system, this Life of motion. Knowledge creates space and it is in each new space that we grow and into which we awaken.

The Place of Awakening

THE PLACE OF AWAKENING is not beautiful because it's about love, it's about love because it is beautiful.

The Mill on the Floss

WHEN I THINK OF the writing of George Eliot, in <u>Silas Marner</u>, or <u>The Mill on the Floss</u>, there is not a single word that does not belong there.

"She was looking at the tier of geraniums as she spoke, and Stephen made no answer, but he was looking at her. And does not a supreme poet blend light and sound into one, calling darkness mute and light eloquent? Something strangely powerful there was in the light of Stephen's long gaze, for it made Maggie's face turn toward it and look upward at it - slowly, like a flower at the ascending brightness."

This is from <u>The Mill on the Floss</u>. It is a beautiful work. It is the work of a master artist, a great artist. <u>The Mill on the</u> <u>Floss</u> is a book not about love, but about the heart of love which is Life. It is a book which, through the structural skill of the writer and the grace of her form, is a work of art.

It is not a happy book, it is a tragedy in the finest sense. But the beauty of the book transcends its tragedy. The beauty of the writing transcends its subject, it transcends anything the story could be about. It is not the point of the book to make people happy, it is the point of the book to give people its beauty. It is not happiness that makes people happy, it is beauty, it is the heart being touched.

The Subject Instead of the Art

Some of us don't read books because the writing is great, but because the story continues our false sense of well-being.

We don't look at Goya paintings, we want to look at Monet paintings. We don't see great films, we see films that do not challenge us in mind or in heart. All because we measure the subject instead of the art. We must learn how

to experience art. The truth is that we know how to experience art but we have forgotten. We have forgotten what we know. We forget because forgetting is a response to fear. We're afraid to experience the beauty of Life, afraid it will disappear. We are afraid it wasn't there in the first place.

16

The Heart of the World is Broken

WE DON'T WANT ENLIGHTENMENT

WE DON'T WANT ENLIGHTENMENT, most of us. We disparage the idea. Rabindranath Tagore said, "We gain freedom when we have paid the full price for the right to live." We are afraid to live. We are afraid to be spontaneous. We are afraid to feel feelings. We read bad books, we look at pleasant, superficial paintings, we see films that are as facile, as puerile as possible, all because we are trying to hide in the art of ourselves.

We have forgotten how to dream. We have given up caring. We have forgotten that the world is our oyster. We are depressed as a world.

INDIFFERENCE IS A STRANGLEHOLD

IT IS NOT LIFE that is withholding itself from us, it is we who are withholding from it. We say stupid things to one another, wishing everyone the best and saying good luck,

have a nice day, sorry about your wife dying, too bad about your job. We are robotic, living Life with the least possible friction, the least possible disturbance, the least possible expression, because we are afraid of Life. We are afraid we will sink further into the abyss of it. We have honed indifference into an art form. Tagore said, "The world suffers most from the disinterested tyranny of its well-wisher."

Indifference is a stranglehold on Life. Indifference thinks it can get away with its insouciance, with its scorn of passion. It thinks it can slide through on its side until Life is over, until the end. Indifference is a tool of isolation and loneliness and of manipulated withdrawal. It is a nearly impenetrable defensive tool. That way its heart is safe, its heart shall be risk-free. But the heart of the world is broken. We could love our home back to us, and our bodies which are earth. We could bring ourselves back from the brink, our home that we have beaten with sticks, and our bodies that we have destroyed with illness and suicide.

Nothing can hold back Life

The truth is nothing can hold back Life, no matter how much we pretend not to care. Life is a passionate affair. When we withhold our passion in our art of Life, we

are just withholding, our paintbrushes in mid-air, our song cut off at the throat. But our art calls us to itself. We are called to live fully, and in time, we discover how to do so.

Perhaps not in this form. Perhaps in this form of our Life, in this lifetime we will make it through hiding. Many of us go from childhood through death in denial of Life. We make indifference our art. We make shallowness our art. We put a block in front of our heart and make denial of Life our art.

But it won't work. It will never work. In some form, sooner or later, we will express fully in Life because Life is for expression. We can't get out of it.

We can be bad actors as long as we want to. But the audience doesn't care about bad acting, it cares about good acting. It cares most about very good acting, acting so good that it's not acting at all. And who is the audience? We are. You and I. We are the actor and the audience.

Thank You Mother

When I act on the stage, before my first entrance, as I wait in the wings, I say aloud to myself, to me, and to my character, and to every actor in the play and every character, and to each member of the audience, I love you. And

I say, thank you Amma. I say I love you to all, and I thank Divine Mother. This is my way of calling to the heart of Life. When I do this, I take myself out of myself as an individual expression, and put myself into the expression of us all, of all of Life. My heart then, is the magnanimous heart of the Mother, as I go on stage, and I have no fear.

Expressing from the heart of love sets me free, and I can give myself with joy to my character. It does not matter if she is heavy with the deepest pain as Jessie in 'Night Mother, or if she is light and playful as Elvira in Blithe Spirit. When these characters came to me I loved and gave my heart to them both.

We do not and never will have one story. We have infinite stories to tell in time. The reason for every story, at its heart of hearts, is love. It is to experience passion that transforms into compassion. It is to experience suffering that transforms into humility. It is to experience fear of love that transforms into the freedom of love.

We Awaken by Practicing Life

THOSE WHO ARE AWAKENED in Life are not awakened by practicing awakening, they are awakened by practicing Life.

Practicing Life, all of Life with nothing left out, all of Life with no materials unused, no feelings unfelt, no place in the heart left unexplored in its multitude of expressions.

LOVE IS THE ART OF LIFE

WE CANNOT GET OUT of using any of our material. Our finished art is being in love with all of Life. It is our finished art because love is the art of Life. That's what we are doing.

In our art in progress, we make cataclysmic mistakes. When we fall in love, it takes time to understand what it means, this surge of love. We go too far. We mistake it for a thing instead of a place in motion.

Some never fall at all. Others fall not for the expression of the other, but for the magnification of themselves. This is Narcissus gazing at himself in the pool before he drowns in himself. This focus on the self is so demanding that seeing another, feeling for another is not possible. The basic self missed the step of cohesion. It lacks integrity, the newel at its core. It cannot create since it is not aware of itself as viable. It can only be created through its reflection in others. Narcissus borrowed himself from his mirrored image in the water because he was insubstantial in himself.

Just One Sparrow

A Picture of a Picture

Narcissism is always the opportunist. It loves grandiosity because the bigger it is the more real itself seems. It is a tool of interest, narcissism is. It has to make itself seem real when it is not. It has to seem to have heart when it does not, it has to seem to have substance when it does not. It is a picture of a picture, a hollowness that cannot be filled because there is nothing there to fill. In its extreme its need is a true void whose appetite has no point of satiation.

Since it has no heart, it has no conscience. It is but a need with no end. It becomes dictators and capitalists and patriarchs and war generals and beaters of people and animals and burners of the land and killers of all sorts. Like every tool in our tool belt, narcissism is just another. But when it is left to its own devices, without form to remind it of its proper use, it creates a devious and devouring monster.

We are Reflected

A mirror image of ourselves does have a good use, and it is to see the kind of form we are, that we ourselves, like all things, have beauty of form outlined with structure. We need

this tool of the mirror only to see that what we are is reflected in all of Life, that all of Life has integrity and heart, as do we.

Other times, instead of remaining in integrity, we merge. We allow our colors to be the colors of another. We fail to stand alone. Form gives in to structure. We become shadows. We come to a place in our dance where we are non-functioning, subordinate, a supernumerary, a tag. We become a stand-in for who we might have been. In the past 2500 years women have become stand-ins. Children have become stand-ins. People of color, old people, sick people, poor people. Even ordinary men have become stand-ins for themselves. We have allowed ourselves to be robbed of form.

We concede to the other. Instead of expressing ourselves we concede, we give in. We sacrifice ourselves and our lives. In the last century self-expression fell into direct disrepute. The passion of women's emotions was denigrated and labeled and put into medical books. Social passion for civil rights and economic freedom was met with clubs and guns and entrapment.

Passion is Frightening

Passion is frightening to reason. In the moment of passion reason is pushed off its metronomic base. It

is an eternal juggling act. But in the end, passion is the way. Nothing that is created can be created without passion. Passion is not meant for reason, reason is meant for passion. Passion leads because passion is the heart of Life calling for expression. It is reason that is the respecter of passion, not passion that is the respecter of reason. Reason must listen in the end. Otherwise reason would reason itself right out of Life into non-existence.

Creating Alone in Companionship

In relationship with others, if we allow ourselves to merge, the Life of our colors fade into sludge. What colors could we have been? What songs would we have sung? Into what kind of shape would we have molded our lives? When we see one another for who we are, creators of a unique work of art, what we want to do is watch in wonder, just like we do a rose or a tree. We want to watch companionably, as we too, the rose beside, create our own picture. When we are familiar enough with one another through our souls' meandering, then we have enough recognition to know how to create alone in companionship, like the sparrows. This individual companionship represents us all in time, all of humanity in its completed art.

In the meantime we are artists not with a completed work, but a work in progress. We are in the midst of artistic crisis and don't know where to turn. Wherever we turn is the wrong direction. It's the wrong dance step, the wrong musical note, the wrong color. But we want to find it. We want to find the right move because we know it is somewhere and we won't give up.

Wanting is Good

THIS IS THE GOOD of wanting. Sometimes we feel it is our desire that is the trap. Our desire keeps us in the trap of wanting, and as long as we want, we won't get free. This is not so. This is mistaken. Wanting is a good thing. It is a most valuable instrument. Wanting is not against us, as if it were a foreign body somehow having taken possession of us. No. Wanting is for us. Wanting doesn't obscure the way, it shows us the way. We can not want for time immemoriam and it won't do us any good because not wanting is denial. It is not admitting that we want, and it won't work no matter how long we do it.

There is no such thing as not wanting. It doesn't exist. Life is living, and it is the wont of Life to have Life, to express as Life. Wanting is our lamppost beckoning.

CALLS TO FORGOTTEN DREAMS

When I wanted alcohol for twenty-six years, it wasn't wanting that was my dilemma, it was the object of my wanting. I wanted alcohol but alcohol did not want me. It's not as though the fulfillment of alcohol was the answer to my wanting. It was not and never was the answer to my wanting. All alcohol was was a hoax. It was jinxed. It wasn't the real thing at all.

But my wanting was not at fault. My wanting was calling me to something else all along but which I couldn't find. And I couldn't find what exactly it was that I wanted until I got away from the substitute that alcohol was. Then I could discover that my wanting was calling me to forgotten dreams, to what my passion was calling for, to find the form of my art besides the lessons of extreme use of a substance in an attempt to make it viable. The square block in a round hole. It would never work.

Wanting is a Great Gift

Wanting is a great gift. When you want something with a passion, it's a clue. It's a message from your art to you. It is not nothing. We must pay attention to what we

want, because it is through what we want that we find our art, and through our art that we find Life.

All Life on earth wants.

Each day Maude and I walk down along Willow Creek. The other day I came upon a lone Mallard duck on the path ahead of me. Maudie had lagged back so the duck was not startled but only looked at me and quacked quietly. I took a step toward her and she took a step further up the path. I loved the duck. I love ducks. I love ducks with a passion, they are so beautiful. I said hi to the duck and talked to her quietly and she quacked gently back at me. I said, I hope your nest is on the other side of the creek, thinking about the big dogs that run free sometimes along this path. I became concerned about her being alone, hoping she had not lost her mate. Where's your buddy? I asked. Where's your mate?

I walked slowly along and she waddled along in front of me, staying off the path, quacking quietly. We walked to the end and around a curve, and suddenly there was the drake. There he was! He was off the path in the grass and came right up to the little duck, and there they were, together. I felt overjoyed with happiness. There he was, and everything was fine, and right as it could be. The duck wants her mate, the drake, and the drake wants his mate, the duck, and together they want little baby ducks.

And the little baby ducks want their parents. And they want the water to swim in. And they want to grow up and be big ducks. They only want a few things and they are happy.

The Nature of our True Wanting

Wanting is good. When we want something we don't really want, like alcohol or money or power, it is those very things that reveal the nature of our true wanting. I may die of alcohol poisoning, but my form will re-form and my wanting will be the same wanting that turned to alcohol when I was in another form.

We don't want excess alcohol, we want to express without it. We don't want power in excess, we want to be powerful without over-wanting power. It is not alcohol or money or power or any anything that we want in excess. It is not the thing itself that the wanting is about. Excess wanting is about excess wanting. Wanting has purpose. When we want because we want, it is a clue that we've gone off track. It is a voice saying to us, wrong way.

Not alcohol or money or power or position or possession have anything to do with wanting itself. Anything and

everything are only representative of what we want, and what we want is Life.

We Want Life

We want Life. We want expression. We want to be. We want to create our art. Our art is Life. That is what we want and it is what wanting is for.

Wanting is an instrument of joy. Not wanting is an instrument of joy. They are both steps we can and do take. If we move left in our dance and it's wrong, then we do not want to do it. We know we do not want to move left, we want to move right, and we do it. We cannot know what we do want and not know what we do not want. When I am directing a play I know exactly what I do not want as soon as it happens. When an actor is too far upstage I bring him downstage. When he misrepresents his character, I hear this immediately and know it is not what I want. He comes further into his character until I hear the voice of the character, and I know this is what I want.

We do know what we want and what we don't want, and as artists we keep trying, we keep searching until we

find what it is. And when we see it, we know it absolutely, and we say, yes, there it is. That's it.

Wanting is the Passion

We cannot awaken through practicing not wanting. Practicing not wanting is like trying to paint with no paint. It is like trying to sing a song with no song.

Wanting is the song.

Wanting is the suffering.

Suffering is the fire, the wash through which all is cleared away but the pure heart of Life.

Wanting is the passion, calling for its home in compassion.

There is no way but to want. Wanting is the gift of a clue. Watch what your clue is telling you. You cannot awaken to a Life that does not want. You cannot deny the call of Life for you. Life wants you. Life wants you to awaken to it. What we awaken to is the want Life has for us.

We Subvert Our Wanting

Yet there is no limit to what we will do to lead wanting astray. We create all manner of solutions to our wanting.

We think we have to be saved from our wanting. We subvert our wanting and create a scapegoat and call it the devil or Satan or some other god. We call alcohol the demon, we call drugs evil, we call gambling devil possession. We call lust evil, we call hoarding keeping the company of Satan.

We have created evil, so great is our wanting for Life and the ends we will go to go get it. Evil is a manifestation of our abdicated wanting. Evil is the things we want and deny, and evil grows with the rage of our rejected feelings. It feeds on our shame and is gluttonous with our guilt. In the Hebrew creation story we have a veritable gourmet meal for the devil, man and especially woman being born bad, defying Elohim, Yahweh, being tossed out of the pure world to fester in guilt and shame throughout eternity.

In the two creation stories there is in essence one being created, man. Man will have dominion over secondary creations such as the earth and woman. In the end this afterthought wouldn't work out very well. It was not a good plan but an ignorant and selfish plan. The writer of the story lived on a swatch of dirt around a fig tree. How could he know his local creation story would be taken over by half the world? If he had known that he would have done better. It just goes to show you. This little story conceived around the fire while eating locust stew was the beginning of the end. Eventually the dominion of man would dominate the world to death.

JESUS, AN ENLIGHTENED BEING

JESUS WAS A THROWBACK to a time before the Hebrew patriarchy took hold. He had no such limited ideas. He had transcended his roots. In John, he said, "Even before the beginning of time, I am." Jesus was awakened to the pure being of Life where there is no time and all things are equal, where there is no hierarchy, there is no such bullshit. He didn't give a fig, and rode into town on a donkey. He didn't have anything to prove and that fact angered the Roman upper echelon more than anything. He didn't necessarily have courage, he didn't have anything in particular, he just knew the truth of Life.

But Jesus was short-lived. Rome stepped on him like an ant. His audacity could not be tolerated. Rome's control was ideally perfect. The Jew's were acknowledged as little as possible and then only for a time before their homeland and their temple was sacked again. Jesus, a common Jew, was a minor irritant. His execution was one of many, other violators of Roman Imperial whim and caprice. Rome's massively entrenched ego would manifest in figures such as Caligula having a statue of himself erected in the temple of Jerusalem. No, Rome could not abide a single independent step from riffraff like the Nazarene.

Proper Messianic Expectations

That was the shape of our sculpture then, and it has been the shape of our sculpture since. Jesus was a little light who turned out to be a big disappointment. He did not meet proper messianic expectations. So people added to his story. Instead of leaving him dead on a cross along with hundreds of others who dared insurrection, he was resurrected. He was given a birth story that fit with Hebrew tradition, and miracles were created for him to prove his metal as the messianic material that had been expected.

Paul arrived with his prevarications. He ignored the Life of Jesus, his parables and aphoristic teaching, and took hold only of the resurrection story, and created the Christ. Jesus would be it. Jesus would be the messiah, the rescuer and redeemer. He would be Jesus Christ.

A Trap called Church

Jesus, who once was a light of Life and love upon the earth, was grabbed and put into a trap called church. Here he could be safe. Here he could be kept. Here he could be exploited. After all, what good is the light of truth without

getting it nailed down and organized? And what good was knowing the truth if you couldn't tell others what it was? This was the dance we were dancing.

The Christian church took the Hebrew creation story portraying humankind as most probably a mistake, and elevated and universalized sin so that the inherent bad in all could be reflected, and an empire of guilt and shame-based control could be established. Constantine brought a few of his cronies together at the Council of Nicaea and they came up with the proper Christian belief once and for all. They wrote up an oath and called it the Nicene Creed. From then on, if you believed in the creed you were good, if you didn't you were evil. If you spoke the creed you were saved, if you didn't you were damned. It was easy for all. Women would not lead in any area. No such thing would ever be considered. The Gnostics, perhaps the broadest interpreters of Jesus' teaching were reviled as rebels and blasphemers. All beliefs were rejected and subject to punishment by the law of the Roman Christian Emperor. Didn't we just do that a few years ago?

A Fate Worse than Life

CHRISTIANITY THEN, WOULD BE according to the Cronies of Nicea with the promise that if you commit to these

words eternal Life would be assured. Death would conclude in an afterlife of reward according to obedience to the church, or punishment and eternal damnation for infractions. What finer way to control than to create threat from a world beyond, the truth of which could never be known and the reality of which could never be seen?

Death was not a process of Life, it was an end and a portal to a fate worse than Life. Our art again outpictured desperation and limited intelligence. We refined the tool of control through illusion and intimidation. Our creative structure was an endless font of ideas for how to stand without substance.

STRUCTURAL ENERGY GOES TO TOWN

ONE CHURCH, ONE CREED, one power. The church became the state. This was a good idea, this Christianity. The structural energy of control in our art loved this new beginning. It was like taking candy from a baby, it could make whatever it wanted. It was an opportunity to use sin, guilt and shame to advance the position of power and control that was beyond imagination.

Reinforcement was called in. The Last Supper story was written and Eucharist was created. This was a stroke

of brilliance. How better to remind Christians of their sin and worthlessness than to make it a blood ritual? Now they could never forget. Now not only were they born in sin, but somebody died for it. People would be held in the bondage of debt forever. What a coup.

Through Communion Jesus would be the sacrifice that Christians would pay for. How could they pay enough? They could never pay enough. This church of the state couldn't believe their luck. It held all the power, all the devotion, all the money, all the lands, all the lives of all the people forever. It was too good to be true.

REMINDERS OF GUILT AND SHAME

THIS CHURCH OF OURS, of the state of Christianity, built buildings for followers to go into and pay penance to the war god Yahweh that we took from the Hebrews, and to the graciousness of the state who interpreted it. This bit of our art was going fine according to our instruments of power, control, greed, and selfishness.

With the church of state we helped people remember their worthlessness and shame in every way possible. We sculpted icons of a dead naked Jesus bleeding from a cross and put them above the communion alter in every building.

We expropriated the name sacred and gave it to the image of the corpse of Jesus, and then expanded the name to the communion table and to the whole building. This we did so that people wouldn't ask questions we could not answer.

We stole another name to keep ourselves hidden and that name was holy. The more things we called holy the less we would be challenged. Because sacred and holy were words of superstition. What you did with superstition was do it or not do it without questioning, without reason. Because what was holy was the whole thing, the whole story, the whole explanation. We called the buildings of our state religion, churches.

We called a history book holy and called it Bible, library. We called rituals holy, we appointed men to carry out the affairs of our churches and called them holy. We called the emperor and the whole empire holy. We are exploiters of Life and of language, of all things that we think can get us what we want.

We Made Christianity Infallible

CHRISTIANITY WE MADE INFALLIBLE, and we made all its representatives infallible. That way, with what was sacred, holy, and infallible, people could commit their loyalty since

their questions about Christianity and Jesus could all be answered. These are the buildings, these are the rules, these are the ways to salvation, these are the punishments, these are the men who can teach the ways, and they are holy, we said. They are so because they are holy. What is holy is what is holy, we said.

We Called Unholy Evil

This seemed a perfect system. We made everything sacred and holy that we didn't want to and couldn't answer, then we created the unholy. It was unwise to mess with the unholy. We didn't like unholy because it meant unruly. It meant people thinking things through, and we couldn't have that. So we called the unholy evil, and added that you couldn't get away with it. Not only would your soul be stolen by the scapegoat Satan, but your body would perish with it. What was, was. If you played the game you were spared, if you didn't, you'd be eliminated.

Christians took on the role of Divine. There was no way out. Your only salvation was through the gates of the state church of Christianity. The church was God of the lonely and abused, and Jesus was the poster child.

We Wandered out of Position

But while guilt and shame worked miracles for keeping each other lifeless and clueless, we still tended to wander out of position. So we used another handy tool called the threat of elimination through the fires of hell. We came up with quite an exciting story in Revelations. After the battle of the end of time the good get taken up to heaven, and the bad get left on earth to die deaths of suffering and agony. This is the fulfillment of the Christian promise of salvation and the torture of those who question the authority of the Christ. This was another way we could use Jesus. He was so handy.

How foolish to contrive reasons for men to fight. Men must fight. Even after they are dead through the fight, they rise and fight again. Christianity and other monotheistic religions are intentionally designed for struggle through the perception of dualism. They provide a long-term opportunity for men to engage in war. This dualistic nature, the set-up of good and bad invites fighting like a boxing ring. This is why monotheism was created. Men could be heroic and fight to the death on every field in the world. This dualism, where I am right and you are wrong is the cause for the battlefield. It is the design contrived to fit the

male species. This way there is ample opportunity to gather power and control anywhere for as long as they want.

Hell was good, and the promise of it through the apocalypse was a great bit. We made a keeper of hell and called him Satan. It was an airtight system. If you didn't get caught in Life, you'd get caught after Life. This was a fine trap we set. Oh yes, you'd have to pay sooner or later, so you might as well concede your Life now, you might as well accept your enslavement to the church god of man. It is true after all, and everybody knows it, that might makes right.

Sinning Together

Our art of the Hebrew religion was a group effort. It illustrated collective guilt. It was about sinning together and paying together. But our art of Christianity was about the sin and damnation of each of us separately. You sin, you pay, you go to hell. We drew the picture of hell very well. We enjoyed that creation, it had a lot of possibility. We followed the Jewish theme of wrongdoing bringing on disaster. We created what was right and what was wrong and then set up consequences which we called righteous judgment. It was all part of the game. Only now instead of collective Jews it was individual Christians. We made

this Christian idea into the art of a game. The more wrong moves you make the worse you are, and if you are good enough at being bad, you are called evil.

Evil is good. We didn't realize what potential the instrument of evil had. Evil loves power. It wanted power so much that it started manifesting through human Life form. It became a part of our picture and we hardly noticed we created it. Once again we were impressed by the capacity of our materials.

We Have Called Evil Real

Sometimes evil gets into a vulnerable human form just because it wants so much to be real, it wants so much to have Life because after all we have made promises. We have called evil real. We have invented Satan and lots of other demons. What did we expect? We just don't know how powerful we are as artists. We just don't know the unlimited nature of our creation. We think Life is Life and we're something else. We say it's about Life and not about us. We create things and then say we didn't do it, that Life did it. We look at what we call devil possession and call evil real because we don't understand the nature of our creative capacity. We created evil and we did so very well. We gave

evil a mind of it's own and then we act surprised when it takes independent action.

We Can Create Life

IN THE ILLNESS OF brain disorder, sometimes manifested as altered reality or psychosis we can hear or see or feel individually the voice of evil that we have created collectively. The voices we hear or the images we see in altered reality that we call evil are not our own individual voices projected, they are our communal voice of what we have determined is evil. This is easy enough to discern. Evil knows we think it is evil. We think it's itself, that it is a separate being, but we do so only because that's the power we have given it.

All the voices and images most of us don't hear are the voices and images we have created that are unseen and unheard parts of our picture. They are voices and sounds without form on our canvas as we know it. But there are many canvases. There are worlds within worlds within worlds. It is not surprising that what we have called real manifests, even though we make it up. We didn't mean it, we say, about evil. Evil was just evil because we said so. We said so because it aided our purposes at the time. Our brains can handle good and bad, black and white, and that is nearly the extent of its capacity to date.

Nothing on Earth is Evil

We know evil isn't real. We know perfectly well with every fiber of our being that there is only Life.

There is nothing evil on earth.

Evil is just a tool, we say, like all our other tools. But how powerful is power? How powerful is guilt? How powerful is shame? How powerful is our power of threatening to eliminate one another from Life? It's powerful. And when we create evil, it gets created. We cannot pretend it's a joke. Is there evil in your heart? Yes. There is evil in all our hearts. We created it. What is this evil? It is just a big phony. It is us acting like idiots and fools. It is nothing to us. It is a power play that has run out of steam. But it is evil, it has a lot to feed on here in what we have made, here in our collective quaking heart.

Jesus was Perfect Form

There is no evil, no Satan or Satan's minions, no hell and no end of time. Armageddon, the Apocalypse is a first century action film, a scary but hackneyed Bruce Willis, Russell Crow epic drama meant to arouse fear and trembling and

entertainment. Which side will I be on? Will I support the representative of Jesus or will I be struck down by the anti-christ?

Satan is as evil as we can think at this point in our musical score. This battle of Armageddon, which represents the clash of good and evil and the triumph of good as an illustration of Life, is an instinctive sense of the need for resolution, of time coming to an end. All things die in some kind of battle. We pride ourselves in peaceful death, but death is a struggle no matter what. It is the nature of death to call through the resistance of Life. The endtime battle is the coming of death reaching for Life. The Apocalypse is the grand birth process. And what a new beginning around the corner, Life redoubled.

There is no need for Jesus to come again. He said it all the first time. He's not a warrior meant to fight evil on the endtime battlefield. He's not the type at all. Again and again he admonished his students for not getting what he was talking about. There is no external kingdom, there is no external battle that can get us what we want. But he was an awakened being. He was not understood then and is not today. The writer of the Apocalypse clearly was more interested in action drama and creating Gog and Magog than he was in what Jesus had to say.

The writer of Revelation is unknown. It has been said by older sources that the creator is St. John the Divine. But

St. John the Divine could not have been further from war department thinking if he had been on Mars.

I Am With You Always

JESUS SAID IT ALL the first time, "I am with you always even unto the end of time." He was about the truth of who we are. But Revelation was tacked on to the end of the story and many Christians and others believe Jesus will land in the Armageddon parking area and proceed to duel with Satan and his backers who will be defeated and thrown into hell. This is a child's story. It is not for those who wish to ask more of their brain and of their heart than this Roman coliseum-type endless slaughter of sinners.

The New Testament books are creative non-fiction. They contain a few of Jesus' actual words and acts, and versions of stories people told about the person of him. Jesus came along in the middle of a big chunk of our symphony that was about structure's futile but murderous attempt to dominate form. Jesus popped up right in the middle, and there he was, perfect form, awakened heart in the middle of sleep struggling with itself.

He was just a blip on the screen of unawakened fury. But while everything about him could then be stepped

on, distorted, abused, dismembered, sold as priceless, and tossed aside as junk, the form of light that Jesus was has never been blown out.

It has never been blown out because it was there all along. Jesus was just a song of Life. The song of Life always is and always has been. We can hear it anytime no matter how much noise we make to obscure it. Nothing will ever stop the song of Life from singing.

THE END

"Oh my dear sisters,
our life is not over yet.
We shall live! The music is so gay, so
joyous, it seems
as if just a little more and
we shall know why we
live, why we suffer...
If only we knew, if only
we knew!"

Olga, The Three Sisters, Chekhov

17

Jesus Was An Actor, Christianity Was A Show

Angels or Demons

We create demons and angels just like we create evil and good. Demons reflect what we reject, angels reflect what we desire. But there are not angels of this earth anymore than there are demons. There may be extraterrestrials who we have experienced and called angels or demons. But they would be ETs, not angels or demons. Angels and demons is our own archetype of good and bad. But angels and demons as representatives of a Christian God do not exist anymore than God and gods exist. Even if we created demons and angels and gods and world religions as a result of our experience of alien presence on our planet, what angels and demons represent is a natural intuition that we live in opposites. Our continual desire is resolution and thus balance. We create and enjoy our sculpture of good and bad. We enjoy

this bit in our score because we have an understanding of it within ourselves.

In truth neither good nor bad exists, neither you nor me, neither the planet nor anything visible from the planet. In truth there is only nothingness. We do not exist except as expressions of Life. We do not exist except as art.

Ripping Off Truth

In my work "Acting the Essence," I have a quote that goes, "How much truth did you rip off today? How well you can rip off truth cannot get to be an art form."

But we can get very close. We create very good copies. We create evil so well we deceive ourselves. We say, This situation or this person really is evil. Ripping off truth can get to be an art form, but just like a forger of Titian, the art is in the forger, not in the forged Titian.

The great film and stage actress Viveca Lindfors once said to me, "You cannot cover up not having connected with cleverness." What evil is is too much cleverness. It's us not having connected with our heart. Evil thinks it can make an art of ripping off the truth. But it's all "full of sound and fury signifying nothing," in Shakespeare's words. When all is said and done, it is not the loudest and

toughest religion or actor or painter who gets the attention, it's the realest. It's the one that's truest to the heart of Life. It's the best.

Jesus was an actor, Christianity was a show.

Jesus was about the art of Life, Christianity was about building the facade, the backdrop for the drama.

Out of Thin Air

THE HEART OF JESUS was merciful, and his was the heart of Life. He could see things would get out of control, just like they always do when art is being created. He could also see that at the core of the effort there was a real desire, a genuine searching for the right note, the right shade of color.

He knew because he went through it himself. He was not an automatic master of the art of Life. He did not descend out of thin air. In some form, in some time, he went through the struggle and came to the consciousness of awakening. Jesus got that there is no other way to learn the art than to do it. You don't get a free ride. You can't con Life into letting you not do it. If you are Arthur Rubenstein you are Arthur Rubenstein. You can't be a fake piano player and be Arthur Rubenstein.

Jesus as Arthur Rubenstein

Jesus was the Arthur Rubenstein of the art of Life. Not because he was appointed, or recruited, but because in some time, in some form he practiced Life until he got it. He got the concerto right.

Jesus was not Jesus because he was created. He was not a star because he was discovered on the movie set with John Wayne. He was what he was because of his own art, his own work. He might have brought the awareness of his art of Life into his Lifetime like Mozart did his melodic capacity. Perhaps he went to Buddha's cave and spent his own nine years in retreat. But at some time he put his heart and mind to his calling and learned how. He awakened to his art just like Rubenstein did the art of the piano.

Jesus Already Crucified

He did not come into his enlightenment through crucifixion. The crucifixion was an historical event. Jesus didn't suffer any more or less than any of the other thousands who were crucified by the Romans.

He brought his crucifixion with him to us. He had already been crucified, and he had already arisen. He brought his awareness with him and he gave it to us. He sang his song for us. He sang it for us freely. He said, "What you want you already have, you already are. You are the light you want. Jesus had seen the light. He said there is only one thing and you and I and it are the same. Sort it out, he said. But we were daft and couldn't sort it out. Today we are daft as well. We have not gotten the message. But we're on a cusp ready to cross over. New consciousness cannot be long awaiting.

Rubenstein can show us how to play a tune, but it is another thing for us to play it like Rubenstein. It's just not the same. No. We have to do it ourselves. We have to learn our own way. We have to create our own art, in our own time. Jesus and Rubenstein, they did the work that took them home. Every great artist gives us hope, shows us what is possible. They lift us up with instant Life. That's what art does. All we see in Jesus is the sense of a great artist at work, that's all he was.

A Preview of Eternity

In Acting the Essence, I say, "Art is a preview of eternity." Jesus and Rubenstein, Bach and Mozart,

Titian and Donatello, all of them, all true artists, show us what and who we are. All fully expressed art is created Life. It is Life living. We recognize it because we can. We see it because it's who we are, it's where we're heading. We behold the art, and our heart says yes. Yes.

Recognize the Life

It is not the picture or the tune we recognize, it is the Life. Virginia Woolf said,

"Hamlet was,
and a Beethoven quartet was,
but there was not Shakespeare
and there was not Beethoven
...and there was certainly not God.
...We are the words.
We are the music.
We are the thing itself."

There was the Life of Jesus, but there was not Jesus. There was the Life of Siddhartha, but there was not Siddhartha. There is the Life of me, and of you, but there is not me, and there is not you.

Easier to Create

Why is it that there seems to be so few great artists of Life? Why can't more of us do it? The art of Life is an ambitious undertaking indeed. It is a trickier affair than the art of the world. What we create in the world requires our distance from it. But Life creating us in the world is a more difficult task. It is easier to create the picture than to be created as the picture.

Life into Infinity

All expression is Life creating itself. What we are, as transformational expression, is Life having created Life having created Life into infinity. Wave after wave after never-ending wave.

Art in the World

When we compose, when we sing, when we dance, we are re-creating the art that we are. All art in the world is expression of the art of ourselves. The reason we create art is because it is a depiction of the home of our heart. We create

the art to answer the art of us. It is a communication with the heart that we are. Every time we express, we are creating our way backward. But the only way we can go is forward. We hear our art and look at our art and feel our art and it says to us, Here I am, I'm still here, keep going, come this way. Our art reminds us who we are, that we have Life and are Life. That's why we do it. And all of Life expresses, because that's what Life does. It connects itself with itself. It is the crest connecting with the wave, the pulse with the rest. It is the motion of Life. This is the dance that all things are.

Be the Dance

What the desire of our heart is, is to not only dance ourselves, but to be the dance; to not only ride the wave, but to be the wave. This is the true art that we are creating. And this is the reason it is harder to do, because it is harder to be than to do.

To do is structure, to be is form.

The reason the art of Life seems so hard is because we don't really want to do it. We don't want to be, really.

We want to do. We are active. We have energy yet to expend. We have ideas yet to use. We don't want to be completed. Yet when we are completed, we will be completed.

Life Creates New Art

WE ARE NOT COMPLETED because we are not completed. When we want to be completed we will be completed. What is Jesus doing now? What are any awakened ones doing now? They are new art and they are creating new art. They are creating altogether new art because that's what Life does. Awakening to the art of Life is the catapultion of the crest, the collapse of structure which is reality, and another wave begins. The motion goes on. There is never not nothing, and there is never not something. There is never not the motion of love. The motion of love is creative. It cannot stagnate, it cannot be void.

There is not void.

There is only nothingness, and there is only somethingness.

There is only the dance of love. This is all we know. We do not and cannot know anything but love.

The Heart of the Heart

When we doubt our heart, when we reject our heart, when we fortress our heart, it is our way of moving forward in our art. It is sincere effort. No matter what deception we layer the heart with, the heart of the heart is true. The heart of the heart cannot be but true.

It is this truth that pulls us forward. We lag, and bog, and get stuck indefinitely, but the heart calls us to it and we go. The reason we don't all awaken is because Life is not an object to be handed to us like a jewel, it is a creative process that we get to do in our own time and way.

Our Way to Awakening

Awakening is not just handed to us, because it is not already created. We create our way to it. Every season is not spring. We must move through winter first. In time there are beginnings, middles, and endings. This is the nature of Life. Winter, spring, summer, fall.

As transformational beings, we are free. We are free to create what we want, and we do. When we work to awaken, to be complete, we are. We are because it is in the course of

the tide. It is spring becoming spring. Awakening is spring. That's all it is and all everything is, the time of a season. Nor can it be avoided. But avoid we do, until we are done.

The art of Life is very complicated indeed. It is a creative game of the highest order. But it is not a game at all, and sooner or later we stop playing it as if it were set up as something for us to defeat. The advent of a one, singular God made Life the enemy. This is the most extreme instrument we have used. God has made Life inadequate to the task. Now that we are free of God we can begin to take Life back, to come back from our wandering to our home in the heart of Life.

Our Tool Of Lack

In the meantime, in our unfamiliarity with our materials, we are juggling and trying to find balance. We selfishly take everything we can get, all the power, all the riches, all the land, all the affection, all the devotion, all the loyalty, all the honor, and sit back in pride and gluttony. We are afraid. We don't know how to do it right. We don't know how much we need so we take it all. This is our artists tool of lack.

Little children do not know lack. For them there is only abundance. The answer in Life is to be as childlike

as we are in truth. But even though we know this we don't do it, the same way we don't turn the other cheek, because we don't believe in abundance, we believe in lack. If we don't cheat and steal and covet and hoard how will we ever have enough? What does the perception of lack give us in our symphonic score? Flat moments dragged through perhaps, and places over-made, over-colored, over-sung, over-formed, covering up the simple beauty of the perfect sound underneath.

Perceiving lack while amassing fortunes or objects big and small is delusion. We're collectors of all things that can serve to our advantage. In our consciousness of lack we can never get enough. Thus in over-building we obscure the very thing we want, to touch the abundance that our art is. Lack is a tool that cuts us off from the higher intelligence that leads toward awakening. In truth, enlightenment is capricious, whimsical for most people. Most of us would abandon enlightenment for wealth and power any time, any day.

WE DO NOT SEE

SOMETIMES IN PERCEPTION OF lack we give up. We give over. We shut ourselves away because we are afraid we can't get enough. In hurt and suffering and anger we pretend we

don't care. We go to one extreme or the other in our stage of amateur exploration. We do not see that Life is handing itself to us. It is all around us, but we do not see. We do not see because we are yet too far away from our art. We are like wobbling toddlers, falling into and out of bulky objects. We cannot do the dance well yet, we have other things to do. We must learn coordination and develop a sense of proportion.

We cannot dance because we would not know the dance, we cannot awaken because we would not know awakening. We cannot awaken until we awaken.

Teachers All Around

We have teachers of the art of Life all around us. Our extended family the animals and plants and trees and rivers and oceans of the earth are all awakened to Life. They are all our teachers. We have gotten carried away with ourselves and forgotten that the earth is our canvas, our score, and without it we cannot get anywhere. We are renegade. In our rogue state we have gotten grandiose. We think we can create from the outside in. We think we ourselves are the canvas. It is because of this that we are lost. It is because of this that we can't make it work.

And who, being lost, would not make up helpmates, would not make up gods? Who, having lost their sense of connection with Life, would not look for it elsewhere? This is how we create gods. Some of us have taken the little gods and put them all into one big god. That, we feel, is more efficient, more sensible. One God, fewer arguments.

God is Unused Life

BUT GOD IS NOT God, it is unused Life. It is our infinite materials. This is a scary proposition for us who have already made an omnipotent God to whom we have abdicated our materials. How do we get them back?

It is hard to let go of God. It is hard to take the truth back. It is not easy to take back our responsibility once we have given it away. We have made a God and even given it our divinity, given it our Life. We are empty shells without it. We think only our God can show us the way, because we are too dense and small and Life doesn't know what it's doing. We think only our God can keep us honest and loving because we do not have what it takes. We think only our God can help us when we are in need, because damn it, we are tired in our art work of Life and want to lie down with our blanket.

WE ARE EXPRESSIONS OF NO GOD

WE ARE EXPRESSIONS OF no god. We are expressions of Life. We are powerful. The Life within us is all-powerful. The power we thought we gave to God is not God's after all, it's ours.

Life is nothing but love. Life does not care how many gods we create. Life is infinite creative energy. It is available to us and is the very support of us in every breath we take. Think of breathing. How could we breathe without love? In another way, what cares if we breathe or not? Does it require caring? The gift we have for Life is itself. It is Life that is love. Our breath is the love of Life for us. We can be anything we want. Because in truth there is no lack and there is no limit to what we are. This is art and this is us as art expressed.

LIFE DOES NOT KEEP SCORE

LIFE DOES NOT KEEP score. It does not and cannot abandon us to the least degree possible. When we awaken, we awaken to this reality, that who and what we are is the beauty and truth of Life.

We Never Run Out of Music

Every form we take, every Lifetime we choose is a page of our book, a note on our score. Every form we take is a stroke of the bow on the violin. We never run out of forms to express, we never run out of chances. We go on until we realize the concerto that is creating through us, and then we go on to another. We never run out of music. The music of us is the infinite song of Life.

Our Picture Looks Ruined

And yet, we say, the picture of us together looks like a crisis. It looks ruined. It looks like we have run over it with a tractor. We are frustrated and desperate. We have gone so far that we have attacked our beautiful instrument, the earth.

We are a loose canon, a two-year old run riot in a Lennox shop. What do we do? We keep on working, using our tools that are tools of love and intelligence to discover what we want to do next. The only escape from the mess of art is through the mess. We create the mess, the Gordian knot, and if we stay with it, it will unravel itself. This is how it is done, and this is how we do it.

Jesus Was An Actor, Christianity Was A Show

The Bigger the Mess

It is no small mess that we make. We make the biggest of all possible mess, because the bigger the mess, the more potential we are given for truth to be revealed. Look at the anguish, the infinite poignance in Rachmaninoff's Second Piano Concerto, and the incredible power unleashed in the Third. It is only because Rachmaninoff went to the core of the mess he experienced in his art, and faced it, that he could create art of such astounding beauty.

In the process of creating disaster, we go as far afield as we can. It's true it is a tractor that we have used, it's an earth-crusher, it's dynamite. We go as far as we can creating boundaries and breaking them down. It is in this way that we discover the limits of the use our instruments. We break them, and smash them and try to destroy them. If we smash the earth over the head of the universe, it will be gone and we will sit dumbfounded, we will sit in regret. Oh, we shouldn't really have done that, we say.

We shouldn't have smashed the last violin over the head of the music stand. We shouldn't have thrown the book manuscript into the fireplace. We shouldn't have torn

the symphony score to pieces. We shouldn't have thrown our Life down the toilet. Oh jeez, we say, that was stupid. But we do do it. We destroy whole species of Life, of our family, and we don't really care too much. Even though that species, that frog, that bird, that cat, that wild horse, that elephant, was the last one.

Some Do Care

Some do care. Some of us care, some of us don't. And that's the state of our picture. But we are all part of the picture. There is no picture of those who care separate from those who don't. There is no such thing. Because not to care is just a stage of discovering the tool of caring. There is no such thing as those who care and those who don't. Life cares, period. Caring is its nature. The instrument of caring is to learn how to care. It is not a choice. We don't get to reject any notes from their possible use in our score. And we don't want to. We want all the notes, and we get all the notes.

But if we smash the earth in our infantile cluelessness, when we lose our balance and our crystal room falls to pieces, we will find another room. We will find another room because Life will give it to us. Life has no boundaries

and no limits, and everything it has it wants to give us and does give us.

The Earth is not Life

The earth is not Life. The earth is not Life anymore than we are Life. Our form will perish with the earth, just as it will in time no matter in what way it happens. The form of Life is just form, and in time, all things express into the crest, and are let go into the wave. There is only nothingness. There is nothingness, and there is somethingness. There is Life, and there is earth, and there is the dance of love between Life and the earth.

Life Suffers to Live

But Life wants to live. It wants passionately to have Life. There is nothing mediocre in Life, even though we learn how to use the tool of mediocrity. Life suffers to live. Life is heart. It can only be real in its heart. Life does not exist in anything that isn't anything except the absolute fullness of its heart. There is no other Life. There is no other truth in the art of our Life but that which is the heart fully expressed.

THE STAGE OF LIFE

W𝙴 𝙲𝙰𝙽𝙽𝙾𝚃 𝙼𝙰𝙺𝙴 𝚆𝙷𝙰𝚃 is not real, real. We want to be real on the stage of our art as much as on the stage of our Life. In "Acting the Essence," I say, "Not acting means feeling all the joy, all the agony, all the anger and strength and longing of the one you are giving Life to. Not acting means feeling those feelings truly. We claim the feelings of the one we are acting in depth and breadth just like we claim our own. As much as we can be someone else is as much as we can be ourselves. We want to not act anyone else just as we want to not act ourselves."

What we want is the truth of ourselves in the art of our lives. And we are the truth of ourselves. But what we do in our blindness is try and make it instead of be it. We try and act it, and our acting creates absurdity. We become an absurdity of pride. Arrogance comes in and we like arrogance because it helps reinforce our falseness. We become masters of techniques to show we are what we are not.

We can appear to be munificent, generous, kind, considerate, understanding, and trustworthy. But what we are instead is small, devious, sneaky, and scared. We are just a backdrop on loose hinges. And when the hinges slide from side to side we get insecure. We get more scared because

we've built the stairs with no newel again. We feel we are on stilts and paranoia sets in. To off-set the paranoia we puff ourselves up into grandiosity. We become infallible. Our word is law. Here we come again, pomp and glory again, no clothes again.

THE LOOSE HINGES SLIDE

IN SPITE OF THE six-figure income and the penthouse office and a score of hopping minions, the loose hinges still slide. Nothing assuages the paranoia, and we gather more titles and awards to sandbag our fortress. Harder and grander, we bilk our adversaries out of their bits of space. We rule every corner in town. The plot to topple us grows closer and we build more electrified fences to stay behind. But it is not possible for us to think we are the prisoner. Indeed, others are more and more likely to commit infractions and we deal with them swiftly. We throw them in jail and it seems the more we throw in, the more there are to be thrown in.

In the depth of our false being, we fracture. Our loose hinges fragment our backdrop. In the world of our picture we create misery, illness, and death that enters through the eyes and bodies of one another with our foolish energy. We

have penetrated the thinking of others through skewing their balance because our paranoia and grandiosity overflowed the greed and the pride of us. Our fractured being ran from us in rivers.

In creating fracturing in our picture, we outpicture fractured structures in our lives. The brain disorders of schizophrenia and Alzheimer's for example, are diseases of fragmentation, diseases of those in fractured cultures with fractured consciousness. Fracturing illnesses are irreparable.

Our Fractured Backdrop

IN THE FRACTURING DISEASES which we deny with greater fervor than ever, more and more young people are afflicted. We do not know that there are more people with schizophrenia than heart disease and lung disease combined. This is a fact we do not know because we do not want to and we will keep our heads buried as long as we choose. Brain diseases are unpopular and should continue to languish in the closet for as long as possible.

We can see the image of ourselves in the diseases of fragmentation and we fly into a rage at being caught. We defend ourselves by blaming the ones we make ill and go to any lengths to supply proof backed by science and by social

decency. This is outrageous, we say, the audacity of other people to present themselves with such an ugly condition. The nerve of those loose hinges.

It pisses us off royally, so not only do we blame others for the illness we created, but we dismiss them entirely, calling them of no significance anyway. We exile them and give them the tag of insane. Illness was one thing, we say, but this is going too far. We cannot chance it, the discovery of our fractured backdrop, so like the child we are, we say, They did it, this insane person brought it on themselves. We blame it on the ones we make ill. But, there we were, ourselves, revealed right in the midst of fractured illness. We don't want to be seen with sick people who make us look bad, so we deny their existence altogether and toss them out the door and onto the steaming grates of city streets.

THE FRACTURING ILLNESSES

FRACTURING IS THE DESCRIPTION of psychosis in schizophrenia, bipolar disorder, depression, Alzheimer's, brain injury and other brain disorders. They are throwaway illnesses, illnesses that are objectionable, unacceptable, and incurable, even though these illnesses have no class, no

country, no sex, no race. They effect us all, for they are the outpicturing of our fractured selves. But a few in our picture are beginning to pay attention and to come around. We are beginning to understand that the illnesses we create are directly an indication of our own minds and our own world. We are starting to catch on to the resemblance to our deepest selves.

Surely we cannot affect one another's genetics to produce these ugly diseases. But we do. If others influence my self and my life, then they influence my brain chemistry. For generation after generation my energy has affected your energy. Our reaction over time and in the moment is health or disease. Oh oh, we say, what do we have here? Instantly we act so that no one can see this violation of self that these sick people are displaying. We put this ugly bit aside and leave it there.

We don't like to admit liability in our artwork, but the problem is, we're the only one there. There's no one else to do it but us. The mirror-image illnesses we have created are threatening and we have to dispatch quickly with those who are afflicted, those who we have made to carry our burden of mistakes. We put them in prisons called institutions for as long as we can get away with it. When we let them out we do so grudgingly, releasing them into the

suburbs and cities where they are not accepted as credible anyway.

Misguided Through Labeling

Many people respond to their lack of self with narcissism. Better to not have genuine feeling than to continue being hammered by your father or someone else bigger than you. These are the children who we have made to harm others, misogynists and child-abusers, and rapists and serial killers, all those who reflect our lack of truth, our fragmenting backdrop, we either use to serve our own purposes, or we punish and kill with vengeance equal to the way in which we feel ourselves have been punished.

It is only because we have misperceived the thing we are judging that we reject one another. We are misguided through labeling. If we do not label anything from moment to moment, if we do not name anything, any object or process or idea or thought of any kind then we become available to see without categorization. If we can see all things new, with no description and no label, then we are on the way to seeing original form as it exists in presence.

Nothing is itself. When we think we have a thing nailed down and thoroughly explained, we look at the thing or the person and realize we don't know anything more than when we started. The person, the thing, is absolutely indiscernible. This is because the thing or the person is not what we think it is and will never be. Anything, all things are expression. They are Life energy flowing like a wave into reality. Once we begin to stop labeling all things we allow fracturing to be mended because it is not nailed down where it can never move again.

Labeling dismisses the deeper truth of all things. It disguises it and says what's false is real and what's real does not include those who we have done with. We label an experience or a relationship and put it aside as finished, usually without looking and without thinking.

Nothing is Excluded

THE TRUTH IS THAT all of what we are is mirrored in our art. Everything is in our art with nothing left out. We do not get to exclude anything from our art. All of what we create is there. The purpose of art is to give us space in which to be. The purpose is to find the heartbeat that calls us. When we create the art and find the heart, it is not us

alone that sees it, for if we hit the heart target, it opens its eyes for all to see. We are drawn then to the art. Whether the symphony or the sculpture, the film, the painting, or the dance, we are drawn as if to Life because in truth art is Life. It is living and that's what makes it art. No art is art without being fully alive. The purpose of art is the revelation of Life. We cannot not be art. Art, expression, gives us a way to become what we are.

Given Through Passion

We cannot escape the passion that is Life. We have infinite teachers, and they are teachers because they have come into Life through the passion of heart. Life is given through, and born in, passion. Everything on earth is a teacher to us. And we, ourselves, the Life that we are, is a teacher to us.

The Hindu goddess Kali is unborn passion and passion renewed. She is the devourer of ego. She is the power the night gives to the day. She is the something of expression that becomes in time. The day is the day because of the night. Kali carries us through the night till dawn.

Somethingness is something because nothingness is nothing. In our art we are the darkness becoming the day,

and the day becoming the darkness. We are in the motion, and we are the motion. Art is the love of nothingness and somethingness. Not anything in Life is outside of art. Life is art and art is the love of Life for Life.

WE ARE THE LIVING ART

WHEN WE AWAKEN TO the illumination of day, we awaken in love and compassion and humility. This is the fulfillment of our art of Life. We ourselves then, are the living art of the art of Life. When we experience one another as awakened, we know this, we recognize the art of Life. We know the teachers of the living art of Life by what they are. We know one another in awakened being by the light of Life that we emanate. It is the Life we see in all art.

In one another we experience the light of illumination within our heart. We do not know by what is uttered in words, but in the song of Life that is singing the heart. We do not know by what is recorded in books, but by the living story of Life. We know an awakened heart of living Life in the same way we know the awakened Life of any art. We can see it, we can hear it, we can feel it. We know it because the heart of us and the awakened heart recognize one another. We know the awakened heart of living Life

because there is nothing hidden, nothing separate, nothing cordoned off in all of being.

THE AWAKENED HEART

IN THE WORLD, I think of Amma, Divine Mother, the infinite compassion and humility that is her presence. She is a fountain of the unlimited Life of love. She is the awakened heart. In awakening we have known a breakthrough in consciousness that reveals the true nature of self and of reality. Every time we gain knowledge we reach a new plateau, a new window for light to come in. And yet, while enlightenment is the point it is not the point at the same time. We think enlightenment is the ultimate experience on earth. To see more will make us happy, we decide. We'll have the answers and finally be one-up on the universe.

But it is not awakening we want really. What we want is to love and to be loved and to know who we are. Who is it that is occupying our body? What we want is to be further into the present moment. We feel excluded. Does this moment include me?

We want to belong, we want to be loved. Without love the Life within us dies. In fact it is love that we want in the presence of our days. We leave awakening by the wayside.

It will take care of itself. It is not for us to pursue. It is not separate from love. Love is the very thing awakening brings. Love is the point and the presence.

Manifestation of Heart-Mind

What enlightenment does is free us into the space of light. There we are, free to live or die. The more we go forward the less we exist in the material and the closer we are to the greater truth of ourselves. And who are we? We are the manifestation of heart-mind. We are the love of Life. We are moving on with our character, our score, our sculpture. We are creative beings that create our world.

In truth there is no place in enlightenment that is unlike any other place. Nothing is nothing. Nothing in Life exceeds anything else in Life, not awakening and not anything. Such a thing is not possible. When we awaken we awaken to nothingness.

Yet most of us are not committed to the pursuit of truth. We are more committed to the pursuit of money and power and Life as we know it. We would take any one of these in trade for enlightenment any day. No matter our choice, we shall ultimately awaken.

What am I to Life?

The point of desiring illumination is that the more we learn the more sense of belonging we have. That's what we want. We desire to know more about who we are. We desire knowledge of what we mean to Life, not so much what Life means to us. We want answers to our questions Who are we? and What's it all about? In truth although our question is what is Life? our true question is what am I to Life? This is what we wish to awaken to. Because in our art so far we have made of Life an adversary. This will go on until we let go of God. We cannot become who we are until we let go of every bit, God and every god who has been living our lives for us, every belief that weakens us and adds to our delusion.

Meister Eckhart said "I pray God to rid me of God." God is an obstacle and must be wiped clean from our slate.

Water Over the Fall

We must start at the beginning each moment without clinging to the past moment. Each moment is new and has never existed before. The idea is to drop the past cleanly.

Drop who we have been. Drop your personality, drop your name, drop your wants, fears, and desires. Drop your history. Drop your habits. Drop until there is nothing left. As soon as you speak Life let it go like water over a fall. Let it go. It is neither good nor bad, desirable or undesirable. In the end we find that nothing is worth holding onto. As in a dance we want to hold, release, hold. It we hold on too long our holding becomes a trap and the dance cannot flow. Holding on is the trap.

But in our fear we want to hold on. We don't like to drop things, we like to gain things. We feel it is only in this way we can be ourselves and protect ourselves. We feel when we find ourselves we will be somebody. If you are stranded alone on a desert island you are no one. In time you forget the past. You forget all your sources of identity. For awhile you feel you have lost yourself altogether. Who are you then? You had nearly caught up with yourself when you were left on this island. Who are you without labels and descriptions? Even your body is not you. It feels extraneous, cumbersome. You'd like to do without it. You feel freer now without the burden of self. Now you'd like to do without the weight and needs of your body. You look out from your brain. You don't know how you're going to get out but you have a sense, a calling, and you turn again into the depths of your consciousness.

Jesus Was An Actor, Christianity Was A Show

NOTHING OUTSIDE SCIENCE

IN SEEKING SELF WE feel the more we gather to feed it the better. We are insatiable. We can never get enough to make us feel satisfied. This is because we are deluded. We follow our ego as if it were a god, and it is a god. It is a god with no end, it is a black hole. It is a black hole because that's what it's supposed to be. The point when ego shows us a sparkly trinket is to decide if it suits us or not. It is not to make the choice indiscriminately. We must decide if what our ego is doing is what we want or don't want. We decide who we are in the end, not our ego. But the devouring ego does just what it's intended to do.

Yet we feel if we knew more about where to look and what exactly we needed we'd have self down and be able to exploit it. Where is that last thing that will make us feel legitimate? It never occurs to us that we are looking in the wrong place. We begin to work scientifically to define self. Here, we say, is the essential self, in the frontal cortex of the brain or the hypothalamus of the brain. But it is not there. It is not in brain science that self lay, even though self cannot live without it. It is in consciousness.

Just One Sparrow

Pursuit of Knowledge

Science is the pursuit of knowledge, and as we discover our deeper selves, our selves that are in truth formless artistic material, we are followed by science. Science wants to know about presence and about what it is beyond reality. Eventually we will discover the way to explain experience in language, a way to understand that which is not seen. Today we do not yet have the language, We do not have a way to test or to predict direct experience without interpretation.

Scientists are in the business of searching for greater truth through testable and repeatable knowledge. In time science will explain our present search for meaning in scientific terms, and we will go on to a new awakening. We will experience many awakenings, as we have already. This is the motion of Life. To awaken, to sleep, to awaken.

Awakening into Nothingness.

We think there is a division between our self, which is this world, and our destiny in another world, between

material and spiritual, between here and there, between one parallel universe and another. But it is not so. All things exist as maya, illusion. There is no difference between now and future, material and spiritual, there is only presence. There is only nothingness. The experience of illumination is not beyond scientific pursuit, but it will always be beyond present language and understanding. This is because reality and non-physical reality are forever beyond the grasp of self in present Life. Even as we move toward it, it does not exist. Our art and ourselves as art are eternally uncreated until they are created. We cannot know what it is because it doesn't know what it is until it is. It is nothingness.

All things are a mystery until they are understood. Awakening to truth is no problem. It can and does happen without ceasing. The objectivity of science is a saving, un-god source that can be counted on to see the deeper truth of reality. There is science in art. Science becomes art. It is the excitement of left brained intelligence, the satisfying result of critical thinking. It is the structuring of art, the bolstering of art. Science is a happy invention that can be counted on. The critical thinking skills required get us a long ways on the road to the narrow gate. Learn critical thinking and you will be equipped to see clearly.

Shot With a Gun

An awakened one is not less in feeling for Life because he is awakened, he is more in feeling for Life. His heart is the heart of Life. He is not above the pain of Life, but weeps openly for the broken hearts of all. This is enlightened being. This is Amma.

He is no longer about the expression of himself, but is about the expression of all of Life. He is beautiful, for he is beauty. He is the truth of Life. He is above nothing, but is humbled by all of Life's expressions. He is vulnerable. He can be shot with a gun, or stoned, or burned at the stake, or crucified, for it is not that he is both human and divine, but that his humanity is divine. He heals, and is healing itself. He is holy as Life is holy and cannot be made separate from the heart that he is.

18

Nothing is Not Divine

NOTHING IS SACRED BUT THE HEART

THERE IS NOTHING HOLY but the awakened heart of living Life. There are no things or gods or any anything that is sacred but the heart. What we have called holy and sacred are but representations of what is the true holiness and sacredness of Life.

Holiness is nothing in Life that is holy, it is Life that is holy. Holiness is a reflection of the gift that Life is. It is uncompromised. It is gifted by Life to Life. Holiness is the nature of love.

WHAT IS MIRACULOUS

WHAT IS MIRACULOUS IS Life revealed for itself. What is miraculous is the promise of Life awakened. Every expression is miraculous. Everything that is is an expression of

the wonder and love that Life is. The miraculous reveals the sacred heart of Life, the heart beheld.

When we see the awakened heart of living Life we experience the unbroken river of the power of Life. This power is sacred in its inability to be possessed or utilized. It can be nothing but given. This is what sacredness is, and it is the sacredness that is Life. It is Life that is sacred.

All Things are Sacred

The beauty, the miracle of Life astounds us, this ever-flowing fountain that is Life, and we are humbled by this gift that cannot be taken but can only be given. Sacred means an attitude toward Life and her manifestations.

When we awaken to the light and are freed into the light, the heart of us knows all things as sacred. We awaken to all things as sacred, all things as expressions of Life divine. What is divine is not in opposition to what is not divine. Nothing is not divine. There is expression of Life, and it is divine expression. There is no other. It is all material given by Life for the art of Life, for the fulfillment of Life in all things.

The awakened one is holy, the awakened one is sacred, the awakened one is divine, the awakened one is the living

art of Life. It is free, and it is no other. The awakened one is awakened to the heart of Life, there is no other awakening. It is the heart that awakens to the intelligence of Life. There is no mind except through the heart of Life. Structure follows form follows structure follows form. Day, night, day, night. To sleep, to awaken, to sleep, to awaken. To begin, to end, to begin, to end. This is the rhythm. This is the wave through which Life can be and is known.

We go into the night to be reborn into new form. We create another day and a new awakening. This is the nature of Life, this is the way of the dance.

Where am I Stuck?

I ask myself, What is in my heart that I am holding back? Where is it that I am stuck in my picture? Where are the barriers that I can take down? What is my self up to that it denies my freedom in this moment? How can I be smarter in my approach to Life? What trap have I left created and what trap have I left unrecreated?

Be still for a moment and ask these questions. Ask them of Life. Because when you ask, Life will answer. The heart of Life always answers. I look to Divine Mother. What is Divine Mother? She is the expression on earth

of compassion without end. She is the art, knowledge, and wisdom of the universe. In and through Amma we can recognize these instruments of the art of Life in ourselves. When I behold the countenance of Amma all traps cease. There is no trap in Amma because Amma is not here. The traps are all in the world and all is maya, illusion. Amma is not here. She is an expression of ourselves in truth. Where we are is not here. There is not anything in nothingness.

Name Your Traps

Traps are words and language. We use words and stop thinking. Have any part of our original selves been revealed today or has every word we've said been over-used and cliché? Have we connected to our heart at any time today? Traps are misconceptions and misguided ideas, they are rejection of self and glorification of self, they are control and hatred of woman, they are the trap of violence man has set for himself. They are ignorance, they are all of our needs, food, water, bonding and affection, procreation, learning, meaning. Traps are made of all things of the world. Life is a trap. It is the power of the released trap that brings energy to climax. In the climax our birth explodes into new

Life like Superman. The trap reaches unendurably for the coupling that will bring us home.

It is not to you in the world that Amma points, it is to the truer you that abides in presence. It is to the new-born that you are. The presence carries you and all of Life out of the trap and back into nothingness. Life is hard and inscrutable, but you are not. You are Life's art, and art's Life is you. Some survive this world, some don't. But you cannot and will not ever be separated from the Life that you are. When we recognize the trap we get free. This is what makes awakening a prize, because we've struggled enough here in this D ride. We've had enough and we want to go home.

REUNION AND RE-EMERGENCE

SOMETHINGNESS IS EXPRESSION AND when it is expressed it enters into time. It enters into time and takes on Life, and when it is done, like any expression, it comes to a close, just like a play on the stage or a symphony or a book, or like a wave upon the sand. This is the nature of Life and of art. But the story never ends. You do not end. The character on stage is released, just like you, until the next time. Death is metamorphosis. It is reunion and re-emergence, just like all things of Life.

How Can We Endure?

STILL, WE ASK, WHAT kind of Life is it that causes endless pain, that creates suffering every moment of Life? How can we not split ourselves off into gods? Else how can we stand the despair? How can we stand the unknowing? How can we endure? We want to throw away our paints and give up on our picture. We don't care about our art. We want some fresh air. We get tired. We look around. Where do we start? How do we start again?

We start in stillness. Every intelligent thought we have begins in stillness. Be still first. Even in the midst of a boxing match, the fighters get to go to their corners and rest and be quiet for a moment. That's what we do. We put the pen down for a moment. We wash the brush, we release the sculpting tools, and sit down to rest our tired dancing feet. Our task is arduous. But we do not only have tools of conflict and despair, we have tools of strength, and will, and courage, and perseverance. And we have tools of love. Just as much as we have tools to make the journey difficult, we have tools to make it easy, to bring it into the golden meadow that lies on the other side of the tunnel.

Nothing is Not Divine

NOTHINGNESS IS A CLEAN CANVAS

First be still. In the midst of talking, be still.
Feel the feeling.
Let go like a stream falling over rocks.
Release all meaning.
Stay where you are, there is nothing anywhere else.
Give freedom to your curiosity.
Use your brains with critical thinking.
Become the little child you are, about three.
You must feel you belong. Find the place you belong.
Don't give up because where you're headed is right.
Be honest that you do not know what you're doing.
Don't take pride in knowing or in not knowing.
Become aware of presence. It is the gateway to Life.
The revelation of awakening is nothingness.
When you see the light you see nothingness.
Nothingness is the truth and state of complete freedom.

Understand that nothingness must be. It is the clean canvas and the fresh character upon the stage. She comes from nothingness just as you and I. This is the way it is. If there were something already there then that expression would be something else, it would not be you. It would not be the

pure infantile self of you emerging, it would have a history already. But in nothingness there is nothing. No thing.

My Burden is Light

My favorite saying given to Jesus is, "Come unto me all ye who labor and are heavy laden, and I will give you rest, for my yoke is easy, and my burden is light." The me of Jesus was the truth of Life. Come unto the heart of Life that gives you rest. Come unto the wave of the crest and find refuge for your struggle. The me of Jesus was not savior and was not messiah, it was the presence of awakened being.

When we can't go on and we let go finally to die, when we have no strength left and no more energy to struggle, and no sorrow left to bear, and our soul collapses, utterly forlorn; when Kali reveals herself to us, our helper for the long haul, we are taken into the divine heart. We let go into the heart of Life when all our strength is gone, and all our tears have been wept, and we are released into love.

We do not release into nothing. We do not fall. Not anything ever has been left to fall from the heart of love. Not a single leaf, not a single flower, not a single frog, not a single elephant, not a single sparrow, not a single anything falls from the embrace of the heart which is Life.

Nothing is Not Divine

THE SADNESS OF LIFE

It is sad. It is the deepest well of sadness to see a thing of Life break. To think of the suffering of our family of Life, the earth, and the breaking down of the things we love, the abandoning and destruction of our home. This is the tragedy, the suffering created from not knowing who we are.

I think of the wonderful actress Geraldine Page in the film, A Trip to Bountiful. All she wanted was to go home, but when she got there, her home was broken down, empty, and all around her, all the Life she had known, was gone. And yet she sang her Christian hymns earnestly. "Softly and tenderly Jesus is calling, calling for you and for me. Come home, come home, ye who are weary, come home." She turned to her home in heaven for comfort, to relieve her suffering, to renew her strength.

But suffering takes a heavy toll and Life by design cannot endure it without end. Most of Life fails and dies in suffering. It is Life's mercy of death that brings suffering to an end. Suffering is Life's call to care for one another. But when no one cares we are released in death to Divine Mother, to the arms of living Life.

We Are in Peril

SUFFERING TAKES AWAY EVERYTHING but itself. It produces the wisdom caused by having our self taken away, profoundly defeated, humbled beyond humble, pain and suffering beyond endurance and yet turning on the stake point of Life upon which it is impaled. In suffering Life cannot be known and cannot not be known. It is a tool that is about itself. Suffering tells us we are sick and broken. We are in peril. We hope to survive or to die in order to get free from languishing on. But life is powerful and we do not get to die so easily, even as suffering goes on with no moment of retreat, for hours or for years.

We don't really care about becoming wise. It is too little too late. We would rather be relieved of suffering. We would give up our tool of suffering joyously. But how could we learn to care? How could we learn to know anything without suffering? How could we care for our earth if we did not suffer, if we could not feel for our brother and sister species with whom we share the planet? This is the use of suffering. But most would opt out in favor of less caring and more goods. This is because we remain immature and do not know what this is about, this experience of the world.

Nothing is Not Divine

ALL LIFE IS EQUAL

ON OUR WALKS IN the morning, Maudie and I go along the path around the park. It does not rain very often, but when it does, earthworms wash up on the path. The rain is always brief, and the sun comes out again. Earthworms wash up onto the path and if I do not pick them up and put them back in the grass they will die in the sun. I try to pick up as many as I can, but I do not pick up them all.

Which earthworms get saved, which do not? Which will perish, which will not? Is our art of Life as random as this seems? Is one expression chosen to live over another? No. There is no Life that is any more valuable than another. All Life is equal. All Life is equally expressed. There is no division in Life. There is no expression that is any more valuable, any more chosen, any more worthy, any more privileged, any more anything than any other. No Life is more beautiful, more miraculous, or more infilled with Life than any other Life. No Life is happier, sadder, richer, poorer, healthier, sicker, smarter, stupider, prettier, uglier, or more wondrous than any other Life.

No Life is better than any other Life.

Every expression of Life is its own. It is the art of that expression uniquely. But if it has Life, it is Life, and all

things are Life. Nothing that is is not Life. Life is the ocean and every expression is a wave.

Life cannot be victimized. Life is free. No one, and no thing has less or is less than anything else.

Feelings Are Fuel

THE FEELINGS OF THE heart are our fuel. They are our inspiration. They are the expressions of truth waving a flag, calling us forward, lighting our way towards home. Feelings, emotions and intuition illuminate our minds. They are not optional. Feelings illuminate the narrow gate. They are the source of ideas and the dwelling place of the muse.

The Heart without Itself

WHEN FEELINGS ARE NOT welcome and not expressed, it is denial that steps forward. Denial is a handy instrument. It holds up what we think we cannot hold up at the time. The trouble is that it stays in place of its own accord. We can leave it and walk away. We walk away and carry on without the chancy state of its vulnerability. We wrap it up and leave, and think we can get on without noticing it. But what

do we get on with when we have denied the truth of our hearts? And what is the heart without itself? It is a vague memory. It is a sense we have from time to time of a gaping chasm which if we had feelings we would know as loss.

Heart without itself moves on in time but does not go anywhere. It comes in times of exhaustion and is a sense of immeasurable heaviness which if we had feelings we would know as profound sadness and depression. Denial is a roadblock that we get backwards. We think we can block the pain of Life and get on with the rest of it. But what we do is block the Life and invite the pain.

Our denial is easy to spot. In its unreality it is bizarre. It is impervious in the most unlikely situations. It is pleasant and does not like unpleasantness. It does not see and when it looks it is blind. It does not listen and when it hears it is deaf. When you turn it sideways it is flat as a board.

WITHOUT HEART, NOTHING MOVES

DENIAL HAS AN IMPRESSIVE shelf life. It can go through many forms, many lifetimes, and stay in the same spot in the picture. Without heart, nothing moves.

In the grace of Life and in the mercy of the heart, denial cannot remain forever. It is just a stone in the wave,

and eventually it will wash out. Eventually the dam of the denied heart breaks, and we move on to other instruments, other colors. The heart wants to be loving. It is open and unfettered. It cannot be marked or adulterated. It is a well of unlimited giving that is abundant and is never not the absolute abundance of all things.

If anything could extend Life it would be love. But there is only the love of Life which is Life. There is only nothingness in the end and in the beginning. There is nothing here to be here. Where you are, breathing, no sound, no sight, no nothing, you, on the verge of presence, up close to who you are in truth. Where you are, noticing your breathing body, this is all there is. This is the path to awakening and to the truth of nothingness.

Tears for the Prairie Dog

Near where I live, there is a prairie dog town. A couple months ago, as I drove past, I saw a prairie dog who had gotten off the curb and sat at the bottom looking up. I thought at first that I should stop and help him up over the curb, then as I drove by I thought the nearness of my vehicle would frighten him up over the top. I did not look back to see.

The road is wide and he would not be in harm's way. And I thought he would just jump up and go back to his foraging. An hour or so later, when I came home, I saw him hit by the side of the road, in the same place where I had seen him before, raised on his back legs, trying to peer up over the curb's edge. It seemed that someone had intentionally turned toward him and run him down. Grief overwhelmed me. It seemed I had no end of tears for the little prairie dog who I could have saved and did not. Days went by and weeks, and I could not get over the prairie dog. There was wailing in my heart, and it came up, and I wailed over the little prairie dog, and I ached and ached.

I feel my own self in the heart of Life too. I feel the love that Life is, holding me too, carrying me into comfort. In that place, my heart cries for all the hurt prairie dogs, and all the hurt creatures of Life; for all the sisters and brothers, and all the mothers and fathers of Life. I cry for all the helpless and abandoned hearts of Life, all the brokenness and all the lost children that we are.

I cry for our valiant and pitiful efforts and our lifelong struggles to get free of the chain so that we can take one step. I cry for the innocence and the bravery and the relentless effort of each living thing, the never-ending effort Life has to live. In humility I cry for the pure love that Life is. In gratitude I cry for the pure endless giving that is Life.

Creation of us All

THIS IS THE REASON we suffer in Life, because suffering is the hardest of our instruments. In suffering we transform the passion of our own lives into the compassion for the lives of all. In suffering we are transformed from the integrity of our own art into the integrity of the art of all. In suffering we go from the search for beauty to the beauty. In suffering we are transformed from our own creation to the utter humility of the creation of us all.

In suffering our art becomes Life.

In suffering our Life becomes art.

In suffering we awaken to ourselves as the living art of Life.

In suffering we suffer alone. And yet as we suffer the pain of our aloneness is transformed into the suffering of all of Life.

Defeat Takes Life

SUFFERING REQUIRES ALL OF Life. Every idea we have about holding on is suffered away and dropped onto the ground. The suffering that leads to wisdom is that you are

nothing of the world, not even your physical being, that you are not here but only the creative expression of you. You are a flash, you are an idea, energy visiting the solid world.

The result of long-suffering is defeat. Defeat takes Life. It is humorless, standing like an emaciated woman in a dustbowl field. Suffering is the teacher of defeat. In a way every defense you've ever had is beaten to death as with an old shoe by suffering. In long-suffering every trace of who you thought you were is gone, is over and is changed forever.

We Become Teachers

As we accept our feelings and no longer reject them, we no longer reject the feelings of one another. And as we accept the feelings of one another, we stand in the hand of love, of who we are.

As we express the feelings of our hearts, our barriers are released, the fear we have held onto dissipates and is gone without a trace. In expressing our hearts openly, we become teachers. Our vulnerability invites others to come forward. Yet we seem to be aground at this point in our picture, we are so protected from our hearts. The reason for suffering is

to bring us through protection to unprotection. It is to lead us from smallness to the unlimited bigness of the universe in which we play, the universe that we are.

I had a sign in my acting studio that said, "Being There is Feeling the Feeling". You cannot be real if you are not fully present to Life. You cannot create true Life if you are not there to do it. The Life of your character or your story or your symphony can only be brought to Life if you are fully conscious in it, because the Life of your art is your Life. You are the only Life it can have and will ever have. You are your own Life. You're it.

You cannot be real or create what's real if you are not fully real in the present. It won't work if you hold back. It won't work if you are not all there. It doesn't matter how good your technique is. Great art is never about great technique. It is about great heart expressed through technique. There is no structure without form, and no form without structure. There is no left brain without the right. There is no only somethingness, and there is no only nothingness.

INCHES BEFORE REVELATION

THE ONLY WAY TO bring reality forward is to meet it. Suffer the suffering, and enjoy the joy. You cannot fake joy

anymore than you can fake suffering. If you want to be alive you have to feel the feeling. If you don't feel the feeling, you don't create it. This is the answer to Life's questions. What do you do about Life? Cry when you want to, be angry when you want to, be spontaneous, laugh, make love. Feel your feelings.

We may say we don't care about creating true art, or seeing it or hearing it. Some of us say technique is good enough. We'll take the pretty picture, beautiful is not necessary. This is all we can do, this is as far as we can go. We stop sometimes miles before the revelation, but sometimes only inches. We put our foot down the last minute and it's too late.

But while we say we will settle for technique, for what is less than beautiful, it is not true. It is not true, and it will not do anyway because Life will not settle for anything but our fullness of Life. That's why we suffer, that's why we have feelings, because suffering is the call of Life and feelings are the lamppost that guides us home. We cannot get home by trying to be less than we are. We cannot slide by. We cannot sneak in.

We get home to Life by learning how to feel our feelings in the moment when they call. Feelings cannot be delayed interminably. This is where we are in our grounded state, in feelings interminably delayed.

COME ALL THE WAY IN

MORE THAN ANYTHING ELSE, I tell my acting students, Come forward a little bit more. Come forward. Come all the way in.

We are afraid of the presence because the presence has the power. The presence is new. Every moment is new, and it looks scary and we resist. Maybe we'll just hang back. But you cannot hang back. You have no choice in the matter of whether or not you are an artist. You have no choice in the matter of whether or not you are a living Life, the alpha and the omega. The Tarot Fool and The World. You're it.

GRAMA AND I WERE ALIVE

I LOVED MY GRAMA very much. She was the place of secure love in my Life until I was thirty-five and she died. When she died I wept day after day and could not stop. At my mother's house after the memorial service I stood in the corner of the kitchen and cried, but no one else had cried. I was left alone and people continued to talk and eat. It was as though this was hell and all these people were dead and Grama and I were the only ones alive.

The reason for the presence is to be in it. To be a shadow, to be a specter, is a shame. It is the loss of present Life. And not being in the presence is not being in Life. Being there, being in the presence, is feeling the feeling of the present in the present. It's a frightening and exciting venture, it's a risk. Present Life is obliteration of the past. It is being swept away into the climactic moment. Some of us say we are not brave enough, we lack the courage. We are not prepared.

But there is no preparation for the moment. The moment is the Tarot Fool stepping obliviously from the cliff edge. The moment is the moment because it is the moment. It is new and clear and it cannot be gathered into the past or skipped ahead into the future. There is nothing but the moment anyway. There is no past, and there is no future, and there is no Life anywhere but in the moment. The way to Life is the way home, and the way home is in the moment and nowhere else.

Each Moment is an Explosion

WHY HAVE WE GOTTEN so afraid of the moment? Why has it gotten so magnified, so exaggerated? Because each moment wants to be the moment. It wants to hang on. That is what it is supposed to do. But then it lets go. Each moment

is like a monkey swinging through the jungle. He gets a grip, swings, and lets go. Each moment is like a dot-to-dot picture. It can't be anything without the dots. The dot is the structure of the form letting go to connect with another.

Each moment is an explosion into itself. It is a powerhouse of Life. Each moment is a glimpse into all eternity.

Getting stuck in the grip, in the dot, is a stage in our art. It is an old LP record that gets stuck in a groove. It is movement that won't move. It has let fear get the better of it, and it is all part of our work in progress. Life calls us forward like little one-year olds learning how to walk. Come on, Life says, take a step, you can do it. We have forgotten we are children. We are Life's children who are meant to run like the wind and laugh with abandon and cry when we are hurt. We are children of the moment. We are the creations of the moment, the moment is not a creation of us. The moment is where we have our Life. It is where we get free.

Life calls us to be the child that the moment is. There is no old moment. There is no used moment.

The Words Were Powerful

We were born with all the tools and instruments of Life, all of them. When we ask questions of our existence

such as who am I, what is Life, how do I find meaning? we have built-in answers to them all. Our art is askew and we don't know our value because we stopped using our natural tools. We have shut down feelings and subverted them for fear we will be rejected and cheated and weakened by their expression.

We must stay open to the moment, to feel the feeling of it, so that the idea, the inspiration can get through. It is not to feel just to feel. But we must feel in the moment in order to be given the materials we need for our structure. We cannot only feel, we need a way to express the feeling.

Shakespeare had to feel the feelings when he wrote the Hamlet soliloquies, or Macbeth's "Tomorrow and tomorrow and tomorrow." They did not write themselves. He had to feel the feelings in order for the words of power to come to him. He did not make the words powerful, he listened and recorded the words because they were powerful. They carried the power and expressed themselves through him.

Beethoven, as he sat in anguish at his table, couldn't walk away, couldn't go and find a warmer spot and let the Ninth Symphony write itself. No. He couldn't do it from any distance at all. He had to be there fully in the moment, fully available to the ideas, the inspiration of Life. He had to listen with all his might for the right notes, and to know the wrong notes.

We are not the Life

In Acting the Essence I say, "Our job is to be still so we can listen to the voice of the Muse. In fact, what we think does not matter to her. She is there to tell us something we do not already know. As artists, she has chosen us. What she gives us to say or to do has its own Life. It is none of our business."

This process, and it is the process of us all, is a clue to who we are. If we pay attention, and when we pay attention, we realize with profound clarity that we are not the Life, but the vessel of Life. All things are not the Life, but are the vessels of Life, the expressions of Life.

19

The Heart of the Parent is the Child

True Art is Free Life

Creating great art in the world does not make us great people. The art we create in the world is not about us, it is about Life expressing through us. Our creations, our children, are not ours and are not about us. We have chosen to bring the expression of Life to Life. What we ourselves are about is the art of us. What we are about in the art of our Life. In the art of the world we are created through and in the art of Life. We are the art that is created. As transformational expressions, we are both creator and created.

We are the parent and the child. The parent is the formed, the child the forming. The goal of the child is not the parent. The goal of the parent is not the child. The goal of both is the child-parent. We need only a little parent. Every good parent does not over-parent. Every good parent does not reject the child that he is himself. The expression of Life is the child with not a single bit more parent

than it needs to express its form in complete fullness. The heart of every parent is the child.

The Life of all true art is free Life. It is the heart of the child, of ever-renewing newness. It is the eternal moment. With every breath we are the child and the parent, with every breath, the new and the old, the wave and the crest. Every moment is newness and the completion of newness, unfamiliarity and familiarity, arrival and being arrived.

How to Hang On, How to Let Go

Our creation of art in the world is not about us, it is about the picture that is creating us. Our art is the art, the art of us is the artist. We create from nothingness, and we are created to somethingness.

We learn how to hang on, and how to let go. We discover that each time we let go and swing through the air, another branch will appear. We learn that if we come fully forward into the moment by feeling the feeling, we will not perish. Not only that will we not perish, but we will be given a beautiful gift, the wonder and joy of the Life-infilled moment.

The moment of Life is its presence. Life is present. That's where it is. In the newness of our Life as created

art, we learn about the instrument of hope, the confidence that another branch will appear, another moment will arrive. We get to know hope and learn from experience that it is forever within us. The quickening of hope gives us a glimpse into the pure happiness and relief of which we are capable.

CONFIDENCE IS HARD EARNED

CONFIDENCE IS HOPEFUL PREDICTION based on our beliefs. Sometimes it is founded and sometimes not. Sometimes it runs out. It is not a privileged instrument. It is not the treasure of a select few. It is hard earned and chosen. Confidence is not the possession of The Fool. It is to the humbled master that it belongs. Confidence may be known as faith in a religious connotation. But faith is an available tool that has either a positive or a delusional understanding. It is not-knowing abiding in peace. I have confidence that Life knows what it's doing and that I am not left out. The reason I have this faith is because Life offers confidence and allows it. Strong confidence is based on experience not ideology. Life affirms confidence and says this thing you expect can happen because you have confidence. It

is a high-energy position in the wave. It will sink into one's being and become stronger whether it's for good or for not good.

The not-knowing of confidence is a knowing of the heart. The heart teaches us to live confidently because we have learned that confidence can be trusted. We believe with the hearts of the children we are that Life is abundance without limit. We believe that Life has love for us and for all of Life. We believe so because Life tells us. We cannot help but feel it, we cannot help but know it. In our heart we know the truth that Life is for love. This is the confidence that we can have, because in truth it is justified, it works.

Every Move we Make

Life is fair. Not only is it fair, it gives without end to each and to all expressions of itself. Why does it not seem so? Because wherever we are in the creation of our art of Life is where we are. When we do not feel that wherever we are is abundant Life, it is because we have not awakened yet to the incalculable value of every step we take. Every move we make, every word we speak in our work in progress is critical.

We cannot do without a single step we take in the dance. The words we speak are a trap. As soon as we enter them they sink into our soul which is our consciousness, and their energy works power. Every word we speak is a holographic view into the past. Every word that comes forward has a psychometric history. Every word carries energy from endless use over the millennia.

When we think of words such as war, death, kill, or every day words such as pain, milk, bread, tomorrow, father, mother, these words are not ours to dispose of as we wish. They are tools of great building capacity or devastating destructive capacity. We have so far not related to words at all. We have no conception of their power and toss them off like so much trash in the can. If we choose we can use words to release the trap, but we will come to understand that when we speak words it is an enormously powerful step to take.

THE DARKNESS RECEDES

WHEN WE FEEL THAT we have gotten jilted by Life, it is a feeling that is a crucial step, a giant step toward our expression into abundance. The darkest place, the hardest place of our dance is the expression of the call of our heart to

be free, and when we step into the darkness, toward the darkness, it begins to recede. We see the beauty that we have created is beyond words. It is beauty to every depth and every breadth and every height. It is beauty itself, the truth of the abundance of Life. Make no mistake, there is enough for every living thing on earth. But we are a species that takes instead of gives. We do not know that we did not begin nor shall we end in this temporal plane. So we take what we can get while we're here.

Shall we choose Life? Even as we do not, within our minds we know that darkness is the home of light, and light is just darkness spread out. Light and dark, days and nights are a living relic.

Let Go of Smallness

Our art of living Life calls us to let go of smallness by expressing the hurt of our heart and the resentments we have held. It calls us not to judge our art but to find the greater power of our instruments of humility and forbearance.

Our creation calls us to give up regret. What we create is not regrettable and cannot regret. Every experience, every feeling, every step of our lives is a gift of the love of

Life for us. It is a gift of Life because the nature of Life is to give, and the dance of Life is a dance of love.

WE HAVE NOTHING TO FIX

WE HAVE NOTHING IN Life to fix, and nothing in Life to get over, and nothing in Life that needs repair, and nothing in Life that is wrong.

Where we are is sacred. Where we have been is sacred. Where we are going is sacred. Who we are and where we are is inviolable. This is the nature of Life. In our heart we know the truth of what we are. We must tell the truth to ourselves. It is the only truth we know and it is the truth. Wherever we are in our art, it does not matter. If we stand aside and allow the truth to come forward, it will. What is the truth of us? The truth is the love that Life is. Wherever we are right now in this moment we can stop and tell the truth. We can tell the truth because we are the truth and cannot not know it.

The truth is that nothing of the world can define us or evaluate our worth. Not anything. It does not matter what we have done or what we have not done. It does not matter how much we have suffered or how much pain we have endured. It does not matter how callous or how indifferent we have become. It does not matter what we have achieved

or how much wealth we have accrued. It does not matter if we are in the last moment of our lives.

We Are Immeasurable

We are immeasurable by anything in the world. We are not measurable at all. We are sacred Life. We are love. It does not matter what form we take or for how long.

Life does not know time.

Life does not know space.

Life is not anything but the dance of love. It is the motion, and what the motion is, is love. Our art of Life is the structure, and love is the form which brings us back to the perfect place of nothingness. When we awaken we awaken to nothingness. There is not anything but nothingness, and there is not anything but somethingness.

Not a single thing in Life is left unawakened. In the expression of the heart of living Life, all awakens, and all is awakening. You cannot not awaken. You can stay in the sleep of night, in the forest of Psyche for as long as you choose, for eons. But Life is awakened Life, and you are it. The heart of love is our home. We want to go there, and we will go there, and we are there.

THE HEART CALLS TO YOU

LET YOURSELF RETURN THE call of love. Do it. You are the shaman. You are the master, the teacher, the rabbi, the elder, the minister, the priest. You're it.

You are the leader. There is no other leader. You are not the follower. There is no follower. You are the creator of your art. You are the love of Life. The art of your Life is the art of the awakened heart of Life. You must lead. You are the only one who knows the way.

Your art calls you to be the love that it is.

WE HAVE BEEN MUTE

IF WE AWAKEN AND listen, we will answer back. We have been mute for so long. We have closed our ears to the song of Life for so long. Yet Life's song is fully present in the moment and in every moment just as it always has been and always will.

In the Unity church song book, there's a song by Clara H. Scott that says, "Open my eyes, that I may see, glimpses of truth thou hast for me; place in my hand the wonderful key, that shall unclasp and set me free.

"Open my ears, that I may hear, voices of truth thou sendest clear; and while the wave notes fall on my ear, everything false will disappear."

It does not matter how you return Life's call. It does not matter if you give it a name. You are the child of the love of Life. Answer the call. Go on. Follow your hope and confidence and curiosity and delight in Life. They will never fail you. They will never run out.

Now I say to you, where you are in your creation:

In what is harsh,

In what is difficult,

In what is unforgiving,

In what is unkind,

In what is unloving,

Only do this: weep, be still, open your heart, sing the song of Life, rest in the face of love.

For you who are afraid,

For you who are in need,

For you who are ill,

For you who are anxious,

For you who are depressed,

For you who are forlorn,

For you who are lost,

For you who are overwhelmed,

For you who are rejected,
For you who are sad,

Only do this: weep, be still, open your heart, sing the song of Life, rest in the face of love.

These are the way to freedom. There is no other way. Spring your trap by feeling your feelings. You have a secret. You know that Life is yours, that it is love, and that it cannot and will never let you down.

God Will Fill In

It is not that Life will respond as if it had been asleep and just roused by your call as if Life were God. No, Life heals us, strengthens us, brings us every possibility for joy and centeredness every moment of every day without rest. Life is not present to do us a favor, putting us together according to God's specifications. And although we feel Life is a strange place to find oneself without God, we wonder if God will give us a leg-up anyway. Perhaps God will fill in. But no, without interesting use God has left the stage.

There are no empty spots that need help because Life has fallen down on the job. No. Life is complete and inseparable from us. Life is us. We do not have to pray to Life

for help as if Life couldn't be bothered unless we were on the list. Life heals our bodies and minds and hearts continually in every single moment without our devotion or thanks and even without our noticing.

It is not that God created Life but that in our striving we create God to help us fight our battles and to win. We are like a child with an imaginary friend. With our baby blanket close we think in despair and resentment that Life is inadequate to the task of taking care of us and even of itself. We feel that Life needs God to set it straight. That way we have support to reject Life and its endless demands. Life is not on our side so we need an advantage. We think Life is a contest. We'll turn to Allah and God and Yahweh. God will help us deal with this unnecessarily unpleasant place until we are gone.

But Allah is not Life and will die as our consciousness changes. God will die as consciousness changes and the intelligence comes that it is Life that is the source of all that is and is not.

INSURANCE WITH GOD

IN TRUTH IT IS Life that is the answer and gives the answer to us. You are not a mistake. You do not need anything beyond what Life gives for you. Life does not and cannot lack

anything whatsoever. It cannot and does not take anything from you. You do not need personal insurance with God for the injustice and callousness of Life.

We do not even begin to realize what Life does for us in every single moment. It is inconceivable.

Gods give us what we feel we need at the time. That is what they are meant to do. When they are revealed through illumination they give way like drifting sand dunes to new light and new Life. They themselves are released from the trap and are no more.

We want to learn to not hold onto anything. Not gods, not ideas, not beliefs, not love and not Life. Not anything whatsoever. When we release all things without fail, we return to the purity of nothingness of which we are. We go home.

Give Up Godot

Are there answers to our questions about the purpose of life, the meaning? Yes, just as there are answers to all questions. But some questions have future answers for us, when we work our way there, when we gain the knowledge for the question to be answered. And we have gained this knowledge: from those who are awakened we learn that shunyata, nothingness is the truth and nature of reality.

And yet we continue to wait for Godot. But we will none of us meet Godot no matter how long we wait. Godot does not exist. Only Vladimir and Estragon exist and they must look to another direction. To get out of the trap they must roll it up and remove it from the stage.

Give up Godot. Can't you see that God is a relic? God is the emperor with no clothes. God robs you of your mind. No artist begins with their canvas covered by a supernatural being. No composer begins his score when another tune is in his mind. No actor enters the stage as a character who already exists. No, we must start with a clean slate, a clean mind in order for our creative selves to reach us, for the muse to consider us. If we do not she will pass us by. She will have moved on because we have not given her enough room to stay. We have not let go the cliff edge that will take us to new Life.

Empty your mind. Dump it out like an old box of junk. Give up every thought you've ever had. Be quiet. Then you can start, then you are worthy. Then you can have a Life that belongs to you. Once you give up the delusion of divine intervention you can get your life back.

God is an invention whose use is expired, a tradition who sits in a museum in a wooden chair and rocks side to side, so old, and nobody willing to help him to pull the plug. He is trapped.

This is what you must do. Let God die. He has done enough. Bless him and let him go. Start fresh.

LIFE WANTS US

IN THE END THERE is the mystery of the yet unknown and the future for artists to explore. The gods themselves are released from the trap. When we begin using our brains and hearts independently as is their intended use, we will be on our way to finding the pathway back to Life.

It is Life that we want and that wants us. Life never stops calling. It is ringing the dinner bell even as we speak. Come. Come for sustenance, come for Life.

A SINGLE MOMENT AWAY

"Do you know where you're goin' to?" Diana Ross sings,
"Do you like the things that Life is showin' you?
Where are you goin' to, do you know?"

Wherever you are in your work in progress, do you know you are a single moment away from seeing what Life is showing you? Do you know you are a single moment away from choosing the instrument for your next step? Do you know that where you are in your art is exactly the place you need to be for you to receive the right word, to hear the right note, to make the right move in the dance? You've

been in the right place all along. There is no place that is not the right place for you to be in the unfolding of your art.

Let go to Life. Where you are is none of your concern. You are not about it. You are not about the picture, you are about the Life. Let go. In the spring the leaves of the dogwood and apple come bursting forth, and they hold on tight. In the summer the leaves grow into full being and prepare to let go again. In the fall the leaves retreat and let go. In the winter the leaves rest. This is the motion of all Life. The rest, the wave, the crest, the fall.

You are transformational expression. The creator that you are can hold on or let go wherever you are in your work, while the creation that you are continues into being. You will awaken to the artist that you are, while the art of your becoming goes on. You the artist and you the art. Neither has any end.

You Always Will Be

You are and will always be the creator and the created.

You are and will always be nothingness and somethingness.

You are the dance between nothingness and somethingness, and the dance that you are, is love.

"Dance then wherever you may be," the song goes,

"I am the Lord of the Dance, said he,
I'll lead you all wherever you may be,
I will lead you all in the Dance, said he."

The love that you are is the Life of the dance. The call of the dance is to dance, the call of the song is to sing, the call of love is to love.

I Love You

IN MY STUDY WHERE I write there is a new little spider. I see the spider and her love comes to the love of my heart, and I say I love you.

My little dog Maudie is the heart of love, and I say I love you.

I see the sparrows at the feeder, and I say I love you.

Up in the treetop is a finch singing with all his heart, and I say I love you.

I look at the picture of my dad who died, and I say I love you Dad.

I think of the little prairie dog who died, and I say I love you, prairie dog.

Say the words, sing the song, dance the dance that is the love of Life for you and in you. Our hearts fill with

gratitude for the love that is everywhere around, for the love that is not anywhere not found and not being. There is no place that love is not, even and especially as we weep and rock for ourselves and one another, in grief and illness, forward and back, wailing into the night. Even as we die and our consciousness is released, the dance is of the heart and is the heart. There is no place that the dance is not dancing.

Let Your Heart Be

Come forward, wherever you are. You are loved, and you are love. Lay aside your tools for a moment, and answer the love calling you all around. See, there it is, and there it is, and there it is. Awaken. Your heart calls you to let down the backdrop for a moment, put your task aside. Let your heart be for a moment. Let yourself feel safe, just for a moment. To release fear is powerful. Let it go, it's bogus. Be strong. The love of the heart of Life loves you and cannot not love you. The art of Life you are creating is your ticket home. Your art of Life is a train that speeds along the plains and meanders through the valleys.

A Good Old Friend

Your art is your road to Life. It is the narrow gate. You are finding it, and you are going through. Even now you are home and cannot be not home. How can you be not home? The awakened Life is yours. You are the home of it.

Let yourself be home, as all of Life is home. You will see yourself there, and you will be glad. You will enjoin the safety and renewal of home. You will be a good old friend, a beloved one, and your heart will say, You've arrived, I'm so glad you have arrived.

Absolute Love

The dance of Life takes many forms, infinite forms. We are the wave, we are the crest, the pulse of love without beginning, the rest of love without end. This is the beauty of the gift of Life. It is Life always, and we are the heart of love that fills the eternal present. Every thing, every moment, is absolute love, and we are it.

It cannot be but so.

END

www.ingramcontent.com/pod-product-compliance
Lightning Source LLC
Chambersburg PA
CBHW061502180526
45171CB00001B/4